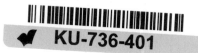
WallWorks

Wall Works

A group of 38 site-specific wall install-
ations in editions, produced from
1992 to 1998 by Edition Schellmann,
Munich–New York, in association with
Jeanne Greenberg Art Advisory, New York.

Edition Schellmann
Römerstrasse 14, 80801 München,
Tel 089-33 17 17 Fax 33 28 00
50 Greene St., New York, NY 10013,
tel 212-219 1821 fax 941 9206

Catalog

Edited by Jörg Schellmann
Essays by Uwe M. Schneede, Hamburg
and David Rimanelli, New York
© 1999 by Edition Schellmann,
Munich–New York
© essays by the authors
© illustrations of architecture by the architects
Reproductions: Eichmann & Köppl, Munich;
Repro Bayer, Munich (computer montages)
Graphic Design: Mendell und Oberer,
Munich
All rights reserved
Printed in Germany by Passavia, Passau
ISBN 3-88814-865-0

Distribution for the book trade:
Schirmer/Mosel Verlag, Munich (Europe)
DAP, New York (Americas, Asia)

Wall Works
Architekturbezogene Wandarbeiten

Wall Works
Site-Specific Wall Installations

Herausgegeben von Jörg Schellmann

Edited by Jörg Schellmann

Edition Schellmann, München–New York
Schirmer/Mosel Verlag, München

Architects

We are indebted to the following
architects for generously providing both
photographs and permission to illustrate
computer-generated installations of
these wall works in outstanding spaces
of their design:

Allies & Morrison
Tadao Ando
Axel Bleyer
Mario Botta
Christoph Buck
David Chipperfield
Frank Gehry
Richard Gluckman
Mark Guard
Philip Johnson
A. J. Kostelac
Lauber & Wöhr
Richard Meier
Gerhard Merz
Pawson and Silvestrin
Richard Rogers
Schneider und Schumacher
Annabelle Selldorff
Seth Stein
Oswald M. Ungers
Rafael Viñoly
David Wild

Also illustrated are historic
interiors by the following architects:
Hendrik P. Berlage
Andrea Palladio
Paul Ludwig Troost
Franz von Stuck
Ludwig Wittgenstein

Inhalt

Contents

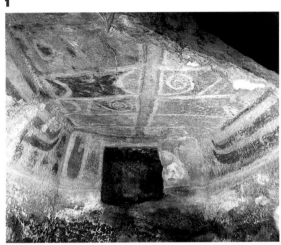

1

2

Von der Einheit der Wand mit Malerei

Nie haben die Wand und der Raum, architektonische Elemente, ihre Faszination für die Maler verloren. Die Gründe für diese Faszination indes wechselten.

Im Mittelalter wuchs zwar das Bedürfnis, der Andacht auch vor transportablen Bildern nachzukommen, in der Renaissance entstanden die vollends eigenständigen Werke, in denen die Malerei ihre spezifischen Gesetze auf einem besonderen Bildträger und in einem dazu hergestellten Rahmen realisierte, womit das Tafelbild zur gängigen Form des gemalten Werks wurde, die den Vorzug hat, transferierbar zu sein und deshalb umstandslos in ganz unterschiedlichen räumlichen Kontexten zur Wirkung zu kommen – was gattungsgeschichtlich die Institution Museum und schließlich auch das Medium Ausstellung ermöglichte.

Aber die Wandmalerei behielt auch in Zeiten der Emanzipation des Tafelbildes noch ihre besondere Bedeutung, zunächst für spezielle erzählerische Aufgaben zur Veranschaulichung von Geschichte und Glaubensinhalten in Kirche und Palast, dann im Barock bei der hochdramatischen inhaltlichen Aufladung und oft auch optischen Durchbrechung von Architektur, in der beginnenden Moderne gar als symbolische Form, und am Ende des 20. Jahrhunderts ist sie wie selbstverständlich wieder eine Gattung unter vielen geworden, zu deren Charakteristika gehört, daß sich hier die Kunst dem Alltag unmittelbar verbindet.

Die Wand scheint, nicht zuletzt wegen ihrer Ausdehnung und wegen ihrer faktischen, durch die Notwendigkeiten und Funktionen des Baus gegebenen Grenzen besonders geeignet für Gliederungen durch Farben und durch Formen, die sich der Fläche entweder bewußt bedienen oder sie mit ihren eigenen, den malerischen Mitteln optisch überwinden: mit ihr oder gegen sie arbeiten.

In der Gegenwart ist es vor allem die Funktionalität der gebauten Räume, die dem fest eingefügten Bild eine Wirksamkeit ermöglicht, welche sich von derjenigen im Museum spürbar unterscheidet.

Alle Malerei, überhaupt alle Darstellung scheint so begonnen zu haben, auf der Wand, zunächst auf der natürlich gegebenen Wand am Fels, in der Höhle. Um das 20. Jahrtausend v. Chr. herum entstanden Tierbilder mit festen Konturen, im 14. und 13. Jahrtausend v. Chr. kam es zu jenen malerisch angelegten Darstellungen aus Erdfarben, die uns aus den Höhlen von Lascaux und Altamira bekannt geworden sind. Tiere sind darauf zu sehen, Menschen und Tiermenschen. Jagdmagie scheint eine wesentliche Rolle dabei gespielt zu haben, aber offenbar geht es in den abgekürzten, symbolisch wirkenden Figurationen auch um das Verhältnis der Menschen zu den übergeordneten Kräften. Kultisch begründet sind sie auf alle Fälle (**1**).

Durch Jahrtausende gehen Kult und dekorative Ästhetik eine Einheit ein. Während der Bronzezeit sind ausgemalte Gräber der Nuraghen auf Sardinien geometrisch unterteilt, die Felder mit symbolischen Zeichen besetzt, häufig einem streng stilisierten Stierschädel. Der Stein wird durch die Farbe lebhaft-anschaulich, das Grab durch die abstrahierte Gegenwart des Unsichtbaren zu einer bedeutungsvoll-kultischen Stätte (**2**).

Bei den Etruskern wird die Wand bereits zu bildlichen Erzählungen aus dem Leben genutzt, und in der pompejanischen Malerei anfangs des 1. Jahrhunderts n. Chr. durch Perspektive, dreidimensionale Ansichten, Scheinarchitekturen, Raumillusionen, Ausblicke auf landschaftliche Szenen in all ihren artistischen Möglichkeiten entwickelt, die Statik und die Grenzen des Raums optisch aufzubrechen, die Tektonik zu durchkreuzen, vor allem: das Gebaute um das Vorgestellte, die Konstruktion um die Imagination zu bereichern. Durch die Malerei wird die Architektur zur Welt (**3**).

On the Unity of Wall and Painting

The wall and the room, architectonic elements, have always fascinated painters. The reasons for this fascination, however, have changed.

The Middle Ages saw an increased demand for painted icons – portable objects of worship. The Renaissance witnessed the creation of autonomous works in which the genre of painting manifested its own particular laws upon specially prepared foundations, within frames expressly constructed to contain it. Consequently, the panel painting became the most common form of painted artwork, with the concomitant advantage of being moveable so that it could exert its effects in various spatial contexts. As far as the history of the genre is concerned, it was this innovation which made possible the institution of the museum and, ultimately, the medium of the exhibition as well.

Wall-paintings, however, retained their significance even during the era of painting's emancipation by the panel. Murals continued to perform their special narrative tasks - at first, by illustrating the history and dogmas of the Church and the palace; later, during the Baroque era, by freighting architecture with highly dramatic content, as well as by creating optical breaks in that architecture; and in the early Modern period, as symbolic form. Now, as the 20th century nears its end, wall-painting is one genre among many others – but it is one which directly links art and everyday life.

Due to its expansion and its limits – determined by the functions of the building – the wall appears especially suited for sub-division by colors and forms which either exploit the plane or else try to overcome it. At present, the functional nature of a space constructed for living or working grants a permanently installed image a type of efficacy tangibly different than that produced if the same image were to be installed within a museum setting.

All painting, and in general, all representation, seems to have begun on walls, the first walls those occurring naturally in caves. Animal images first appeared around the 20th millennium B.C. Painterly representations using earth pigments, like those familiar to us from Lascaux and Altamira, were created during the 14th and 13th millennia B.C. and depict animals, humans, and beings somewhere between. Ritual hunting magic appears to have generated this imagery, but it also seems that these abbreviated, symbolic figurations may play a mediatory role between human beings and higher powers. In any case, these representations are inarguably motivated by magic and religion (**1**).

Religious and decorative aesthetics have been closely aligned for thousands of years. During the Bronze Age, the same ancient people who built nuraghi in Sardinia used color to geometrically subdivide the painted walls of their tombs. Within single-color fields they painted symbols, often a rigorously stylized bull's skull. Through paint the natural stone of the walls was transformed, vividly illustrating an abstracted presence of the invisible; thus the entire tomb became an important cult site (**2**).

The Etruscans began using the wall as a substrate for pictorial narratives of daily life. Pompeian wall-paintings of the early 1st century A.D. used three-dimensional perspectival devices to create trompe l'oeil, illusory architectures and landscapes. A plethora of artistic means were developed to visually negate the static equilibrium, optically burst the boundaries of the room, refute tectonics and, above all, enhance the edifice by adding the imagined and enrich the construction by adding the imagination. Clad in paint, architecture became the world (**3**).

During the early period of Western art, narrative tasks were often entrusted to wall-paintings, as if the mural were an oversized illumination and the wall an enormous manuscript page. In Mantegna's work in the Camera degli Sposi in the Palazzo Ducale in Mantua,

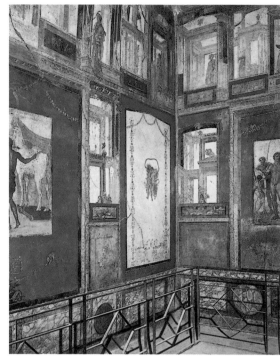

3

4

In der Frühzeit der abendländischen Kunst ist die Wandmalerei oft wie vergrößerte Buchmalerei mit erzählerischen Aufgaben betraut. Bei Mantegna in der Camera degli Sposi im Palazzo Ducale zu Mantua tritt die Architektur ganz hinter die Malerei zurück, die mit ihren spezifischen Mitteln eine eigene Räumlichkeit und ihre eigene Gesetzlichkeit ausbildet. Schließlich übernimmt die Wandmalerei bis ins 17. und 18. Jahrhundert hinein Aufgaben, die die Möglichkeiten des Tafelbilds bei weitem übersteigen: die breit angelegte Darstellung dramatischer Ereignisse, die öffentliche bildnerische Argumentation, Repräsentation und Dekoration, formale und inhaltliche Steigerung der Architektur.

Man denke an die geistreichen Wechselverhältnisse zwischen Bild und Wand in der von Raffael mitgestalteten römischen Farnesina, an die geniale Interpretation des Raums durch Michelangelos Ausstattung der Sixtinischen Kapelle, an Veroneses künstliche Wirklichkeiten in der Villa Barbaro in Masér, die illusionistisch das Innen mit dem Außen verschränken, an Tiepolos grandiose Raumaufbrüche (**4**).

Hier geht es um das umfassende Erlebnis des Betrachters, die psychische Überwältigung durch das räumlich-malerische Ganze. Was sonst nur die Natur bietet, wird nun durch die Einheit von Architektur und Malerei ermöglicht: die sinnliche Erfahrung des Erhabenen und der Größe. Darüber hinaus will diese Malerei mit ihren ausgetüftelten Programmen oft geistig und geistlich erziehen.

Wiederentdeckt wurde die lange zerbrochene Einheit von Architektur und Bild, als deren Auftraggeber, die weltlichen und die christlichen Potentaten, ihre Macht längst verloren hatten, die alten Hierarchien gestürzt waren und die Welt sich nur noch in Partikeln künstlerisch fassen ließ.

Aus der Sehnsucht nach einer neuerlichen Einheit und um die herrenlos gewordene Kunst durch architektonische Zweckbindung zu legitimieren, entwickelte im 19. Jahrhundert ein Künstler wie Puvis de Chavannes seine monumentalen, dekorativen Allegorien. Doch die Einheit blieb ein Traum: Puvis malte groß auf Leinwand statt auf die Wand, Edvard Munch konnte seine Pläne nur so bruchstückhaft verwirklichen wie Max Klinger oder Ferdinand Hodler. Wandmalerei wurde zur symbolischen Form für die Sehnsucht nach der Synthese und der gegenseitigen Erhöhung der vornehmsten aller künstlerischen Gattungen.

Immerhin gelangen etwa Hans von Marées mit den Fresken in der Zoologischen Station Neapel 1873 und Gustav Klimt mit dem Beethoven-Fries für die Wiener Secession 1902 große Würfe, in denen sich die Vorstellung vom Gesamtkunstwerk realisieren konnte (**5**).

Sieht man von der öffentlichen, politischen Argumentationsweise der mexikanischen Muralisten Diego Rivera und David Alfaro Siqueiros und von den in der Regel eklektizistisch erfüllten offiziellen Aufgaben ab, hat sich die Wandmalerei im 20. Jahrhundert aller Repräsentation, aller Illusionismen und aller Erzählungen begeben, gleichwohl aber die dekorativen Züge auch dort beibehalten, wo der künstlerische Ansatz ein durchaus radikaler war. Denn Wandmalerei ist neben allem anderen immer auch Dekor.

An der Einheit von Architektur und Bild wird weiterhin gearbeitet, aber weniger im Sinne einer Utopie denn im Sinne praktischen Einsatzes von Kunst vor Ort, im unmittelbaren Lebensumfeld von Menschen. Dort allerdings holt sich das bildnerische Werk wiederum seine Legitimation vom gebauten, funktionalen Umraum und stemmt sich dergestalt gegen jene freie Verfügbarkeit des Tafelbildes, die von Künstlern schon seit dem frühen 19. Jahrhundert oft als lästig empfunden wurde. In einer festen Bindung bedarf das Bild nicht jedes Mal einer neuen Rechtfertigung, und es muß sich nicht ständig wechselnder Nachbarschaften erwehren.

Während man sich in Holland im Kreis um Piet Mondrian zunächst für ein malerisch-konstruktivistisches All-over bei den Entwürfen für Innenräume entschied,

architecture is completely overshadowed
by painting, which uses its specific
methods to establish its own spatiality.
Well into the 17th and 18th centuries,
wall-paintings continued to perform tasks
which far exceeded the potential of
panel paintings: sweeping depictions
of dramatic events; publicly-accessible
visual argumentation, representation,
and decoration; and enhancement of
architecture through the addition of
new form and content. One need only
recall, for example, the ingenious
interrelationships between image and
wall at the Farnesina in Rome,
which Raphael helped to design; the
virtuosic interpretation of the space in
Michelangelo's embellishment of the
Sistine chapel; the illusory intermingling
of interior and exterior evident in
Veronese's artificial realities at the Villa
Barbaro in Maser; and Tiepolo's
grandiose spatial breakthroughs (**4**).

The issue here is the transcendental
experience of the beholder, who feels
awed and overwhelmed by a spatial
and painterly totality. That which in the
past had been offered by none save
Nature is made possible through the
union of architecture and painting: the
sensual experience of sublimity and
grandeur. Beyond this achievement,
paintings in this genre and their cunning
strategies are also often intended to
further their viewers' intellectual and
spiritual education.

Long-shattered, the unity of architec-
ture and image was rediscovered
many years after the people who had
commissioned both – i.e. the worldly
or Christian potentates – had lost
their erstwhile power, after the old
hierarchies had been toppled, and
when the world could only be artistically
comprehended, if at all, in fragments.

In the 19th century, many an artist
like Puvis de Chavannes was impelled
to develop his monumental, decorative
allegories by the yearning for a renewed
unity and by the urge to legitimize by
a link to architectonic purposes – an
orphaned art which had lost its masters.
But the unity remained a dream: Puvis

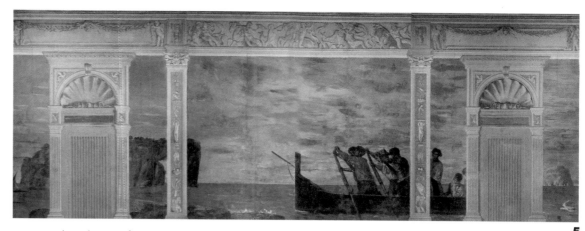

painted in large format on canvas,
rather than on the wall; Edvard Munch,
Max Klinger, and Ferdinand Holder could
only partially realize their ambitious
plans. Wall-painting became a symbolic
form of the yearning for synthesis and
for the mutual elevation of the two
noblest artistic genres. Nonetheless,
artists like Hans von Marées, with his
frescoes in the Zoological Station in
Naples (1873), or Gustav Klimt, with his
Beethoven frieze for the Viennese
Secession (1902), ventured great and
successful attempts at realizing the dream
of an all-encompassing artwork (**5**).

If one momentarily ignores public and
political content as embodied in works
by the Mexican muralists Diego Rivera
and David Alfaro Siqueiros, or the WPA
murals created throughout the United
States during its Great Depression, then
the 20th-century wall painting seems to
have almost entirely dispensed with
representation and eschewed illusionism
and narrative. However, it has preserved
its decorative tendencies, even in
contexts where the aesthetic intention
was a thoroughly radical one. After all,
whatever else it may be, wall painting
is always also decor.

Architecture and image continue to
be unified, less in a utopian sense and
more in a pragmatic approach to the
immediate habitat of human beings. In
such contexts, the artwork derives its
legitimacy from its constructed, functional
surroundings and thus actively opposes
the readily transferable panel painting,
whose compliant disposability artists
have frequently experienced as a burden
since the early 19th century. Because it
is inseparable from the wall that bears
it, a mural doesn't need to be justified in

gingen sowohl Theo van Doesburg bei der "Aubette" in Straßburg 1928 als auch Oskar Schlemmer bereits 1923 im Weimarer Bauhaus und dann im Haus Rabe in Zwenkau bei Leipzig 1930/31 zu Wandgestaltungen über, in denen reliefartige und plastische Elemente gleichwertig neben die Malerei gestellt waren. Damit hatten die Künstler allen Materialmöglichkeiten an der Wand – um im Bild zu bleiben – Tür und Tor geöffnet (**6**).

Bei der neuerlichen Beschäftigung mit Wandarbeiten haben sich seit den sechziger und den siebziger Jahren unterschiedlichste Erscheinungsformen herausgebildet. Wollte man einige Typen herausarbeiten, könnte man sechs Künstler namhaft machen, welche Maßstäbe gesetzt, nämlich Verfahren ausgebildet haben, die seitdem differenziert werden.

Sol LeWitt arbeitete rein mit der Farbe, erneuerte Malerei unter konzeptionellen Vorzeichen und scheute dabei zuweilen nicht die an sich schon seit langem verworfenen perspektivischen Effekte (**7**).

Dan Flavin brachte die Farben des Lichts auf die Wand – durch die Abstrahlung von Neonröhren.

Donald Judd entdeckte die Wand neu als einen dem Boden entsprechenden Träger von Skulptur (die dabei aber stets autonom blieb).

Jannis Kounellis arbeitete mit seiner Integration einfacher und ärmlicher Materialien, dem Bauholz, dem Ruß, Steinen, alten Säcken, in die Wand oder in Wandöffnungen zugleich skulptural und architektonisch.

Joseph Kosuth machte wie *Lawrence Weiner* die Wand zum Träger schriftlicher Bildreflexion, die gelegentlich die Funktion der Wand und der Malerei zum Thema hatte – ein prägnantes Beispiel ist Sol LeWitts für diese Edition entwickelte Arbeit *Wall Drawing*, die wörtlich sagt, was sie bildlich ist (dem sind Neonarbeiten wie Kosuths *Five Words in White Neon* Mitte der sechziger Jahre vorangegangen).

Dabei müßte man noch unterscheiden zwischen den ganz freien, häufig für each new context, nor must it repeatedly compete with its temporary, inconstant neighbors.

In Holland, Piet Mondrian and his circle initially decided in favor of a painterly-constructivist "all over" for the design of interior spaces. Both Theo van Doesburg (in the Aubette in Strasbourg, 1928) as well as Oskar Schlemmer (as early as 1923 in the Weimar Bauhaus, and then in Rabe residence in Zwenkau near Leipzig, 1930-31) switched to wall designs in which relief-like and sculptural elements were juxtaposed with and granted a value equal to that of painting. In so doing, these artists quite literally "opened the doors and cast open the gates" to all material options on the wall (**6**).

The resurgence of interest in "wall works" since the 1960s and 70s has inspired an extremely broad spectrum of divergent phenomena. If one were to attempt a typology, one might name six artists who set standards and developed procedures (which have since been refined).

Sol LeWitt *renewed painting from a conceptual standpoint by working with color, and had no qualms about occasionally using unfashionable perspectival effects (**7**).*

Dan Flavin *brought the colors of light itself to the wall – through the fluorescence of the neon tube.*

Donald Judd *rediscovered the wall as an equal to the floor for supporting autonomous sculptures.*

Jannis Kounellis *worked in a simultaneously sculptural and architectonic fashion by integrating simple, "poor" materials like building timbers, soot, stones or old sacks into the wall.*

Joseph Kosuth *and* Lawrence Weiner *both made the wall into a ground for written statements whose themes often focused on the function of the wall and of painting itself. One striking example of this is Sol LeWitt's work* Wall Drawing: *developed especially for this series, it literally says in words what it ontologically is in images.*

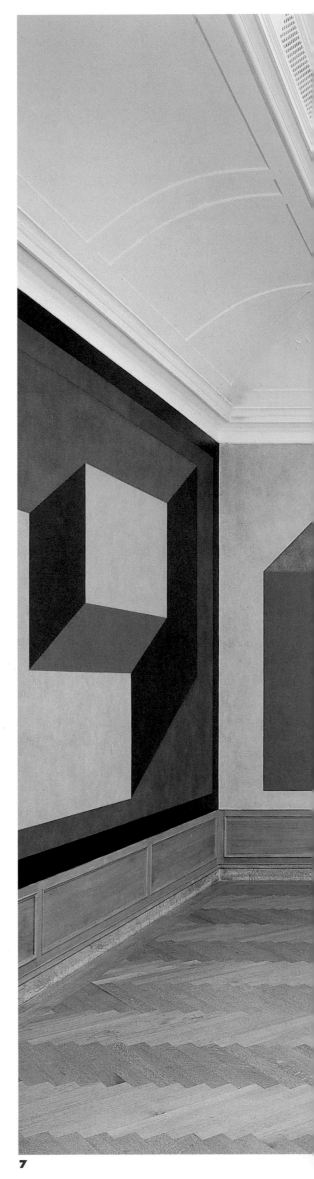

12

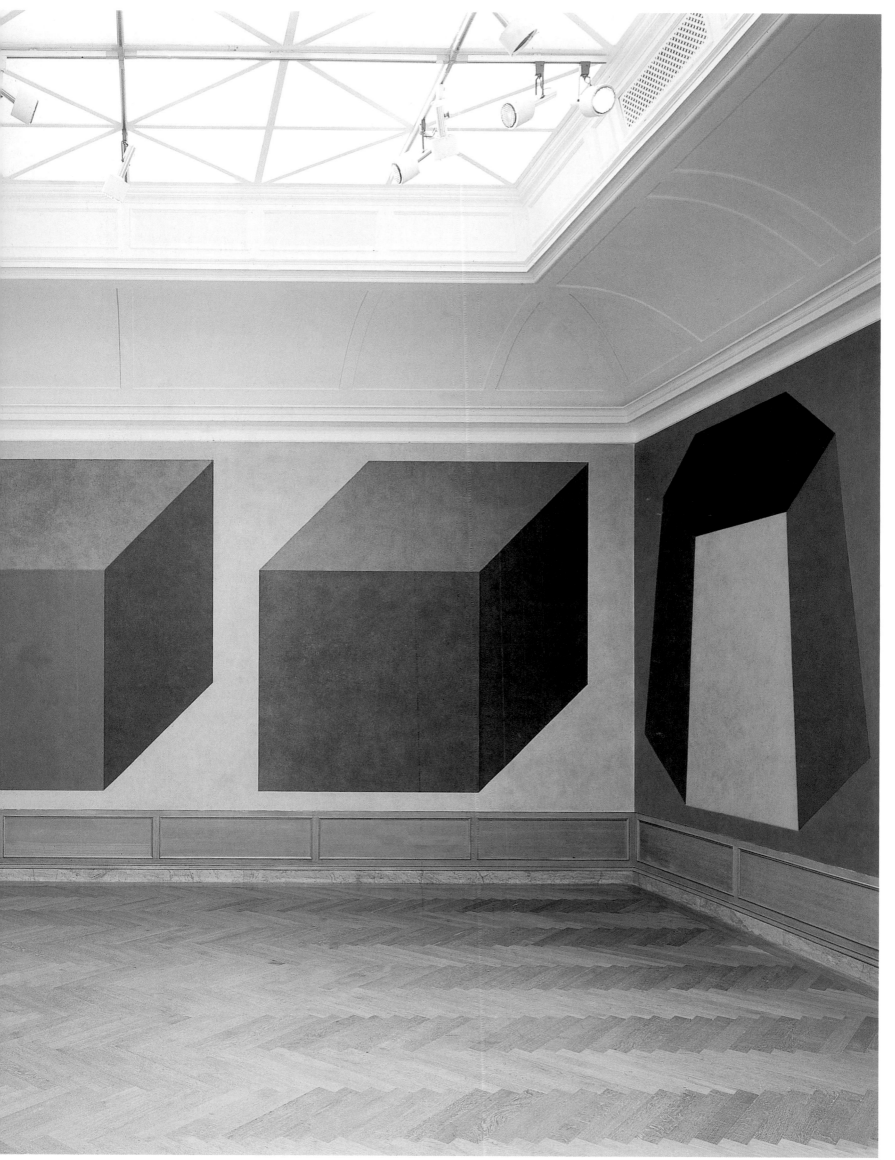

Museen und Ausstellungshäuser realisierten Wandarbeiten, die in der Regel nur auf Zeit angelegt sind, und den in funktionalen Bauten eingefügten. Den letzteren gilt hier das Interesse: statt des gehobenen, den Betrachter schon einstimmenden Kunstkontextes des Museums nun der ganz normale Alltag, in dem sich die künstlerischen Eingriffe gegen alles andere zu behaupten haben; statt der temporären Installation die dauerhafte. In diesem Punkt knüpfen heutige Wandgestaltungen für Funktionsbauten an die Lösungen aus früheren Jahrhunderten an.

Mit den Eingriffen der Künstler kann noch der trivialsten Architektur Sinn verliehen werden oder ein durchaus entschiedener Bau eine zusätzlich klärende Binnenstruktur und farbige Bildhaftigkeit erhalten. Ein wesentliches Beispiel für den ersten Fall wäre Gerhard Merz' Verwandlung eines sehr simplen Treppenhauses in ein Kunstwerk (*Tivoli*, München, Barerstraße 9) aus dem Jahr 1985 (**8**), ein ebenso glückliches Beispiel für den zweiten Fall Lothar Baumgartens Ausgestaltung des neuen Bundespräsidialamtes in Berlin 1998.

Lothar Baumgartens Grundkonzept, in diesem Zusammenhang von ihm selbst formuliert: "Alle Maße und Formfiguren lassen sich auf die Grammatik der (d. h. dieser) Architektur zurückführen; sie leiten sich aus ihr selbst ab. Es gibt somit keine neue Gestaltung, keine dekorativen Eingriffe oder Formerfindungen, die auf einem anderen Modul basieren als dem dieses Gebäudes. Auch in dieser Arbeit geht es mir um die gesetzmäßige und inhaltliche Übereinstimmung aller Teile." In einem solchen Sonderfall ist die vollendete Einheit von Architektur und Wandgestaltung auch im 20. Jahrhundert erreichbar.

In den *Wall Works* ist die Editionspraxis zum erstenmal auf das Prinzip Wandgestaltung übertragen worden. Dabei ist ausschlaggebend, daß die Werke nicht beliebig an die Wand gebracht werden können, sondern jeweils nach den Vorgaben der Künstler individuell auf das funktionale räumliche Ambiente eingestellt werden müssen, damit sie sich ihm auf spezifische Weise und unverwechselbar verbinden. Wie beim Bauen liegen Entwurf und Ausführung in verschiedenen Händen. Im übrigen werden anscheinend nicht miteinander zu kombinierende Komponenten zusammengebracht: die Auflage und die ortsspezifische Installation.

Daß der private Rahmen für solche Eingriffe bestens geeignet sein kann, hat Jan Hoets Ausstellung "Chambres d'Amis" 1986 in Gent auf ihre Weise, nämlich mit Einzellösungen, besonders überzeugend deutlich gemacht (**9**).

Hier wurde auch augenfällig, was die präzis in ihr privates räumliches Umfeld eingestellten, was die mit der Tendenz zur Dauerhaftigkeit implantierten Bilder und Materialien zu bewirken vermögen. Jan Hoet hat in einem Rückblick berichtet, die Werke hätten die Besucher für die Umgebung sensibilisiert, die Kunst habe sich vor der Übermacht des Wirklichen geltend gemacht und dessen Wahrnehmung entschieden beeinflußt – und: "Chambres d'Amis machte die Trennung von Museum und Alltag vergessen."

Kunst ist für den Alltag da. In den Wandarbeiten – auch denen dieser Edition –, die sich ihrem Wesen nach dauerhaft behaupten, leuchtet ein Widerschein jener ursprünglichen Einheit von Raum, Malerei und Dekor, von Kunst und Alltag auf, in der die Kunst noch keiner spezifischen Rechtfertigung bedurfte. In der unverbrüchlichen Verbindung herrscht eine Selbstverständlichkeit, über die außer der Natur nur die Geschichte gebietet. Die Geschichte der Bilder aber begann auf der Wand.

Uwe M. Schneede

Another distinction should also be drawn: on the one hand, there are autonomous wall works realized especially for museums or exhibitions and which, in most cases, are only temporary; on the other, there are wall works which form integral parts of buildings designed for the prosaic activities of living, working, and commerce. It is the latter which are of particular interest here: rather than being set within the elevated context of a museum (which already prepares the viewer for the encounter with an artwork), these wall works are installed in the midst of ordinary, everyday life where aesthetic interventions must compete for attention against a host of other stimuli; and rather than being a temporary installation, an artwork of this sort is a permanent fixture of the building. In this way, today's wall designs for functional buildings allude to solutions originally discovered centuries ago.

Artists' interventions can lend meaning to even the most trivial architecture, or bestow an additional, clarifying internal structure and a more colorful, vivid atmosphere in an already highly-developed architecture. Gerhard Merz' 1985 transformation of a very simple stairwell into a work of art (Tivoli, Barer Strasse 9, Munich) is a good example of the former (**8**). Lothar Baumgarten's 1998 wall work for the new federal presidential office building in Berlin is an equally successful example of the latter.

In his own words, Baumgarten articulates his fundamental concept as follows: "All dimension and form can be reduced to the grammar of architecture; they are naturally derived from that grammar." Hence, no new designs, no decorative interventions, nor any formal inventions are based upon any other elements of construction except upon those which are already present in the building itself. A case such as this demonstrates that the perfect unity of architecture and wall design can indeed be achieved in the 20th century.

Wall Works marks the first time that the principle of the edition has been applied to the practice of wall design. It's key that the artworks cannot be mounted randomly on the wall, but instead must be individually "fine-tuned" to suit their surroundings in accordance with the artist's specifications. This adjustment ensures that each work unites with its environment in its own specific and non- interchangeable way. As with building, here design and execution are not in the same hands. Furthermore, two components which seem incompatible – the edition and the site-specific installation – are successfully brought together.

Jan Hoet's exhibition Chambres d'Amis (Gent, 1986) clearly and convincingly proved that private spaces are optimally suited for interventions of this sort. Hoet's exhibition cogently demonstrated the remarkable effects that images and materials can have when they are inserted in the environment of a private space with the intention of remaining there permanently. In retrospect, Hoet reported that the works sensitized visitors to the surroundings, that the art was able to assert itself despite the overwhelming power of the real, and that the art decisively influenced the way reality was perceived. "Chambres d'Amis," Hoet said, "made it possible to forget the separation between museum and daily life." (**9**)

Art is for daily life – that's why it's here. In permanent wall works, including those created especially for this series, we can glimpse a reflection of that ancient unity between space, painting and decor, between art and daily life, when art did not yet require any special justification. In this indestructible bond lies a naturalness, a matter of course, which is possessed by Nature alone – and by history. The history of images, however, began on the wall.

Uwe M. Schneede

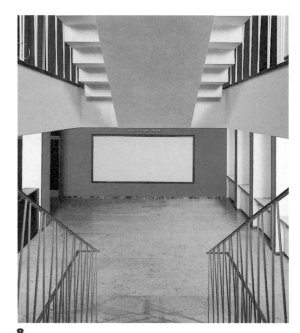

8

9

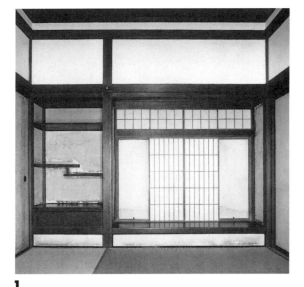

1

Wall Works: Mehr als nur Backstein und Putz

Heutige Künstler, für die die Wand selbst das Medium ihrer Kunst ist und die die Wand nicht nur für das "Aufhängen" von Kunst benutzen, stehen in einer langen, ja uralten Tradition. Zunächst könnte man meinen, daß die Wandarbeiten, die in den letzten drei Jahrzehnten entstanden, unmittelbar auf der Minimal, Pop und Concept Art basieren, und diese Vorstellung ist ja auch weitgehend richtig. Doch bevor wir auf die erst in der Nachkriegszeit ansetzende kunstgeschichtliche Entwicklung eingehen, bevor wir uns also dem Thema "Wandarbeit" zuwenden – sollten wir uns dem Thema "Wand an sich" widmen: der Wand als einem architektonischen Element und nicht einer künstlerischen Formulierung.

Ohne Zweifel sind die ersten uns bekannten Kunstwerke untrennbar mit einer Art von Wand verbunden: die Höhlenmalereien von Altamira und Lascaux usw. Der genaue Sinn dieser Höhlenzeichnungen bleibt ein Geheimnis, wenn auch allgemein Konsens darüber besteht, daß ihre Funktion zumindest zum Teil außerästhetisch, d.h. in gewissem Sinne magisch war. Diese magische oder religiöse Bedeutung der Wand bleibt auch in späteren weiterentwickelten Kulturen bestehen: jedes Schulkind weiß z.B., daß die Alten Ägypter die Wände ihrer architektonischen Denkmäler beinahe flächendeckend mit Hieroglyphen bestückt hatten. Da die inhaltliche Bedeutung dem heutigen Betrachter weitgehend verschlossen bleibt, werden sie heute eher als Kunstwerke von erlesener Schönheit betrachtet. Doch innerhalb der Kultur, die sie schuf, dienten diese uralten "Wandarbeiten" als ein wesentliches Medium zur Vermittlung wichtiger religiöser, politischer und geschichtlicher Ideen an das des Lesens und Schreibens kundige Volk.

Doch genug des gänzlich Offensichtlichen. Lassen wir die *Villa dei Misteri* in Pompeji und die Tapisserien, die die mittelalterlichen Burgbewohner vor kalten, feuchten Wänden schützten, lassen wir die Wandmaler der Renaissance und des Barock außer acht. Für den Übergang in unsere Zeit indes, wäre ein Umweg über die Architektur Japans nicht ohne Nutzen. In der traditionellen japanischen Architektur weisen die Wände sehr spezifische Eigenheiten auf. Vor dem Einfluß des Modernismus waren Japan bereisende Abendländer über die scheinbare Leere der japanischen Räume oft verwundert. Fremde neigten dazu, die subtilen Artikulationen der Wände selbst zu übersehen. In der Begegnung mit einer gänzlich leeren Wand müßte man diese eigentlich in Beziehung zu den anderen Wänden sehen – zu Wänden, die praktischen und ästhetischen Funktionen dienen. Der im 17. Jahrhundert entstandene Katsura Palast in Japan ist hierfür ein optimales, wenngleich äußerst seltenes Beispiel. Man begegnet dort einem blau-weißen Raster auf einer Wand, einer dekorativen Ausgestaltung, die erstaunliche Ähnlichkeit mit dem reduktiven Modernismus des 20. Jahrhunderts aufweist. Keine Wand gleicht der anderen; manche hatten Nischen zum Abstellen von Gebrauchsgegenständen oder zum Ausstellen von Kunstgegenständen (**1**). Die Leere japanischer Gebäude, die von den westlichen Besuchern damals als so beunruhigend empfunden wurde, war eigentlich eine Folge ihrer eigenen interkulturellen Kurzsichtigkeit: sie waren unfähig zu erkennen, daß das visuelle Geschehen sich vom Innenraum auf die Wände selbst verlagert hatte.

Noch eine letzte Bemerkung über die Ästhetik japanischer Architektur, ehe wir uns im Zeitraffer in unsere eigene Zeit versetzen. In der traditionellen japanischen Architektur dienen die Wände nicht als statische Stützen; auch die Architektur der Moderne in unserem Jahrhundert hat die Wand von ihrer Funktion als einer konstruktiven Stütze befreit. Mies van der Rohes offener Grundriss tritt an die Stelle des für ihn veralteten Musters von vier Wänden, die einen Raum ergeben (**2**). Ebenso entthronten in der westlichen Architektur gläserne "Vorhang-Wände" die konstruktive (Stein-)Wand. Fast wie

Wall Works: More than just Drywall and Plaster

Contemporary artists who use the wall as an intrinsic medium for the creation — rather than merely the display — of works of art are working within a long-established, indeed, ancient tradition. The immediate impulse might be to regard wall works of the last three decades as the direct legacy of Minimal, Pop, and Conceptual Art, and this idea remains essentially sound. But before we fall back on a purely postwar art historical narrative — before we discuss the "wall work" — there is the abiding issue of the wall itself: an architectural element, not an "art" gesture.

Of course, the earliest art works we know of are intrinsic to a certain kind of wall: the cave paintings of Altamira, Lascaux, etc. The exact import of these cave drawings remains shrouded in mystery, although consensus would lead us to believe that their function was at least in part extra-aesthetic, i.e. a function that was quasi-magical. This magical or religious function persists in later, more technologically-advanced cultures, for example, the hieroglyphs of the ancient Egyptians, which as any grammar-school student knows covered profusely all of the major architectural monuments of the time. Impenetrable as information to most viewers today — they now register for most as often exquisite art works — this mode of ancient "wall work" served to impart to the culture that created them an essential means of conveying to the literate populace the most important religious, political, and historical ideas of the times.

So much for the excruciatingly obvious. We will skip the Villa of the Mysteries in Pompeii; the tapestries which shielded the old damp walls of medieval castle keeps; the muralists of the Renaissance and the Baroque. As a means of transition to our own era, however, we might digress via the architecture of Japan. In traditional Japanese architecture, all of the walls are articulated in specific ways. Prior to Modernism, Westerners visiting Japan were inevitably struck by the seeming emptiness of Japanese rooms; they were oblivious to the subtle articulations of the walls themselves. Encountering an utterly bare wall, one would have to view it in the context of the other walls, walls serving practical and aesthetic functions. The seventeenth century Katsura Palace in Japan is an ideal, albeit extremely rarified example. Here one might encounter a blue-and-white grid on one wall, a decorative flourish strikingly congruent with twentieth century reductivist Modernism. No walls are identical. Other walls would be equipped with recessions for functional use or the display of art objects (**1**). The emptiness that early Western visitors found so disquieting in Japanese buildings was in fact a consequence of their own cross-cultural myopia: they simply could not see that visual incident had been displaced from a room's interior to the walls themselves.

A final note on the aesthetics of Japanese architecture that fast-forwards us to our own time: in traditional Japanese architecture, walls do not serve as structural supports. So in our own century, Modernist architecture liberated the wall from its function as structural support. The open plan of Mies van der Rohe rendered obsolete the traditional plan of four walls per room, with rooms typically arrayed in a symmetrical layout (**2**). Glass curtain walls similarly dethroned the structural wall in modern Western architecture. Interior walls became rather like puzzle pieces, to be altered and rearranged with an eye toward innovative solutions to design problems, or arresting aesthetic effect (**3**). As such, the very possibility of wall works such as those included in this catalog depends no less on the achievements of Modernism in architecture than it does on the "postmodernist" dispensations granted by the densely interrelated possibilities inaugurated by the art of the sixties. Nevertheless, Andy Warhol's Cow wallpaper; Sol LeWitt's wall drawings; and Lawrence Weiner's descriptive text pieces, among others, remain the most

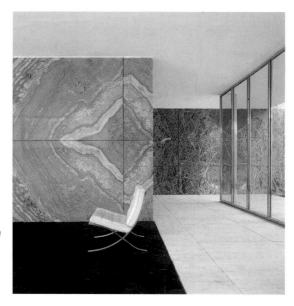

2

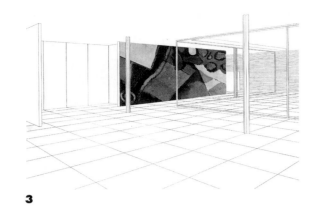

3

Teile eines 'Puzzles ließen sich Innenwände beliebig verändern und umstellen, um zu innovativen Entwurfslösungen zu kommen oder neue ästhetische Wirkungen zu erzielen (**3**).

Das Bedürfnis nach Wandarbeiten entstand aus den Konzepten der Moderne, aber auch aus der "postmodernen" Offenheit, des Zusammentreffens ganz unterschiedlicher Stil- und Bildebenen, die die Kunst der 60er Jahre eingeleitet hat. Wie auch immer, Andy Warhols Kuh-Tapeten, Sol LeWitts Wandzeichnungen, Lawrence Weiners Text-Stücke, um nur einige Beispiele zu nennen, sind die prägenden Vorläufer für die hier vorgestellten Wandarbeiten.

Der berühmte "weiße Kubus" des Galerieraumes ist einerseits der Ausgangspunkt für viele dieser Arbeiten, andererseits auch oft die Zielscheibe ihrer Infragestellung. Da Galerieräume üblicherweise für das Ausstellen traditioneller Bilder oder Skulpturen konzipiert sind, eignen sie sich nicht unbedingt für das Zeigen von Wandarbeiten. Denn der typische westliche Kunstgegenstand – das Gemälde – ist dafür geschaffen, an der Wand zu hängen; es ist ein Bestandteil des Mobiliars anstatt zu einem mit dem Raum verwachsenen Element zu werden, etwa nach dem Motto: "paßt es nicht über'm Sofa, probieren wir's doch im Flur." Der Typus Wandarbeit paßt aber durchaus in die Raumgebilde des neueren Galeriedesigns: Orte, die variable Ausstellungsarchitektur, den Auf- und Abbau temporärer Wände zulassen.

Die wahre Prüfung der Wandarbeit jedoch findet im Kontext des wirklichen Lebens und nicht in der Galerie statt. Wie funktionieren diese speziellen Kunstwerke in der Wohnsituation? Wie lassen sie sich in eine bereits existierende Struktur integrieren? Oder ist nicht ihr Sinn, eben diese Struktur – zumindest visuell – in Frage zu stellen? Richard Artschwagers *Corner Splats* sind ein Paradebeispiel eines solchen Widerspruchs. Ausgehend von dem aktivierten Raum der Ecke – eine Idee, die auch die Minimal und Post-Minimal Art kennt – schafft Artschwager eine Malerei, die absolut flach auf der

Wandfläche liegt. Sie persifliert und verkörpert zugleich unsere Vorstellung von Kunst als teurem Dekor. Rudolf Stingel transponiert einen gewöhnlichen Bestandteil des Wohndekors, den Teppich, vom Boden, wo er der alltäglichen Abnützung ausgesetzt ist, auf die privilegierte Wandfläche, die einst ausschließlich Bildern und anderen Kunstwerken vorbehalten war. So zeigen Artschwager und Stingel gegensätzliche Ansätze für Wandarbeiten. Beide gehen im wesentlichen von der Ironie, die der neueren Kunstproduktion eigen ist, aus: der eine, indem er Banales ästhetisiert, der andere, indem er normales häusliches Interieur transformiert.

Da die Wände inzwischen viel von ihrem nur konstruktiven Charakter verloren haben, unternehmen es einige Künstler, Fremdkörper aus der Außenwelt wie Straßenschilder und Plakate für ihre Zwecke zu benutzen. Matt Mullicans *Five Signs* gehört zu dieser Kategorie. Obwohl sein symbolisches System persönlich bleibt – denn die Zeichen können nicht wortwörtlich wie Schilder gelesen werden – entwickeln sie doch ihr konzeptuelles Vokabular aus eben solchen alltäglich-profanen Botschaften. Im Falle von Sylvie Fleurys *ETERNITY* stehen Werbung und Mode auf einer Innenwand und nicht, wie üblich, auf Reklametafeln oder Werbeseiten von Zeitschriften. Fleurys Ironie – denn welche Art Ewigkeit könnte ein Kunstwerk oder Parfum versprechen? – wird verstärkt durch das Medium, das sie für diese Arbeit gewählt hat: eine Wand, die man beliebig übermalen kann. Und schließlich Peter Halleys *Static Wallpaper* (with Smoking Cell) bei dem sein "Cell and Conduit"-Motiv als Tapetenmuster eingesetzt wird. Dabei werden symbolische Strukturen an die Oberfläche gebracht, die eigentlich hinter der Wand verborgene konstruktive und kommunikative Systeme darstellen.

David Rimanelli

obviously pertinent background for the wall works conceived for this project.

The famous "white cube" of the gallery space is the origin for many of these works, but also often the target for their critiques, even demolitions. Designed with the exhibition of traditional painting and sculpture in mind, the average gallery was often ill-equipped to display wall works such as many of these. The quintessential art object of the West – painting – is designed to hang on the wall. It remains an appurtenance rather than an integral element. If it doesn't work over the sofa, try the hallway. The wall work, as a general type, may function to greater effect within the context of more recent gallery design: often capacious, if not vast spaces offering multiple options for display. For example, many newer galleries today, given the amplitude of their spaces, can readily rig temporary or false walls specifically for the purposes of display.

The real test of the wall work comes in a "real life" rather than gallery context. How do these distinctive works of art function in a domestic setting? How are they integrated into a pre-existing structure, or is their precise purpose to destabilize – if not structurally, at least visually – that very structure? Richard Artschwager's Corner Splat, 1993 exemplifies this contradiction. Proceeding from the activated space of the corner – an idea familiar from Minimal and Post-Minimal art – Artschwager creates a painting flush with the wall itself, which parodies the notion of art as high-end decor even as it exemplifies it. On the other hand, Rudolf Stingel displaces a routine element of domestic decor – shag carpeting – from the floor, where it is subject to ordinary wear-and-tear, to the privileged space of the wall, once reserved for paintings and other art works. Hence, Artschwager and Stingel epitomize divergent possibilities for the wall work: both essentially proceed from the ironies of recent art production, one opting for aestheticized grime, the other for ordinary domestic life transfigured.

As the wall has lost some of its necessarily structural character, incursions from the outside world of street signage and advertising have been exploited by artists. Matt Mullican's Five Signs, 1998 belongs to this category. While his symbolic system remains perforce personal – one cannot literally read them like stop signs or deer-crossing signs – nevertheless they develop their conceptual vocabulary from these mundane messages. In the case of Sylvie Fleury's ETERNITY, 1996, advertising and fashion command the interior wall rather than the billboard or magazine ad. Fleury's irony – what kind of eternity is promised by either an artwork or a perfume? – is reinforced by the medium of this particular work, which can be repainted, etc. Finally, Peter Halley's Static Wallpaper (with Smoking Cell), 1998, in which his cell-and-conduit motif is rendered as wallpaper, brings to the surface symbolic structures representative of the hidden structural and informational systems behind the wall.

David Rimanelli

Artschwager

Buren

Diamond

Flavin

Fleury

Förg

Gilbert & George

Grünfeld

Halley

Hirst

Judd

Knoebel

Kosuth

Kounellis

Levine

LeWitt

Merz

Mullican

Oursler

Paik

Paolini

Pistoletto

Schnabel

Sherman

Steinbach

Stingel

Trockel

Walker

Warhol

Auch Ecken sind visuell kein toter Raum.[2]

No corner is exempt from looking.[2]

Richard Artschwager

Richard Artschwager

Geboren 1923 in Washington D.C., lebt und arbeitet in Hudson, New York. Artschwager hat in seinen Werken eine ganz eigene Mischform aus Skulptur und Malerei, gegenständlicher und ungegenständlicher Kunst entwickelt, die unterschiedliche Stilrichtungen wie Pop, Minimal Art, Photorealismus und Konzeptuelle Kunst in sich verbindet.

Er schafft bildhafte möbelähnliche Skulpturen, skulpturale Bildsurrogate und abstrakte Gemälde, die das Wesen der Illusion untersuchen. Er versucht konsequent, Kunst zu machen, die unsere Sehgewohnheiten durchbricht.

Ein immer wiederkehrendes Material in Artschwagers Werk – gemalt oder als Werkstoff – ist "Formica", ein Holzimitat, das den Betrachter mit den zunehmend nur noch mittelbaren Erfahrungen des Lebens im ausgehenden 20. Jahrhundert sowie mit einer immer mehr von der Vorspiegelung falscher Tatsachen beherrschten Welt konfrontiert.

Die *Corner Splat* - Malereien imitieren ironisch dieses trivial-wohnliche (oder unwohnliche?) Material der amerikanischen Massenkultur. Indem sie Material und Perspektive vortäuschen, erinnern sie an Trompe-l'œil-Malerei. Die *Corner Splats* sind Kreuzungen von Malerei, Skulptur und Einrichtungsgegenständen, die unsere Vorstellungen von den Dingen um uns herum durcheinander bringen und die sich quer stellen zu der unseren Alltag beherrschenden zweckorientierten Denkweise unserer Zivilisation.[3]

Corner Splat 1993

Malerei (Acryl) auf Kunststoffolie, auf die Wand montiert. Unterschiedliche Formen und Maße.
Limitiert auf 20 unterschiedliche Malereien. Zertifikat (**1**): Skizze auf Papier, 28 x 21,5 cm, signiert und numeriert.

Ausführung:

In einer Wandecke (2 und 4) oder auf einer Wandkante (3) mit Doppel-Klebefolie anzubringen.
Hinweis: Die Arbeit sollte so an die Wand geklebt werden, daß sie ohne Beschädigung wieder abgenommen und neu installiert werden kann.
Gelieferte Arbeit: Malerei auf Folie.

26

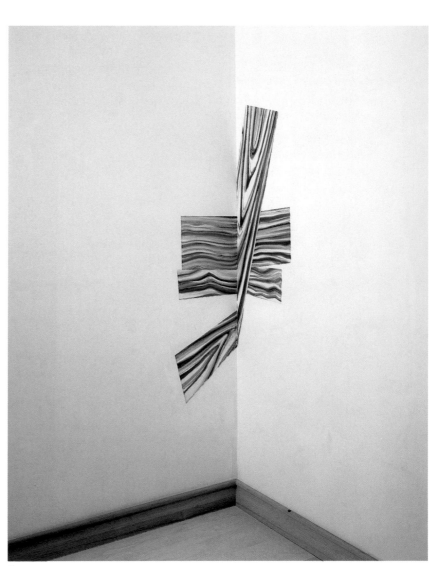

2

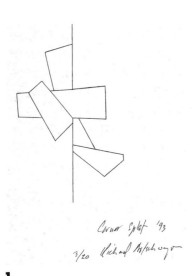

Corner Splat '93
3/20 Richard Artschwager

1

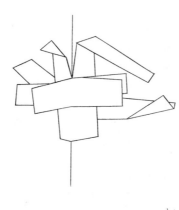

Corner Splat '93
A/P 1/3 Richard Artschwager

1

Richard Artschwager

*Born 1923 in Washington D.C.,
lives and works in Hudson, New
York. Artschwager has created
a singular amalgam of sculpture
and painting, of representation
and abstraction, incorporating
elements of a number of styles –
Pop, Minimalism, Photo-Realism,
and Conceptualism. Maker of
pictorial, furniture-like sculpture,
three-dimensional painting-sur-
rogates, and abstract paintings
that explore the nature of illusion,
Artschwager has consistently
sought to recontextualize the
familiar.*

*Formica, a laminate imitating
wood, is a material Artschwager
repeatedly uses. Its duality –
appearing at once to be both
real wood and painted pattern –
refers to the viewer's condition as
a divided self, to the increasingly-
total mediation of life as it is lived
in the late twentieth-century, and
to a world increasingly domin-
ated by fraud and dissimulation.
The Corner Splat paintings ironi-
cally imitate Formica, an artifical,
stale product of industry whose
name has become part of Amer-
ican mass-culture vernacular.
Suggesting material as well as
perspective in a "fake" way, the
Corner Splats stand in the trad-
ition of trompe-l'œil paintings.
Hybrids of painting, sculpture and
furniture, they confuse our con-
cept of the objects surrounding us
and carve out real and imaginary
spaces which are exceptions
to the hegemonic rationality of
everyday life in the West.[3]*

Corner Splat 1993

*Painting in acrylic on mylar,
mounted on a wall. Different
configurations and sizes,
each unique.
Limited to 20 paintings.
Certificate (**1**): schematic
drawing on paper, 11 x 8 ½",
signed and numbered.*

Installation:

*To be mounted in (2, 4) or at a
corner (3).
Note: the mylar should be
attached to the wall in a manner
which allows deinstallation and
subsequent reinstallation(s).
Work provided: painting on
mylar.*

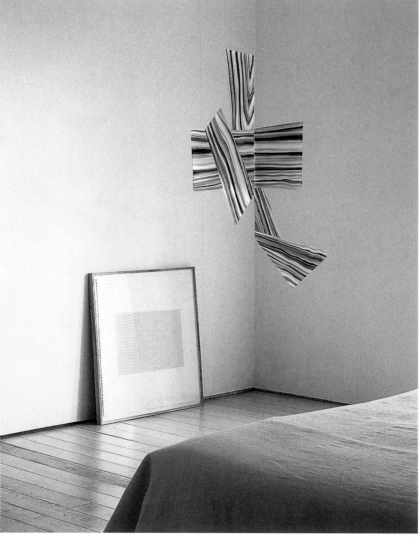

4

Ein bestimmter Typus von Arbeiten kann durchaus von einem Ort zum nächsten wandern, vorausgesetzt, er gehorcht bestimmten präzisen Regeln oder Gebrauchsanweisungen. Das ist der Fall bei den Arbeiten, die sich "wiederaufführen" lassen, wie sich zum Beispiel ein Musikstück wiederaufführen läßt. Das bedeutet auch, daß die konkrete Auslegung die ursprüngliche Anordnung modifizieren kann. Diese neue Ausdeutung, diese Veränderungen ... kommen schlicht durch den neuen Ort zustande, an dem das Werk wiederaufgeführt wird.[4]

A certain type of work is able to journey from one place to another, provided that it follows certain precise rules or instructions. This is the case with works that can be "re-performed" the same way a work of music can be performed over and over again. Each "re-performance" generates new readings and interpretations, originating from each new site in which the work is installed.[4]

Daniel Buren

Daniel Buren

Geboren 1938 in Boulogne-Billancourt (Frankreich), lebt und arbeitet in Paris. Ende der 60er Jahre verweigerte Buren die Malerei als eine "Illustration der Innerlichkeit". Seitdem wurde die Untersuchung der Rahmenbedingungen der zeitgenössischen Kunst, die Abhängigkeit des Kunstwerkes vom spezifischen Ort seiner Realisierung zum übergeordneten Thema seiner Arbeit. Als visuelles Instrument der Untersuchungen wählte Buren eine formale Struktur mit möglichst geringem Aussagewert: den gestreiften Markisenstoff (Streifenbreite 8,7 cm), der nicht als Inhalt, sondern als "visuelles Werkzeug" zur Erreichung künstlerischer Ziele zu verstehen ist. Buren realisiert seine Arbeiten in situ weltweit, in Galerien, Museen, großen Ausstellungen (documenta 1972 und 1982, Biennale Venedig 1986) und in zahlreichen öffentlichen Räumen und Plätzen.[5]

Twenty-five Enamel Plates 1993

25 emaillierte Stahlplatten, verteilt auf die Fläche einer Wand. Platten (**2**) je 43,5 x 43,5 cm, Gesamtmaße der Installation je nach Wand.
Limitiert auf 15 Installationen, jede in einer anderen Farbe. Zertifikat: Text auf Papier, 29,7 x 21 cm, signiert und numeriert.

Skizze des Künstlers (**1**)

Ausführung:

Die Tafeln werden so an einer Wand montiert, daß fünf in gleichem Abstand übereinander und fünf in gleichem Abstand nebeneinander angeordnet sind. Der genaue Abstand der in waagrechter Reihe angeordneten Tafeln ist so zu berechnen, daß ein theoretisch kontinuierlicher Wechsel von senkrechten weißen und farbigen Streifen (8,7 cm) auf der gesamten Wand entsteht.
Die oberste waagrechte Reihe von Platten soll an die Decke angrenzen, die unterste an die Fußbodenkante, wobei die senkrechten Abstände untereinander gleich sind. Die waagerecht nebeneinander angeordneten Tafeln stoßen links an die Wandkante an und haben nach rechts gleiche Abstände untereinander, so daß sie im Prinzip die gesamte Wandlänge ausfüllen, jedoch müssen die Platten im alternierenden Steifenmuster plaziert sein.
Um das zu erreichen, wird sich in der Regel an der rechten Wandkante ein freier Raum ("Rest") ergeben. Wenn dieser Rest größer als 69,6 cm (das sind vier Abstände von je zwei Streifen) wäre und daher einen größeren Abstand zwischen den Platten erlaubt, dann sind die vier Abstände der Platten um je zwei

Streifen zu vergrößern, damit das alternierende Streifenmuster auf der Wand eingehalten wird. Die waagrechten Abstände zwischen den Platten müssen also (mindestens) 1 Streifen oder 3 oder 5 Streifen usw. betragen.
Die Wand muß mindestens 217,5 cm hoch und 252,3 cm breit sein, was sich aus der engstmöglichen Belegung der Wand mit Platten ergibt. Farbe und Beschaffenheit der Wand sind unerheblich. Hat die Wand eine Tür oder ein Fenster oder ein sonstiges Hindernis an der Stelle, wo Tafeln zu plazieren wären, entfallen diese Tafeln. Würden mehr als 10 Tafeln entfallen, kann die Arbeit nicht ausgeführt werden.
Hinweis: Wir empfehlen die Montage durch einen geeigneten Handwerker. Gegen Einsendung der genauen Maße der Wand liefern wir eine Zeichnung, aus der sich die genaue Anordnung der Tafeln ergibt.
Gelieferte Bestandteile:
25 emaillierte Stahlplatten in der gewählten Farbe, mit Schrauben, in Holzkiste.

32

1

2

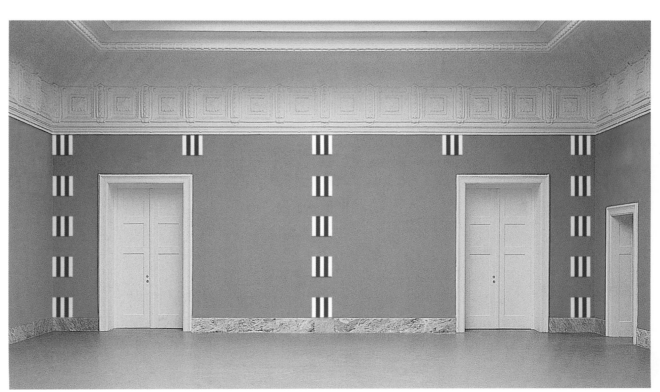

3

Daniel Buren

Born in Boulogne-Billancourt (France) in 1938, lives and works in Paris. At the end of the 1960s Buren rejected painting as a "spiritual illustration." After a period of intense scrutiny of the nature of contemporary art, Buren's preeminent theme became the dependence of an artwork on its place of realization. Endeavoring to employ in his work a formal element as devoid of meaning or reference as is possible, Buren chose to use a canvas awning material, with a consistent stripe width of 8.7 cm. The specificity of this pattern is not meant to be construed as content but rather as a "visual tool," a means to achieve other ends. Buren installs his works worldwide in situ in galleries, museums, exhibitions such as documenta and the Venice Biennale, and numerous public spaces.[5]

Twenty-five Enamel Plates 1993

25 pieces of steel enameled in two colors, to be mounted on a wall. Plates (**2**) 43.5 x 43.5 cm ea.; installation size according to the wall.
Limited to 15 installations, each unique in color. Certificate: text on paper, 11¾ x 8½", signed and numbered.

Artist's sketch (**1**)

Installation:

The 25 enameled plates are to be mounted equidistantly in five rows of five plates, and equidistantly in five columns of five plates. The precise placement of the plates within the rows has to be calculated so that there is a continuity of the plates' pattern of alternating vertical stripes (8.7 cm) within the installation. The top plate of each column must touch the ceiling, the bottom one of each column must touch the floor, with the plates equally spaced between ceiling and floor. The rows begin at the very left, with plates touching the wall's edge. The plates within the rows are to be equally spaced so that they ideally fill the whole width of the wall, yet still maintain the alternating stripe pattern. By doing this, more often than not, there will be an empty space between the last plate and the right edge of the wall. If this empty space exceeds 69.6 cm (which equals four spaces of two stripes' width) and thus allows a wider spacing of the plates within the rows, the four spaces between the five plates have to be increased by two stripes' width each, so that the alternating stripe pattern of the installation is maintained.

Therefore, spaces between plates along the rows equal either 1 stripe (which is the minimum required) or 3 stripes or 5 stripes etc.
The wall must be at least 217.5 cm high and 252.3 cm wide (the minimum space needed to fit 25 plates), and may be of any color or texture. If the wall has a door, window or any other feature at a spot where a plate should be placed, that plate should be omitted. The installation cannot be executed if more than 10 such displacements must occur.
Note: we recommend installation by a skilled craftsperson; upon request Edition Schellmann generates a layout diagram for this wall work using the exact measurements of the wall.
Components provided:
25 enameled plates with installation hardware, in a wooden crate.

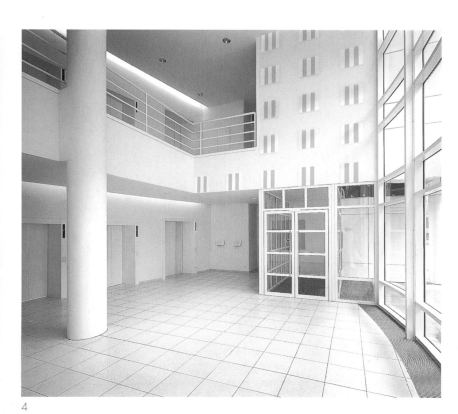

4

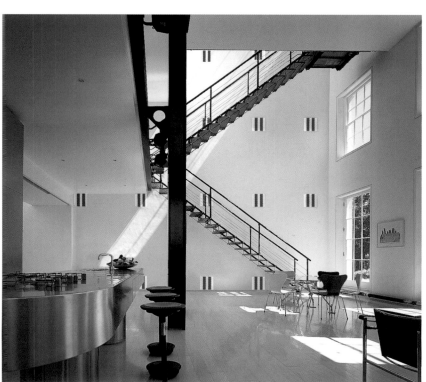

5

Daniel Buren

Unexpected Variable Configurations: A Work in Situ 1998

Ausführung:

Farbig bemalte Wand mit gezeichnetem Raster und 25 bedruckte Aluminiumplatten, Siebdruck graphitgrau/weiß, verteilt auf der Wand. Aluplatten je 43,5 x 43,5 cm; Gesamtmaße der Installation je nach Wand. Limitiert auf 15 Installationen, jede in einer anderen Wandfarbe. Zertifikat: Text auf Papier, 29,7 x 21 cm, signiert und numeriert.

Skizze des Künstlers (**1**)

Die gesamte Wand ist in dem im Zertifikat angegebenen Farbton in matter Wandfarbe zu streichen. Auf diese Fläche ist ein Quadratraster von 43,5 x 43,5 cm zu zeichnen, beginnend in der linken oberen Ecke der Wand, wobei sich in der Regel an dem rechten und am unteren Ende der Wand unvollständige Quadrate ergeben. Für das Raster ist ein Stift von 5 mm Strichstärke (tiefschwarz) zu benutzen. Hat die Wand eine Tür, ein Fenster oder sonstige Hindernisse, ist das Raster ungeachtet dieser Hindernisse auf die Wand aufzubringen; Tür oder Fenster etc. bleiben ausgespart. Ergeben sich auf der Wand weniger als 36 vollständige Quadrate, kann die Arbeit nicht ausgeführt werden. Die 25 Alutafeln, Streifen senkrecht, sind beliebig, aber so auf die Quadrate der Wand zu verteilen, daß die Wand aus einem theoretisch durchgängigen System von abwechselnd graphitgrauen und weißen Streifen besteht. Um das zu erreichen, sind die 13 Tafeln mit drei grauen Streifen auf der ersten, dritten, fünften usw. senkrechten Reihe von Quadraten zu montieren, die 12 Tafeln mit zwei grauen Streifen auf der zweiten, vierten, sechsten usw. senkrechten Reihe. Hinweis: Wir empfehlen die Montage durch einen geeigneten Handwerker (Maler, Schriftenmaler). Gegen Einsendung der genauen Maße der Wand liefern wir eine Zeichnung, aus der sich die genaue Anordnung des Rasters und der Tafeln ergibt. Gelieferte Bestandteile: Wandfarbe im gewählten Farbton und 25 bedruckte Aluminiumtafeln (Bibond) mit Befestigungsschrauben, in Holzkiste.

36

1

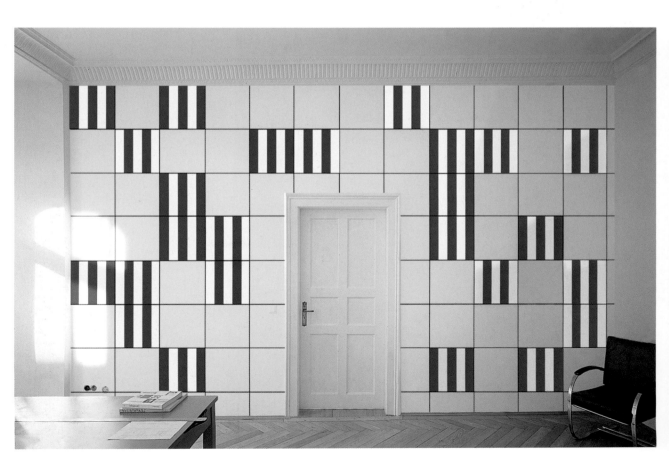

2

Daniel Buren

Unexpected Variable Configurations: A Work in Situ 1998

Installation:

Wall painted in color with hand-drawn grid and 25 aluminum plates, screenprinted graphite gray and white to be mounted on a wall. Plates: 43.5 x 43.5 cm ea.; installation size according to the wall.
Limited to 15 installations, each unique in wall color.
Certificate : text on paper, 11 ¾ x 8 ½", signed and numbered.

Artist's sketch (1)

The entire wall is to be painted with matte latex in the color indicated in the certificate. On this surface, a grid of squares 43.5 x 43.5 cm is to be drawn; incomplete squares may appear at the right and bottom of the wall. The grid is drawn with a black permanent-ink marker or an oil stick 5 mm thick. If the wall has a door, window or any other obstacle(s), the grid is to be executed leaving these elements uncovered. The work cannot be installed if there is not enough room for at least 36 complete squares on the wall. The 25 aluminum plates should be placed with stripes oriented vertically on the squares of the grid in a configuration that maintains an overall pattern of alternating graphite gray and white stripes.

The 13 plates with three graphite stripes should be placed in the odd-numbered columns, and the 12 plates with two graphite stripes should be placed in the even-numbered columns.
Note: we recommend installation by a skilled craftsperson; upon request we will generate a diagram for this wall work using the exact measurements of the wall.
Components provided: latex paint in the color chosen and 25 plates of screenprinted aluminum (Bibond) with installation hardware, in a wooden crate.

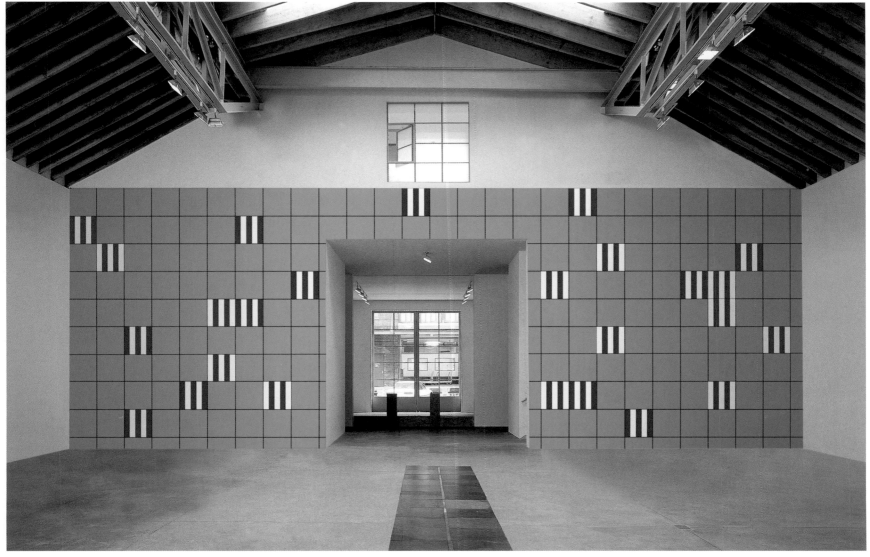

Jessica Diamond

Jessica Diamond

Geboren 1957 in New York, lebt und arbeitet in New York. Diamond zeigte ihre ersten Wandzeichnungen 1988 und erreichte mit Arbeiten wie *Yes Bruce Nauman* und *I hate Business*, beide 1989, internationale Bekanntheit. Geraume Zeit vor der Kusama-Retrospektive 1998 im Museum of Modern Art, New York hatte Diamond ihre Serie *Huldigung an Kusama* in Amerika und Europa ausgestellt, in der sie eine enge Beziehung zu dieser wichtigen Künstlerin herstellte und deren Wiederentdeckung belebte. Obwohl die Serie von Kusamas Bildern, Skulpturen, Spiegelräumen und Happenings inspiriert wurde, haben Diamonds Arbeiten nicht das visuelle Vokabular Kusamas geplündert, sondern sie übersetzen Kusamas tragende Ideen und Motive in eine formale Sprache, die ganz die Diamonds selbst ist.[6] Wie in ihrem früheren Werk nimmt das geschriebene Wort eine zentrale Stellung ein. "Die Maße der Wandzeichnungen sind variabel; jede wird in einer Größe ausgeführt, die dem Gefühl des Raumes entspricht, in dem sie vorübergehend beheimatet ist. Indem sie den Status eines individuellen Sammlerstücks aufgeben, werden diese Zeichnungen ein Teil der Wand, vergängliche Schöpfungen, die uns daran erinnern, daß Kunst, wie jeder Gegenstand unserer Liebe, nicht besessen werden kann, aber für immer Teil unserer Erfahrung wird. Gewichtslos, aber beladen mit Sterblichkeit, sind Diamonds Wandzeichnungen wie Pfeile, die in eine neue Richtung weisen, die uns zu anderen Gedanken und Verbindungen führen".[7]

Tributes to Kusama: The Movements of Reflected Letters in a Mirror
1996

Wandmalerei in blau und silber.
Größe variabel.
Limitiert auf 12 Ausführungen.
Zertifikat: Text und Abbildung auf Papier, 30 x 42 cm, signiert und numeriert.

Ausführung:

Das Bild wird an die Wand projiziert, mit Bleistift nachgezeichnet und mit Farbe ausgemalt.
Die Größe ist frei zu wählen; das Motiv muß den Boden berühren, siehe Abbildungen.
Hinweis: Wir empfehlen die Ausführung durch einen Schriftenmaler.
Gelieferte Hilfsmittel: Film für die Projektion und Acrylfarbe.

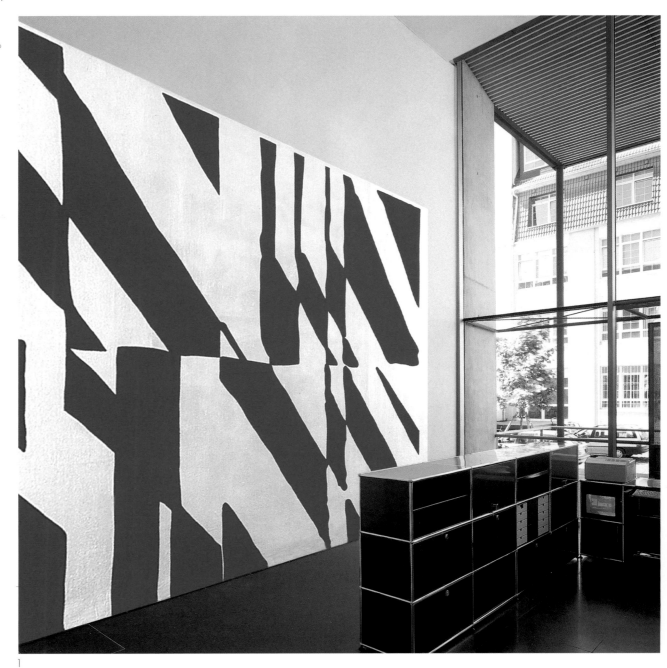

1

Jessica Diamond

Born 1957 in New York, lives and works in New York. Diamond first began exhibiting her wall drawings in 1988, and gained international prominence with works such as Yes Bruce Nauman and I Hate Business (both 1989). Long before the 1998 Kusama retrospective at the Museum of Modern Art, New York, Diamond had been exhibiting her Tributes to Kusama series in America and throughout Europe. With these works, Diamond makes a deep connection and excavates the history of an important woman artist. Ralph Rugoff has pointed out that though her series is inspired by Kusama's paintings, soft sculptures, mirrored environments and Happenings, remarkably Diamond's work does not plunder Kusama's visual vocabulary, rather it radically retranslates Kusama's key ideas and motifs into a formal language that is very much Diamond's own.[6]

As in her previous work, the written word occupies a central role. "Its dimensions are always variable as each work is scaled to the feel of the space where it will temporarily reside. Forsaking the precious individual status of the collectible, the drawing becomes part of the wall, an evanescent creation that reminds us that art – like any object of our love – cannot be possessed, but resides ultimately in our experience and the use we make of it. Weightless, yet freighted with mortality, Diamond's wall drawings are thus like arrows pointing elsewhere, leading us on to other thoughts, other connections."[7]

Tributes to Kusama: The Movements of Reflected Letters in a Mirror
1996

Wall painting in blue and silver, size variable.
Limited to 12 installations.
Certificate: Text and image on paper, 11¾ x 16½", signed and numbered.

Installation:

To be drawn on the wall tracing the projection of the acetate provided, in a size proportionate to the wall. The image is to touch the floor as illustrated.
Note: we recommend installation by a sign painter.
Components provided: acetate for projection and acrylic paint.

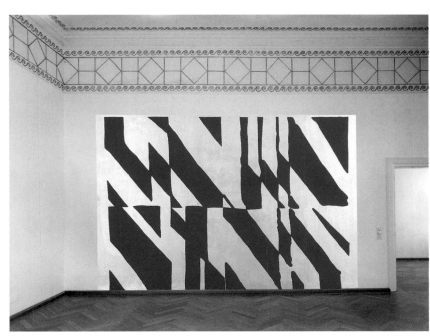

3

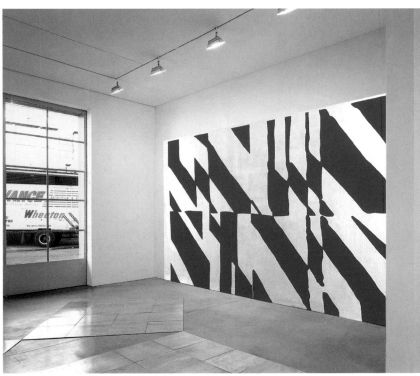

2

43

Ich sehe meine Kunst als eine Folge von Entscheidungen mit dem Ziel, die Traditionen von Malerei und Skulptur in der Architektur zu verbinden mit der Wirkung von elektrischem Licht, die den Raum definiert.[8]

Dieses System bedurfte buchstäblich keiner endgültigen Komposition; es schien sich selbst direkt, dynamisch, dramatisch an der Wand zu halten – ein heiteres und eindringliches Gasbild, dessen Helligkeit seine körperliche Gegenwart fast an Unsichtbarkeit grenzen läßt.[9]

For me art is a sequence of implicit decisions to combine traditions of painting and sculpture in architecture with acts of electric lights defining space.[8]

There was literally no need to compose this system definitively; it seemed to sustain itself directly, dynamically, dramatically on my workroom wall – a buoyant and insistent gaseous image which, through brilliance, somewhat betrayed its physical presence into approximate invisibility.[9]

Dan Flavin

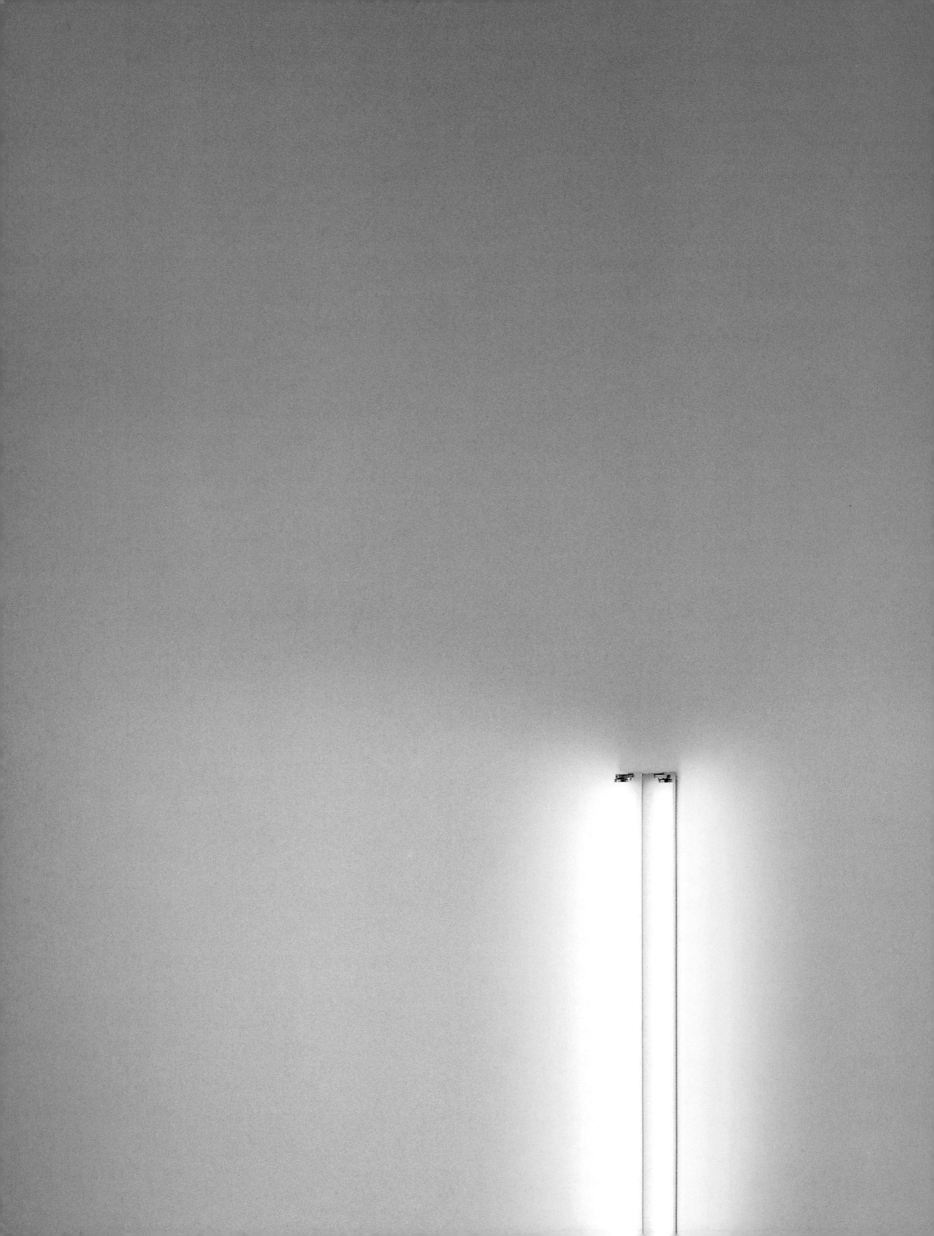

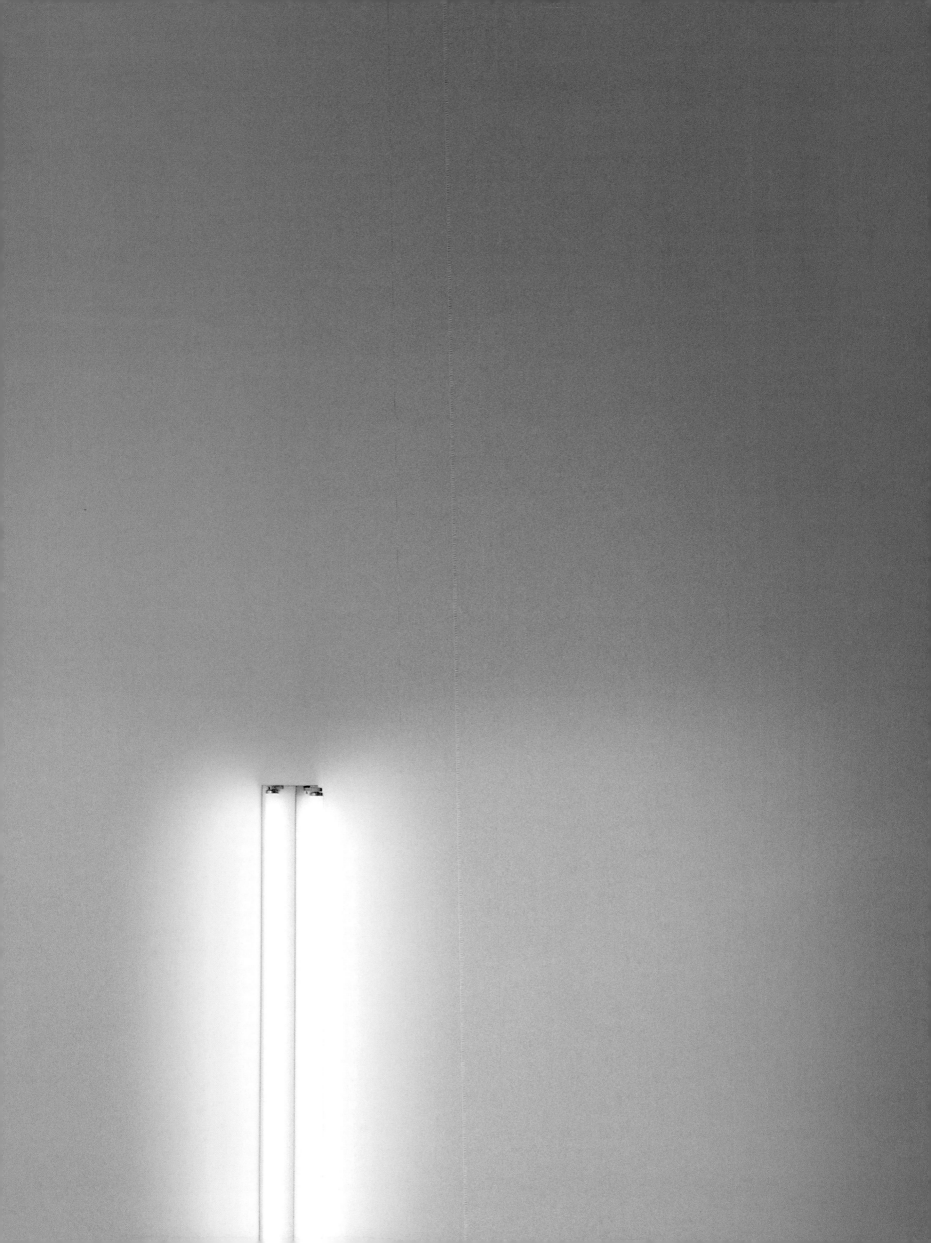

Dan Flavin

Geboren 1933 in New York, gestorben 1996 in Wainscott, New York. Die Kunst des amerikanischen Künstlers besteht aus Licht, fluoreszierendem Licht, erzeugt durch industriell gefertigte Leuchtstoffröhren. Flavin war einer der radikalen Pioniere der minimalistischen Kunsttendenzen der frühen sechziger Jahre in den USA. Er plaziert Licht in gegebene Architektur, er illuminiert architektonische Räume und verwandelt auf subtile Weise deren Wahrnehmung durch den Betrachter. Die Lichtschattierungen und dramatischen Farben, die von den Leuchtkörpern ausgehen,

verwischen die Konturen des sie umgebenden Raumes und – ob direkt auf dem Boden oder an der Wand montiert – bleiben in einem diskreten Verhältnis zum Raum, sehr ähnlich einem Gemälde oder einer Skulptur. Obwohl die Lichtinstallationen ihren Umraum atmosphärisch extrem aufladen, hat Flavin immer jede Mystifizierung und Problematisierung abgelehnt: "Schnelles, unmittelbares Verstehen ist für die Teilnehmer meiner Installationen beabsichtigt. Man sollte heute nicht mehr vor Kunstwerken verweilen müssen." [10]
Die zwei Leuchtstoffsäulen der hier gezeigten Arbeit *Untitled (for Robert Ryman)* teilen die Wand in drei Lichtzonen: warm-kalt-warm.

Untitled (for Robert Ryman) 1996

Leuchtstoffröhren warmtonweiß und tageslichtweiß. Zwei Leuchtkörper je 122 x 14 x 7,5 cm; Gesamtmaße der Installation je nach Wand.
Limitiert auf 2 Exemplare (5 Exemplare geplant, jedoch bis zum Tode des Künstlers nur 2 hergestellt).
Zertifikat (**1**): Farbskizze und Text auf Papier, 28 x 21,5 cm, signiert und numeriert.

Ausführung:

Am Boden stehend mit gleichen Abständen zu den Wandecken und untereinander an der Wand zu installieren. Kabel an der Bodenkante auf Putz.
Hinweis: Wir empfehlen die Installation durch einen Elektriker.
Gelieferte Bestandteile:
Zwei Leuchtkörper in Dreiecksform, mit zwei Sätzen Röhren, in Holzkiste.

48

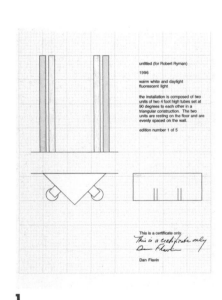

1

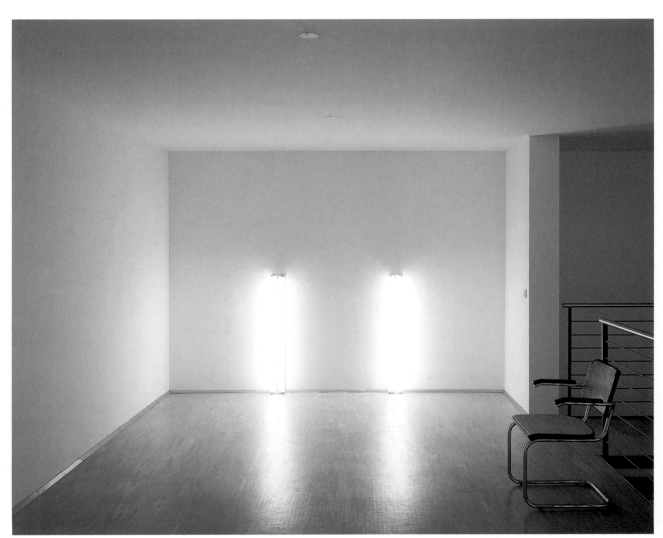

2

Dan Flavin

Born 1933 in New York, died 1996 in Wainscott, New York. The work of this American artist is composed of light; more specifically, fluorescent bulbs and industrial light fixtures. One of the pioneers of minimalism in the early 60s, Flavin's placement of light varies in relationship to the existing architecture, illuminating architectural spaces while subtly altering the viewer's perception of them. While the shadows and dramatic colors that emanate from the pieces blur the contours of the surrounding space, these works – whether installed directly on the floor or wall – retain a discrete relationship toward their environment, much like a painting or sculpture. Although the light installations create a highly-charged environment, Flavin did not believe in overinterpretation or mystification: "Quick, available comprehension is intended for participants in my installations. One should not have to pause over art any longer." [10]
The two fluorescent columns of the work Untitled (for Robert Ryman) shown here divide the wall into three light zones: warm-cool-warm.

Untitled (for Robert Ryman) 1996

Warm white and daylight fluorescent light, two units 48 x 5 1/2 x 3" ea; installation size according to the wall.
Limited to an edition of 2 (5 planned, only 2 made before the artist's death).
Certificate (**1**): text with color diagram on paper, 11 x 8 1/2", signed and numbered.

Installation:

Light fixtures to be installed on the floor and evenly spaced against the wall. Electric cord along the floor, not to be concealed.
Note: we recommend install-ation by an electrician.
Components provided: two units of two 4' high tubes mounted in a triangular fixture, in a wooden crate, with two sets of bulbs.

49

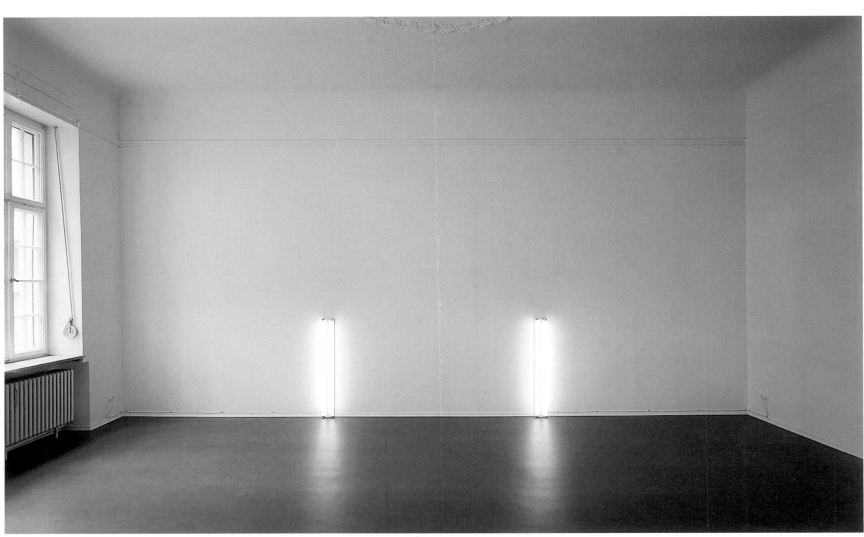

3

Die Leute dachten, ich sei verrückt, Kunst und Mode so zusammenzubringen.

Ich benutze Mode wie einen Pinsel oder eine Videokamera. Weil mich die formalen Aspekte interessieren. Mir geht es nicht darum, Top-Models zu zeigen, sondern um die formalen Effekte und das Prinzip Mode, das einer Künstlerin viel Freiheit gibt.[11]

People thought I was crazy bringing together art and fashion in the way I did.

I use fashion just as one uses a brush or a video camera. For me it is not about showing top models, but about the formal aspects and the principles of fashion – which give an artist a lot of freedom.[11]

Sylvie Fleury

Sylvie Fleury

Geboren 1961 in Genf, lebt und arbeitet in Genf. Die Künstlerin bedient sich formaler Prinzipien der Mode und setzt gezielt deren Ikonen mit hohem Wiedererkennungswert in ihren Werken ein. Sie tut dies ohne vordergründig kritisch Stellung zu nehmen etwa zu den Mechanismen von Werbung und Konsum. Durch die

Verwendung von Kunstmitteln – wie der Wandmalerei – werden Modephänomene ihrer Kurzlebigkeit enthoben und gerieren sich zum Denkmodell. Fleury verzichtet in ihren Wandmalereien bewußt auf die Verwendung von gegenständlichen Bildern; sie beschränkt sich auf den Einsatz von Typographien und Farbkombinationen aus der Modewelt, die im Betrachter unwillkürlich damit verbundene "Images" aufsteigen lassen.[12]

Modeleur ombre et lumière Chanel 1996

Wandmalerei in vier Farben (Dispersion), Maße je nach Wand. Limitiert auf 12 Ausführungen. Zertifikat: Dispersion auf Karton, 29,7 x 42 cm, signiert und numeriert.

Skizze der Künstlerin (**1**)

Ausführung:

Die Wand ist horizontal und vertikal in der Mitte zu teilen; die vier Flächen sind mit Dispersion entsprechend dem Muster auf dem Zertifikat zu streichen. Tür, Fenster oder ein sonstiges Hindernis auf der Wand sind auszusparen.
Hinweis: Wir empfehlen die Ausführung durch einen Maler. Gelieferte Materialien: Dispersionsfarbe in vier Farbtönen.

54

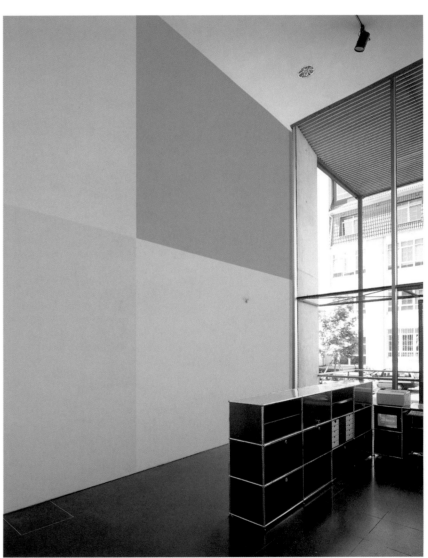

2

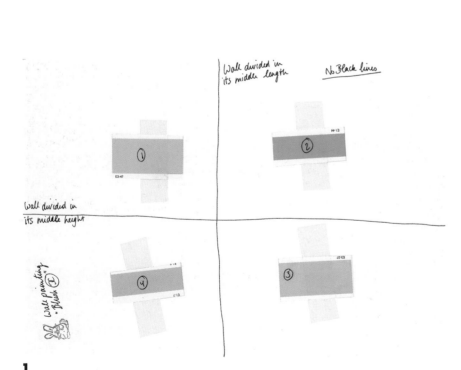

1

Sylvie Fleury

Born 1961 in Geneva, lives and works in Geneva. Fleury exploits elements of fashion in her work, using its formal principles and the highly recognizable "images" created by the fashion industry. She does this without explicitly taking a critical position towards the mechanisms of the market or of consumption. Employing artistic means, Fleury investigates the aesthetics and phenomena of fashion – freeing their conceptual aspects from their transitory nature so they become blueprints for thinking. In her wall paintings, Fleury abstains from using figurative pictures and restricts herself to using typography / text and color combinations – visual phenomena quoted from fashion – which give rise to connections with images in the viewer's mind.[12]

Modeleur ombre et lumière Chanel 1996

Wall painting in four colors of latex paint, size according to the wall.
Limited to 12 installations.
Certificate: acrylic on board, 11¾ x 16½", signed and numbered.

Artist's sketch (**1**)

Installation:

Wall to be divided into four quarters, and painted according to the diagram in the certificate. If the wall has a door, window, or any other feature, it should remain unpainted.
Note: we recommend installation by a professional painter.
Components provided: latex paint in four colors.

3

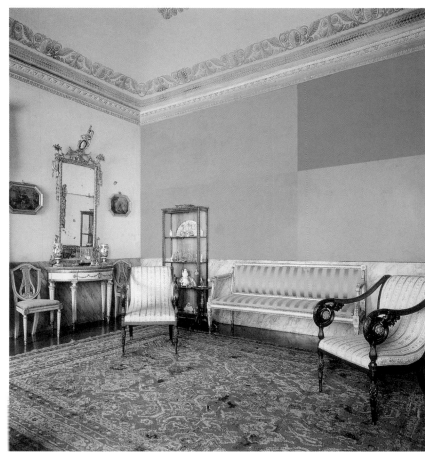

4

ETER

Sylvie Fleury

ETERNITY 1996

Wandmalerei in zwei Farben
(Dispersion), Maße je nach
Wand.
Limitiert auf 12 Ausführungen.
Zertifikat: Dispersion auf Karton,
29,7 x 42 cm, signiert und
numeriert.

Skizze der Künstlerin (**1**)

Ausführung:

Die Wand ist mit Dispersion
zu streichen, wobei Tür, Fenster
oder ein sonstiges Hindernis auf
der Wandfläche außerhalb des
Schriftzugs auszusparen sind;
der Schriftzug ETERNITY berührt
beide Wandenden und die
Decke. Farbtöne nach Zertifikat.
Hinweis: Wir empfehlen die
Ausführung durch einen Schriften-
maler.
Gelieferte Materialien:
Dispersionsfarbe und computer-
erzeugte Schablone in der erfor-
derlichen Größe.

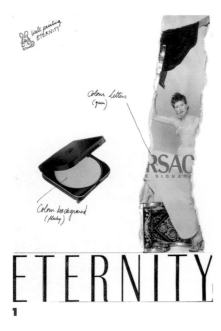

1

58

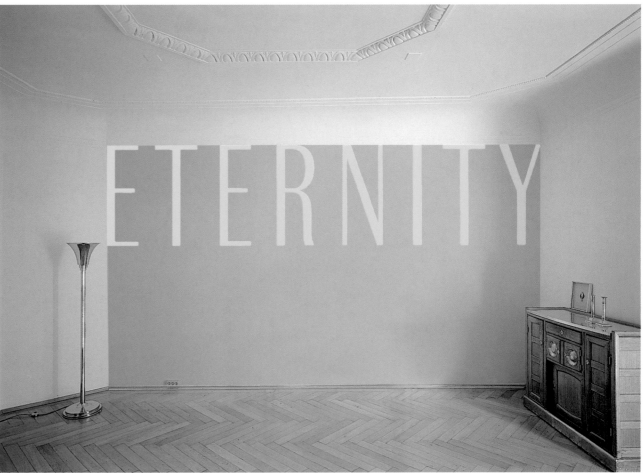

2

Sylvie Fleury

ETERNITY 1996

*Wall painting in two colors
of latex paint, installation size
according to the wall.
Limited to 12 installations.
Certificate: latex on board,
11 ¾ x 16 ½", signed and
numbered.*

*Artist's sketch (**1**)*

Installation:

*Wall to be painted with latex
paint, with features such as
a door or window to be left
unpainted. The word ETERNITY
should be stenciled on the wall
so that it touches the left and
right edges of the wall, as well
as the edge between wall and
ceiling. Colors according to
samples given in the certificate.
Note: we recommend installation
by a sign painter.
Components provided: stencil
in the size required, and latex
paint in two colors.*

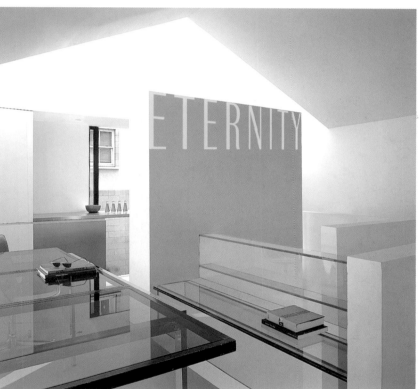

4

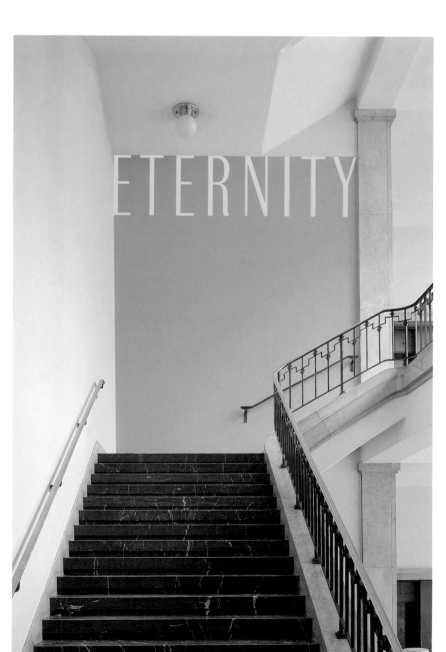

60

Günther Förg

Günther Förg

Geboren 1952 in Füssen, lebt und arbeitet in Areuse (Schweiz). Das Oeuvre des Künstlers umfaßt ein vielschichtiges Korpus von Malerei, Zeichnungen, graphischen Arbeiten, Photographien und plastischen Werken. Als zentraler Aspekt seiner Kunst kommt aber auch die Wandmalerei ins Spiel, und damit das installative Moment der konkreten Situation mit der damit verbundenen direkten Einbindung des Einzelwerks in die realen Gegebenheiten des Raumes. Förgs Wandmalereien sind farbige, meist monochrome

Interventionen in das Gestaltsystem Architektur. Es sind, wie alle seine malerischen Formulierungen, Reflexionen über das Medium selbst, ein fortgesetzter Dialog mit den Heroen moderner Malerei wie Barnett Newman, Ad Reinhardt, Elsworth Kelly, Blinky Palermo und der Ästhetik der Bauhaus-Architektur.
Förg gelingt es, die jeweiligen Mittel, die er anwendet, neu zu bestimmen, indem er Bilder wie ein "Anstreicher" malt, Räume wie ein Handwerker einrichtet und Photos à la Godard arrangiert. Förg eröffnet einen Raum und lädt uns ein, in ihm herumzugehen und mit seinen Augen zu sehen.[14]

Wandteilung 1986-93

Wandmalerei in Dispersion (weiß) und Tempera (gelb), Maße je nach Wand.
Limitiert auf 12 Ausführungen.
Zertifikat (**1**): Tempera und Bleistift auf Bütten, 57 x 76 cm, und Textblatt, beides signiert und numeriert.

Ausführung:

Die Wand ist vertikal von der Decke bis zum Fußboden in zwei gleiche Teile zu unterteilen. Die ganze Wand ist weiß (Dispersion) zu streichen, dann die rechte Hälfte gelb. Befindet sich auf der Wand eine Tür oder ein Fenster, sind diese weiß zu streichen.
Hinweis: Wir empfehlen die Ausführung durch einen Maler.
Geliefertes Material: Temperafarbe Pelikan Plaka 11, gelb.

1

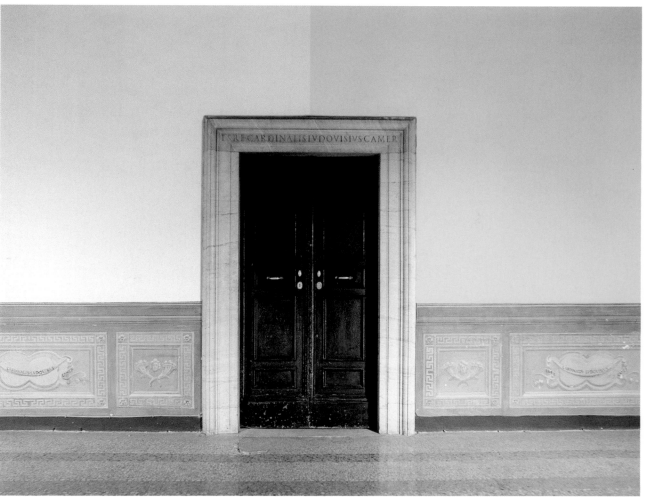

2

Günther Förg

Born 1952 in Füssen, Germany, lives and works in Areuse, Switzerland. The artist's oeuvre is a complex body of work including paintings, drawings, prints, photography, and sculptural works. Wall paintings – a central aspect of Förg's art – appear throughout his career, and integrate the individual work into the conditions of a given space: often monochromatic color-field interventions into the formal system of architecture.

Förg's painterly formulations are a consideration of the medium itself, and are in dialogue with the heroes of contemporary painting – such as Barnett Newman, Ad Reinhardt, Ellsworth Kelly and Blinky Palermo – and with the aesthetics of Bauhaus architecture.
Förg manages to redirect the media he employs by painting picture surfaces like a house painter, by composing rooms like a workman, by composing photographs a la Godard. Förg opens a space and invites us to take a walk in it, seeing through his eyes.[14]

Wall Partition 1986-93

Wall painting in white latex and yellow tempera. Installation size according to the wall.
Limited to 12 installations.
Certificate (1): tempera and pencil on rag paper, 22½ x 30", and text sheet, both signed and numbered.

Installation:

The wall is divided in half from floor to ceiling. The whole wall is painted white, then the right half is painted over with yellow. If there is a door, window or other feature on the wall, it must be painted white.
Note: we recommend installation by a professional painter.
Components provided: tempera paint in yellow.

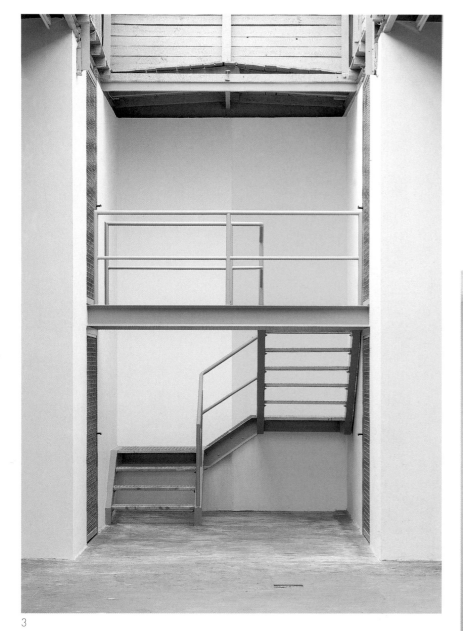

3

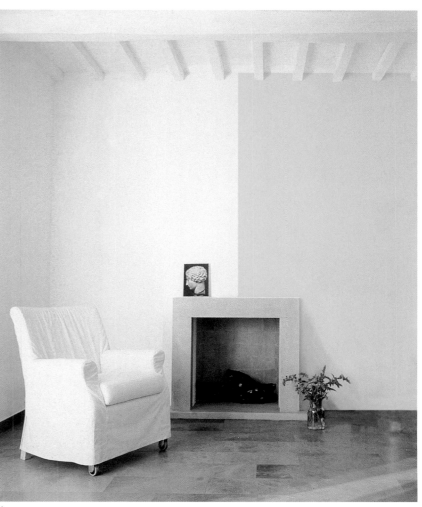

4

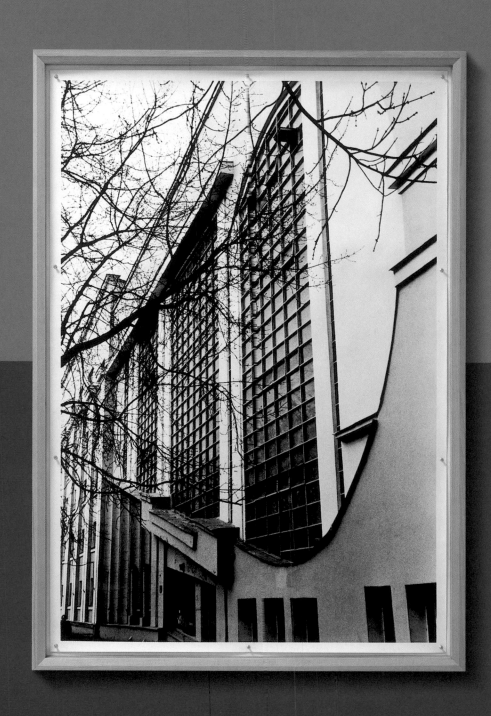

Günther Förg

Wandteilung 1988-96

Ausführung:

Wandmalerei in zwei Farben (Tempera) und gerahmte Photographie, 166 x 116 cm; Gesamtmaße der Installation je nach Wand.
Limitiert auf 12 Installationen.
Zertifikat (**1**): Tempera, Collage und Bleistift auf Bütten, 56 x 76 cm, signiert und numeriert, und Textblatt.

Die Wand ist horizontal in zwei gleiche Teile zu unterteilen. Die obere Hälfte der Wand ist in orange, die untere in zinnoberrot zu streichen. Befindet sich auf der Wand eine Tür oder ein Fenster, sind diese weiß zu streichen. Die gerahmte Photographie ist mittig auf die bemalte Wand oder Teilwand zu hängen, siehe Zertifikat.
Hinweis: Wir empfehlen die Ausführung durch einen Maler.
Gelieferte Bestandteile: Farbe (Pelikan Plaka 15 orange, 24 zinnoberrot) und gerahmte Photographie auf Barytpapier (Gebäude von Konstantin Melnikov, Moskau, ca. 1915).

1

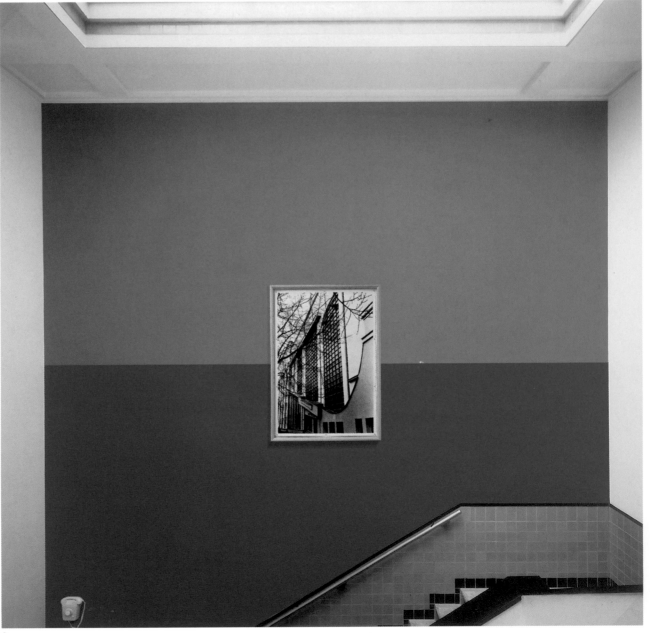

2

Günther Förg

Wall Partition 1988-96

Wall painting in two colors,
with framed photograph,
65 ½ x 41 ¾"; installation size
according to the wall.
Limited to 12 installations.
Certificate (**1**): tempera,
collage and pencil on rag
paper, 22 x 30", signed and
numbered, and text sheet.

Installation:

The wall is divided into two
halves, the top half painted
orange, the bottom red.
If there is a door, window, or
other feature in the wall, it must
be painted white. The framed
photograph is to be hung
centered on the painted wall or
centered on a partial wall, see
diagrams in the certificate.
Note: we recommend install-
ation by a professional painter.
Components provided: tempera
paint in two colors and framed
black-and-white photograph (of
a circa-1915 Moscow building
by Konstantin Melnikov) on
Baryta paper.

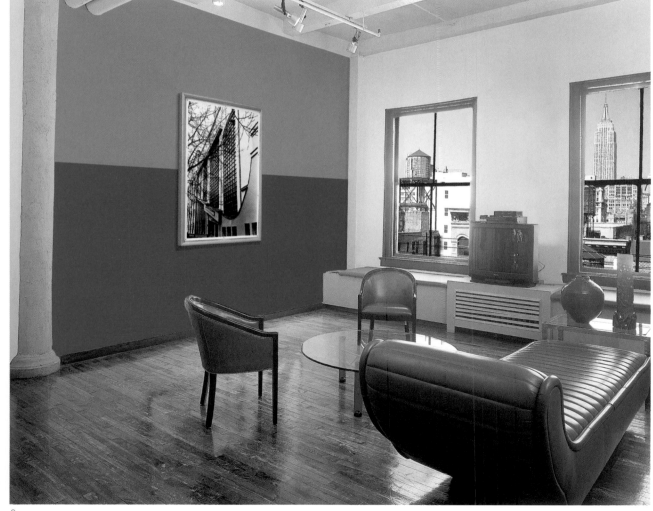

Wir wollen, daß die Leute ihr Leben in unsere Ausstellungen mitbringen, nicht ihr Wissen über Kunst. Wahre Kunst muß die Barrieren des Wissens überwinden und über diese hinweg sprechen. Wir sind gegen die Kunst über Kunst. ... Wir glauben, daß Kunst die Aufgabe hat, die Zivilisation vorwärtszubringen.[17]

We want people to bring their life to our exhibitions, not their knowledge of art. True art has to overcome and speak across the barriers of knowledge. We are opposed to art that is about art. ...We believe that art has a real function to advance civilization.[17]

Gilbert & George

THE SINGING SCULPTURE
1969–1991

by Gilbert and George

Gilbert & George

Geboren 1943 in den Dolomiten (Italien) und 1942 in Totness (Großbritannien), leben und arbeiten in London. Ihrer eigenen Vorstellungswelt folgend gehört das Werk von Gilbert & George der Gattung Skulptur an. In den späten sechziger Jahren, als sie die Kunstakademie verlassen hatten, begründeten sie ihre Doppelexistenz und begannen, sich als "Living Sculptures" zu präsentieren.[18]

Gilbert & George betrachten sich selbst als Krieger, die "für einen totalen Ausdruck kämpfen", die darauf hinzielen, alle unsere Erfahrungen einzubeziehen, die intellektuellen und die körperlichen, selbst die dramatischsten, die banalsten, die aufgrund sozialer Konventionen am meisten gemiedenen. Ihr tägliches Streben nach künstlerisch kreativer Aktion wird zu einer Metapher der unaufhörlichen verzweifelten menschlichen Geschäftigkeit.[19]

The Singing Sculpture 1969-91 1993

Wandplakat, Offset, vierteilig, direkt auf die Wand geklebt. Gesamtmaße: 220 x 270 cm. Limitiert auf 20 Exemplare. Zertifikat: Ein zusätzliches signiertes und numeriertes Plakat.

Ausführung:

Direkt auf die Wand zu tapezieren. Hinweis: Das Kleben der Plakate sollte durch einen Tapezierer ausgeführt werden. Gelieferte Bestandteile: Vierteiliges Plakat, gedruckt auf Citychrom Plakatpapier 135g, je 113 x 139 cm.

74

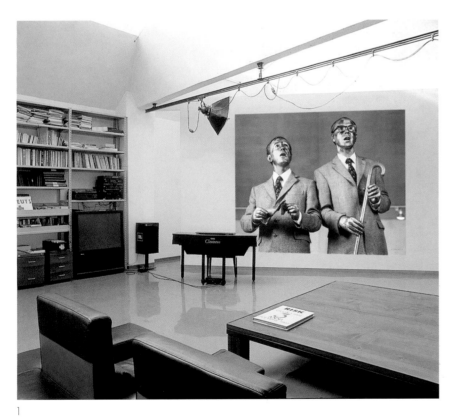

1

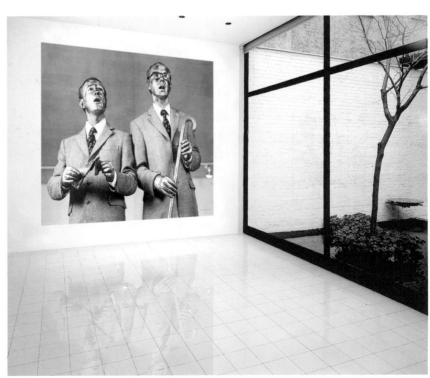

2

Gilbert & George

Gilbert born 1943 in the Dolomites (Italy); and George born 1942 in Totness (Great Britain), both live and work in London. Upon graduation from art school in the late 60s, Gilbert & George developed their own concept of sculpture, when they founded their double existence, and began to present themselves as "living sculptures". [18]

Gilbert & George consider themselves warriors "fighting for a total expression". They want to engage the full range of human experience, intellectual and physical, even the most dramatic, the most banal, the most shunned by social custom. Their daily struggle for artistic action becomes a metaphor for man's incessant, desperate activity. [19]

The Singing Sculpture 1969-91 *1993*

Offset wall poster, in four parts, pasted directly on a wall. Overall size: 86 1/2 x 106 1/4". Limited to an edition of 20. Certificate: one additional signed and numbered poster.

Installation:

To be pasted on a wall. Note: we recommend installation by a wallpaper hanger. Components provided: four-part offset poster, printed on Citychrome billboard paper 135g, each part 44 1/2 x 54 1/2".

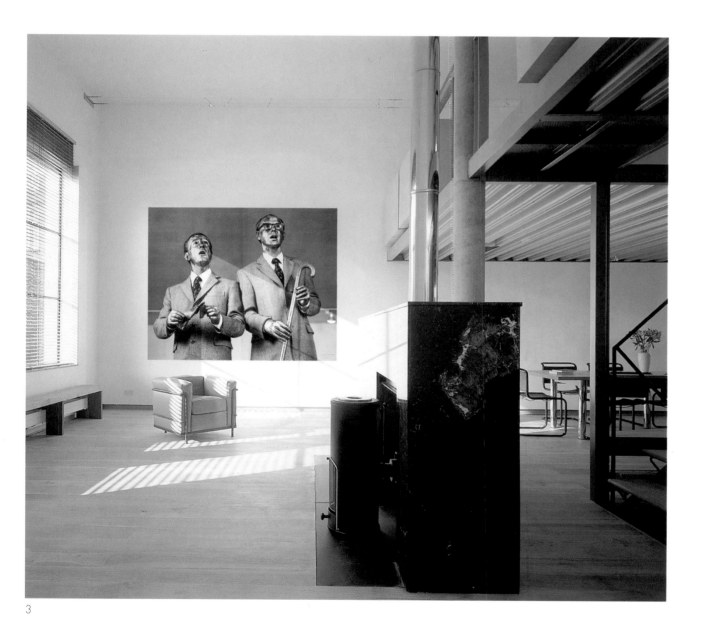

In allen meinen scheinbar sehr unterschiedlichen Arbeiten geht es um Anreiz und Enttäuschung.[20]

All my works, appearing so different from one another, are about attraction and disappointment.[20]

Thomas Grünfeld

Thomas Grünfeld

Geboren 1956 in Opladen bei Köln, lebt und arbeitet in Köln. Thomas Grünfeld erforscht die Intentionen von Design; seine Kunst hat die Präsentation von Dingen zum Inhalt. Mit den Mitteln subtiler Manipulation stellen seine Skulpturen satirisch die falsche Intimität dar, die die heutigen Einrichtungsstile und die

durch sie vermittelte Atmosphäre kennzeichnen. Seine Werke scheinen dem Bereich der Möbel nahezukommen ohne aber jemals zu Möbeln zu werden, sie kritisieren ihre vorgebliche Intimität, beklagen dabei aber den Verlust von Privatsphäre. Grünfelds Arbeiten sind von Paradoxen so stark geprägt, daß die Arbeiten zu selbstzündenden Sprengkörpern zu werden drohen.[21]

Ohne Titel 1992

Objekt (Holz, Schaumstoff, Leder) auf Wandmalerei in vier Farben (Dispersion). Objekt 97,5 x 210 x 35 cm, Gesamtmaße der Installation je nach Wand.
Limitiert auf 10 Installationen, jede in einer anderen vom Künstler festgelegten Farbkombination. Zertifikat (**1**): Computerausdruck, 21 x 29,7 cm, mit Skizze, Text und aufmontierten Lederfarbmustern, signiert und numeriert.

Ausführung:

Das Objekt ist mittig auf einer Wand in einer Höhe von 100 cm vom Fußboden zur Unterkante Objekt anzubringen. Liegt auf der Wand eine Tür oder ein Fenster, ist das Objekt mittig auf das verbleibende Wandstück zu montieren. Die Wandfarben – identisch mit den entsprechenden Farben der Lederpolster – bedecken die Wandviertel jeweils bis zum Wandende.
Hinweis: Wir empfehlen die Ausführung durch einen Maler.
Gelieferte Bestandteile:
Objekt und vier verschiedene Wandfarben.

1

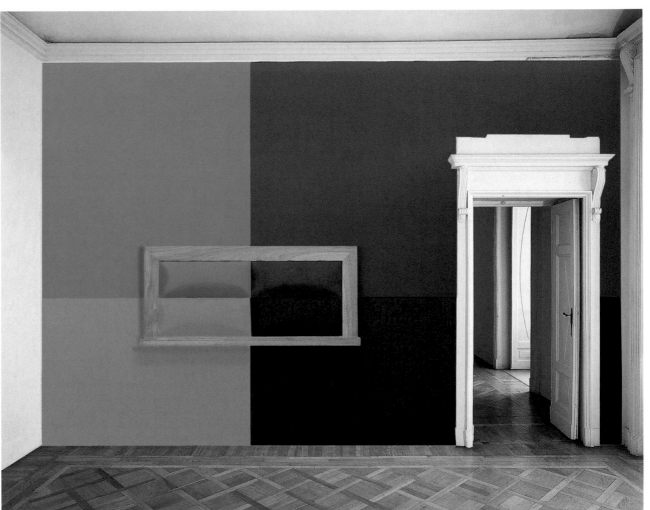

2

Thomas Grünfeld

Born 1956 in Opladen, Germany, lives and works in Cologne. Thomas Grünfeld explores design as intention; his art is an art of display. Calling attention to items which may be precious or unimportant, his sculpture – by the means of subtle manipulation – satirizes that fake intimacy which marks contemporary interiors, as well as the atmosphere they are meant to convey. Suggesting furniture, without ever turning into furniture, deploring forced intimacy while bewailing the loss of privacy, his work depends on combinations so powerful and volatile they threaten to turn each work into a self-detonating device.[21]

Untitled 1992

Object (wood, foam, leather) and wall painting in four colors.
Object 38½ x 82½ x 13¾";
installation size according to the wall.
Limited to 10 installations, unique in color combination.
Certificate (**1**): diagram and text, with leather color samples, 8¼ x 11¾", signed and numbered.

Installation:

The wall is to be divided into four quarters, painted in the four colors of the object's leather. The object is to be mounted in the center of the wall, its bottom edge 100 cm (39") above the floor. If there is a door or window in the wall, the object should be placed centrally within the uninterrupted portion of the wall.
Note: we recommend installation by a professional painter. Components provided: object and four different colors of latex paint.

81

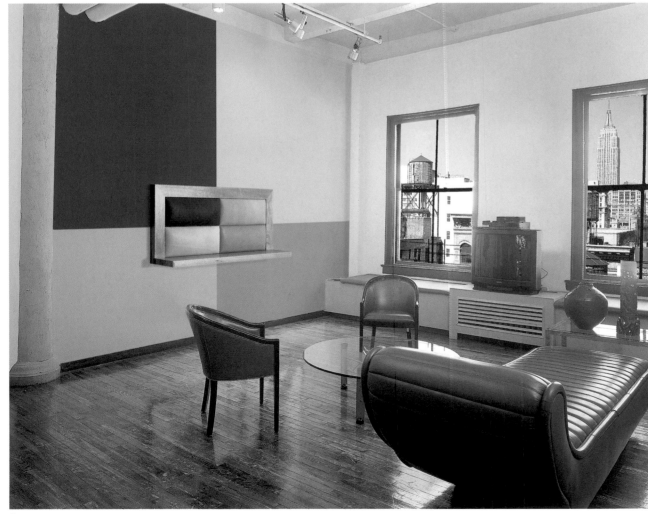

3

Ich wollte weg von der Graphik als einem einzelnen Gegenstand und meine Arbeit statt dessen in Richtung Installation weiterentwickeln. Bei dieser neuesten Generation einer Werkgruppe, die ich 1993 begonnen habe, fasziniert mich, wie man den Computer benutzen kann, um Bilder fortlaufend zu variieren.[22]

I was trying to get away from the idea of an edition as a discrete object and to push it in the direction of an installation. These prints are the latest generation of a body of work I started in 1993. I am fascinated by how one can use the computer to continually transform imagery.[22]

Peter Halley

Peter Halley

Static Wallpaper
1998

Ausführung:

Geboren 1953 in New York, lebt und arbeitet in New York. Seit den frühen achtziger Jahren malt Halley reduzierte Bilder, die Geometrie eher als Widerspiegelung des sozialen als des formalen Umfelds einsetzen. Halley nennt seine gemalten rechtwinkligen Konstruktionen "cells" (Zellen), welche meistens mit einer oder mehreren "conduits" (Leitungen) verbunden sind; diese sollen verdeckte Systeme und Ideologien, die unsere postmoderne Gesellschaft regieren, evozieren. Seine cells und conduits repräsentieren die Steuer- und Regelsysteme der modernen Zivilisation, Schemata, die das

Aussehen der Organisationssysteme bestimmen, wie wir sie heute überall finden, in Computerchips, in der Wirtschaft, in Gebäuden oder Flughäfen.[23] Halleys neue graphische Arbeiten erweitern die Fragestellungen, die seine Malerei aufwirft, und modifizieren sie gleichzeitig. In Static Wallpaper wie auch in seiner Ausstellung 1997 im Museum of Modern Art, New York hängen nicht nur Bilder an der Wand, sondern die Wände sind mit einer am Computer entworfenen Tapete ("Bildschirmstörung") beklebt. Diese Arbeiten haben keine verbindliche Form – sie können in einer ganzen Anzahl unterschiedlicher Größen und Anordnungen ausgeführt werden, wobei eine Variante so gültig wie die andere ist.[24]

Siebdruckblätter in 16 unterschiedlichen Farben, an die Wand tapeziert. Auf die Tapete können nach Wahl gerahmte Iris prints Smoking Cell (2) oder andere Arbeiten von Halley gehängt werden (3,4). Siebdruckblätter je 76 x 94 cm, Iris prints (alle in unterschiedlichen Farben) 89 x 119,5 cm; Gesamtmaße der Installation je nach Wand. Limitiert auf 15 Installationen, jede unterschiedlich in der Anordnung. Zertifikat: Computerausdruck 29 x 42 cm, signiert und numeriert.

Siebdrucke wandfüllend an eine oder mehrere Wände zu tapezieren; die Reihenfolge wird vom Künstler individuell nach den Proportionen der betreffenden Wand bestimmt. Zusätzlich können bis zu vier Iris prints Smoking Cell oder andere Graphiken oder Bilder von Halley auf die tapezierte Wand gehängt werden, wobei die Anordnung in etwa den im Zertifikat skizzierten Varianten (1) folgen soll. Hinweis: Wir empfehlen das Kleben der Siebdrucke durch einen Tapezierer. Gelieferte Bestandteile: Siebdruckblätter in der für die betreffende Wand erforderlichen Anzahl. Gegebenenfalls darauf zu hängende Kunst nach Wahl des Käufers.

1

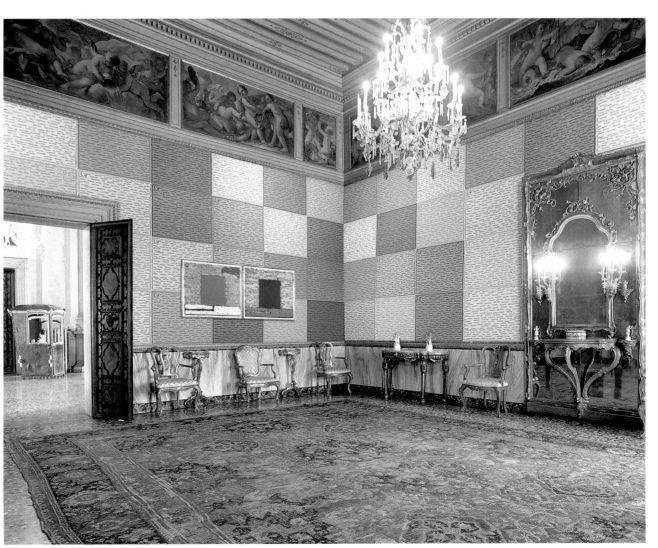

2

Peter Halley

Born 1953 in New York, lives and works in New York. Halley is best known as a painter, and since the early 80s he has made reductive images that treat geometry as a reflection of social, rather than formal, space. Halley refers to the rectilinear constructs he paints as "cells", and they are usually shown connected to one or more incoming or outgoing "conduits", that are meant to evoke the hidden systems and ideologies that govern activity in postindustrial society. His cells and conduits represent the diagrammatic regulatory practices of modern social life, practices that give visual form to organizationa' systems found in everything from computer chips to corporations, buildings and airports.[23]

Halley's recent prints extend the concerns that animate his paintings as well as modify them. In his Static Wallpaper, as in his 1997/98 Museum of Modern Art installation, not only are Halley's works displayed on the walls, but he covers the wall(s) with wallpaper of computer-generated design. There is not a single fixed form; these works can be realized in a number of different sizes and configurations, all of them equally valid.[24]

Static Wallpaper
1998

Silkscreen prints in 16 different colors, pasted directly on a wall, with optional installation of framed unique Iris prints from the Smoking Cell series (2) or other work by Halley hung on top of the wallpaper (3,4). Wallpaper 30 x 37" per sheet; Iris Prints, 35 x 47"; installation size according to the wall. Limited to 15 installations, all different in configuration. Certificate: laser print, 11 ½ x 16 ½ ", signed and numbered.

Installation:

Wallpaper hung on a wall in an order determined by the artist, according to the proportions of the given wall; to cover one wall, several walls, or all walls of a room. Additionally, up to four framed Iris prints from the Smoking Cell series or a different Halley print or painting may be hung on top of the wallpaper, following the artist's diagrams (**1**) in the certificate.
Note: we recommend installation by a wallpaper hanger. Components provided: wallpaper as needed for installation. If desired, works of art by Halley for hanging on top of the wall paper may also be purchased.

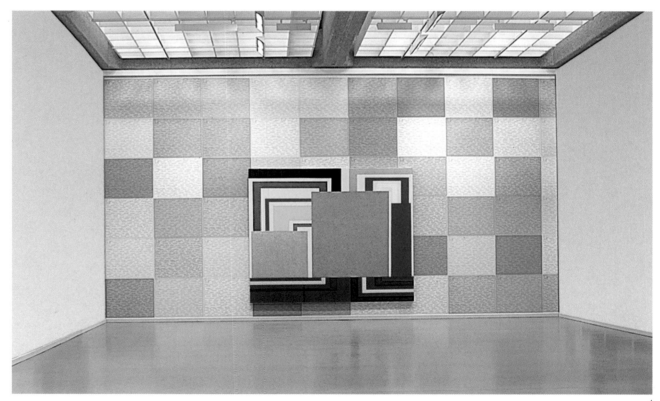

4

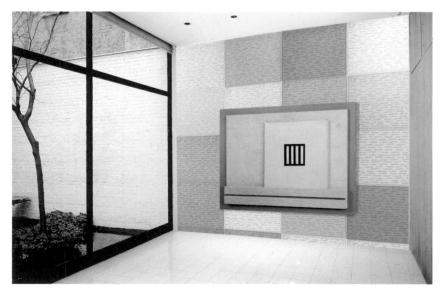

3

Kunst handelt vom Leben und kann auch über nichts anderes handeln … es gibt ja sonst nichts.

Meine spot paintings sind ein naturwissenschaftliches Herangehen an die Malerei ähnlich den wissenschaftlichen Methoden, mit denen die Arzneimittelhersteller das menschliche Leben untersuchen. … Daher der Titel dieser Serie: *Die pharmazeutischen Bilder.* … Kunst ist wie Medizin – sie kann heilen. Ich war immer erstaunt, wie viele Menschen an die Medizin glauben, nicht aber an die Kunst, und beides nicht in Frage stellen. Die spot paintings sind einfach was sie sind, total blöde Bilder, aber sie geben ein absolut richtiges Gefühl.[25]

88

Art's about life and it can't really be about anything else … there isn't anything else.

My spot paintings are a scientific approach to painting in a way similar to the drug companies' scientific approach to life. Hence the title of the series, The Pharmaceutical Paintings. … Art is like medicine – it can heal. Yet I´ve always been amazed how many people believe in medicine but don´t believe in art, without questioning either. The spot paintings are what they are, perfectly dumb paintings which feel absolutely right.[25]

Damien Hirst

Damien Hirst

Geboren 1965 in Bristol, lebt und arbeitet in London. In seinem Werk, bekannt für formale Schönheit und schockierende Direktheit, hat Damien Hirst Kunst geschaffen, die zur meist diskutierten der 90er Jahre gehört. Sein Werk stellt die Vergänglichkeit des Seins dar. Seine Vitrinen, in denen wie in Mausoleen Leben versiegelt ist, lassen uns über Zeit nachdenken und über das Phänomen der Sterblichkeit.[26] Seit 1988 hat Hirst sogenannte spot paintings gemalt, Bilder mit seriell angeordneten farbigen Punkten, die Farbsysteme untersuchen.

Diese Bilder verkörpern eine interessante Parallele zu seinen Skulpturen und Objekten und geben einen verschlüsselten Einblick in Hirsts Denken. Mit Gesetz und Zufall spielend, etabliert Hirst in diesem Bildtypus ein offenes aber hochstrukturiertes System in einem gleichförmigen Raster angeordneter Punkte, deren Farbwerte vom Zufall bestimmt werden. Obwohl diese Bilder seinen Skulpturen nicht ähnlich sehen, weisen sie inhaltliche Gemeinsamkeiten auf. Hirst versucht, mit den abstrakten Elementen dieser Bilder die Mißlichkeit und Zufälligkeit des Lebens darzustellen. Er exerziert eine neue Variante der systematischen Malerei, bestimmt von der Unvorhersehbarkeit des Chaos und nicht erkennbarer Anordnung.[27]

Wandmalerei (Lackfarbe). Größe frei zu bestimmen. Limitiert auf 10 Ausführungen, jede in einer anderen Farbkombination. Zertifikat: Photokopie, 30 x 21 cm, signiert und numeriert.

Die Kreise, 15 horizontal, 10 vertikal, sind mit den gelieferten Lackfarben direkt auf die Wand zu malen. Alle Kreise sind gleich groß; der Abstand der Kreise untereinander ist gleich dem (selbst zu bestimmenden) Durchmesser der Kreise. Die Farbe jedes einzelnen Kreises wird nach dem Zufallsprinzip aus den 150 gelieferten Farben gewählt. Hinweis: Wir empfehlen die Ausführung durch einen Maler oder Schriftenmaler. Gelieferte Bestandteile/Material: Weiß gestrichener Holzkasten (**1**), 100 x 80 x 12,5 cm, mit 150 Dosen Lackfarbe (145 verschiedene Farben und fünfmal schwarz), 150 Pinsel, Zirkel.

1

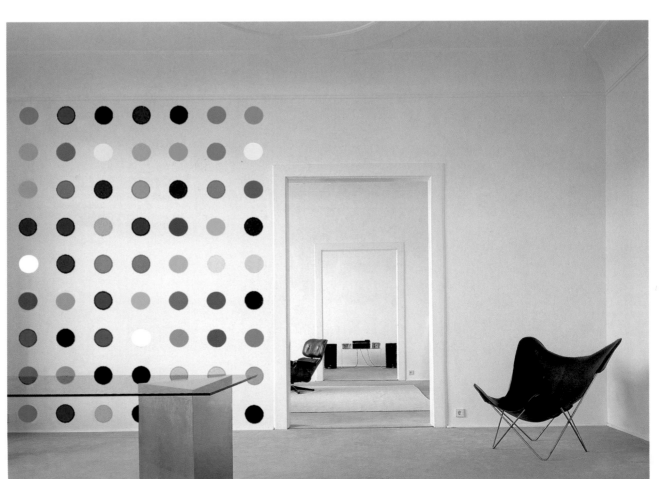

2

Damien Hirst

Born 1965 in Bristol, lives and works in London. In work known for both its formal beauty and its shock value, Hirst has made some of the most-discussed art of the 90s. Hirst's work suggests the transience of life. His "sealed-up vitrines-as-mausoleums" make you think about time and vast cycles of mortality, not only within the sculpture but all around us.[26] Since 1988 Hirst has been making spot paintings that involve color systems.

These paintings form a fascinating parallel to his sculpture, and provide an encoded window onto his thinking. In the paintings, Hirst plays with rules and randomness by setting up an open, but highly structured system. All the paintings have a regular grid of solid, arbitrarily-colored spots. Though these paintings do not resemble his sculpture, they are not dissimilar in content: Hirst attempts to imbue abstract elements of painting with his sense of the awfulness, or at least the arbitrariness, of life. Here, a familiar form like systemic painting is run through with unpredictability as chaos and order blur.[27]

Pharmaceutic Wall Painting, Five Blacks
1993

Wall painting in enamel paint. Size variable.
Limited to 10 installations, each unique in color combination.
Certificate: photocopy, 11¾ x 8", signed and numbered.

Installation:

The spots are to be placed in 10 rows, 15 spots wide. The diameter of the spots (to equal the spaces between spots) is to be determined by the owner. The color of each spot is chosen at random, using one of the 150 colors available.
Note: we recommend installation by a professional painter or sign painter.
Components provided: white painted wooden box (**1**) 39½ x 31½ x 5" containing 150 tins of enamel paint (145 different colors and 5 blacks), 150 brushes, compass.

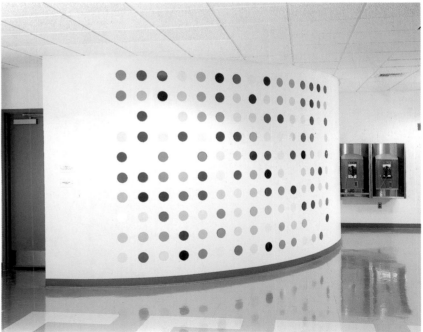

4

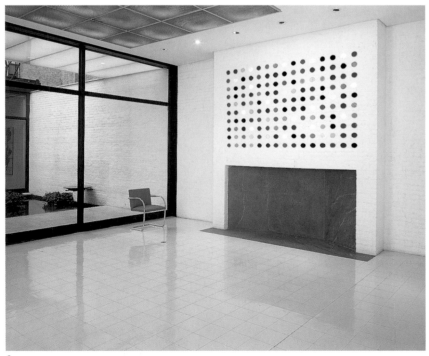

3

Proportion ist für uns sehr wichtig, sowohl in unserem Denken und Leben als auch visuell umgesetzt, denn in ihr sind Denken und Fühlen nicht voneinander getrennt, sie ist Einheit und Harmonie. ... In der Kunst und in der Architektur ist Proportion spezifisch und identifizierbar, sie schafft unsere Zeit und unseren Raum. Proportion und eigentlich jede Intelligenz in der Kunst wird augenblicklich verstanden, zumindest von einigen. ... Ich möchte noch hinzufügen, daß man die Bedeutung der Proportion gar nicht überschätzen kann. Sie könnte fast die Definition für Kunst und Architektur sein.[28]

Proportion is very important to us, both in our minds and lives and as objectified visually, since it is thought and feeling undivided, since it is unity and harmony ... Proportion is specific and identifiable in art and architecture and creates our space and time. Proportion – and in fact all intelligence in art – is instantly understood, at least by some. ... I only want to add that you can't exaggerate the importance of proportion. It could almost be the definition of art and architecture.[28]

Donald Judd

Donald Judd

Untitled 1992

Geboren 1928 in Excelsior Springs, Missouri, gestorben 1994 in New York. Als einer der bedeutendsten Vertreter der Minimal Art hat Donald Judd mit seinen Skulpturen, den "specific objects" aus Stahl, Holz, Aluminium und Plexiglas, die Definition von Raum und Skulptur in radikaler und revolutionierender Weise analysiert.[29] Seine Objekte sind meist seriell angelegt, die Thematik von Ganzheit und ihren Teilen wird sichtbar durch die Prinzipien von Progression und Reihung. Die Bezüge seiner Objekte zum Umraum, ihre sorgfältige Positionierung, ihre Orthogonalität und Scharfkantigkeit und die strukturelle Logik der Anordnung manifestieren eine latente Beziehung Judds zur Architektur.[30] Der Künstler hat in Marfa, Texas, einem ehemaligen Militärgelände, im Lauf der 70er und 80er Jahre seinen Traum verwirklicht von einem Ort, an dem der Künstler seine Vorstellungen von einer idealen und dauerhaften Präsentation von Kunst im Kontext einer architektonischen und natürlichen Umgebung sichtbar machen kann, und hat damit weltweit beachtete neue Maßstäbe für heutige Kunst gesetzt.

Zwei Vertiefungen in einer Wand, mit Plexiglas rot, blau oder grün oder verzinktem Eisenblech. Vertiefungen je 50 x 75 x 25 cm; Gesamtmaße je nach Wand. Limitiert auf 12 Ausführungen. Zertifikat: Text auf Papier, 29,7 x 21 cm, nachlaßsigniert und numeriert.

Skizze des Künstlers (**1**)

Ausführung:

Die Vertiefungen in der Wand können in eine bestehende Wand hinein ausgeführt werden oder – wenn die Wand nicht die erforderliche Dicke aufweist oder es sonstige Hindernisse gibt – die bestehende Wand kann mit Gipskarton aufgedoppelt und die beiden Vertiefungen ausgespart werden (**2**). Die Vertiefungen liegen mittig auf den (imaginären) Linien, die die Wand in drei gleiche Teile unterteilen. Ist die Wand weniger als 500 cm breit, liegen die Vertiefungen nicht auf den Drittellinien, sondern haben links, in der Mitte und rechts gleiche Abstände. Der Mindestabstand der Vertiefungen untereinander und nach rechts und links muß aber je 75 cm betragen, d.h. bei einer Wandbreite unter 375 cm ist die Arbeit nicht ausführbar. Jede Vertiefung ist 75 cm breit, 50 cm hoch, 25 cm tief. Die Wand und die Laibungen der Vertiefungen sind in Putz oder Gipskarton auszuführen und weiß zu streichen. Die Rückwände der Vertiefungen bestehen aus rotem, blauem oder grünem Plexiglas oder aus verzinktem Eisenblech. Die Oberkante der Vertiefungen muß 165 cm Abstand vom Boden haben.
Hinweis: Die Arbeit sollte von einem Maurer bzw. Trockenbauer ausgeführt werden.
Gelieferte Bestandteile: Zwei Platten in der gewählten Farbe bzw. Material.

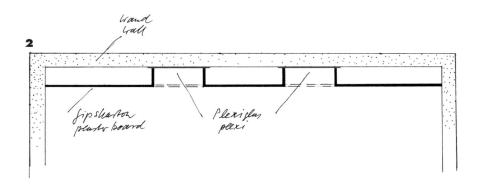

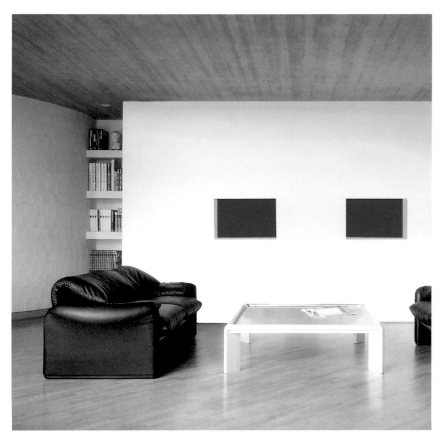

1

3

Donald Judd

Born 1928 in Excelsior Springs, Missouri, died 1994 in New York. Judd is one of the most important minimalists. With his sculptures, his "specific objects" made out of steel, wood, aluminum and plexiglas, he has analyzed the definition of space and sculpture in a radical and revolutionary way.[29] Judd's objects are conceived with the principles of progression and seriality. They manifest a latent inclination towards architecture through their reference to the surrounding space, precise positioning, rectilinearity, and ordered structural logic. In the 70s and 80s he created a setting – in a compound on a former military base in Marfa, Texas – which afforded the opportunity for permanent installations of both his own work and that of other artists, in architectural as well as natural surroundings.[30] Through Marfa, Judd was able to realize his ideal context for the exhibition of contemporary art and in so doing, set a new standard for its presentation.

Untitled 1992

Two recesses on a wall, with red, blue or green plexiglas or galvanized iron.
Recesses 50 x 75 x 25 cm (29 ½ x 19 ¾ x 10") ea.; installation size according to the wall.
Limited to 12 installations.
Certificate: text on paper, 11 ¾ x 8 ¼", signed by the estate and numbered.

Artist's sketch (**1**)

Installation:

The recesses can be constructed in an existing wall or – if the wall is not deep enough – a plaster board wall and recesses can be fabricated in front of the existing wall (**2**). Each recess is 75 cm wide, 50 cm high, and 25 cm deep. They are to be centered on the two lines that would divide the wall into thirds. If the wall is less than 500 cm (16') wide the recesses must be placed equidistant. The minimum distance between the recesses and to the left and right of each must be 75 cm, i.e. if the wall is less than 375 cm (12') wide, the work cannot be executed.

The wall and the sides of the recesses are to be white and made of plaster or plaster board. The backs of the recesses are to be red, blue or green plexiglas or galvanized iron. The tops of the recesses are at 165 cm from the floor.
Note: we recommend installation by a contractor.
Components provided: two sheets of the material chosen.

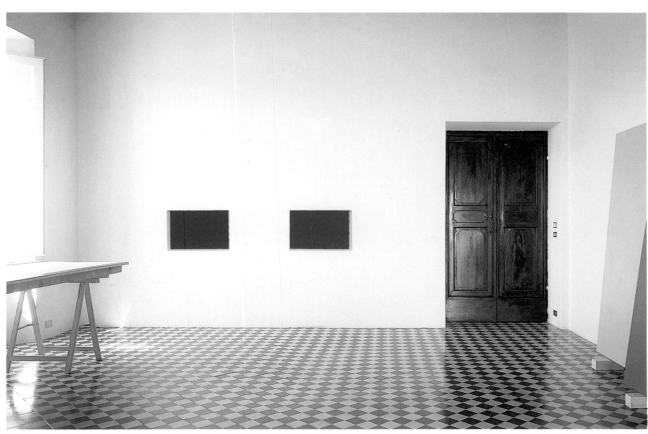

4

"Das Werk von IMI Knoebel ist eine Konstruktion der Utopie des sprachbefreiten Bildes."[31]

"The work of IMI Knoebel is a construct of the utopian idea of a picture free from language."[31]

IMI Knoebel

IMI Knoebel

Geboren 1940 in Dessau, lebt und arbeitet in Düsseldorf. Er gilt neben Palermo als der bedeutendste abstrakte Maler der Generation der Beuys-Schüler. Knoebels Werk rührt radikal an die Wurzeln des Bildbegriffs, es ist eine konsequente Untersuchung des Mediums Malerei, ihrer Bedingungen und Möglichkeiten. Seine geometrischen

Formen sind oft ganz direkt von der Natur oder seiner eigenen Lebenserfahrung hergeleitet, auch von seiner Erfahrung mit vorhandener Kunst – der Kunst aus dem Kanon der Moderne.[32] Es ist charakteristisch für Knoebels experimentelle, konzeptuelle Einstellung, daß er die Geometrie mit neuen Formen unterwandert; Formspannung und Farbenergie verdichten sich in seinen Bildern zu energetischen Feldern.[33]

Mennige (Fünfeck)
1992

Wandmalerei (Bleimennige), 164,5 × 197,7 cm. Limitiert auf 12 Ausführungen. Zertifikat (**1**): Bleimennige auf Karton, in gestanzter Schablone, 102 × 73 cm, signiert und numeriert.

Ausführung:

Nach geliefertem Schema (**2**) mit gelieferter Farbe auf eine Wand zu malen. Hinweis: Wir empfehlen Ausführung durch einen Maler.

104

1

2

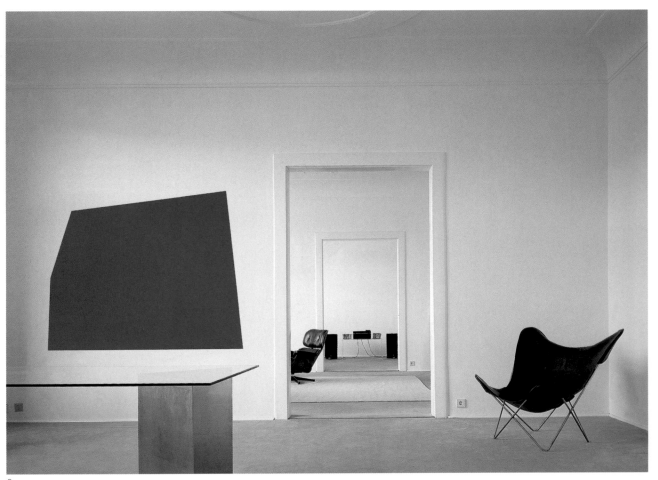

3

IMI Knoebel

Born 1940 in Dessau, Germany, lives and works in Düsseldorf. Along with Palermo, he is considered one of the most important German abstract painters of the post-Beuys generation. His work returns to the roots of the concept of painting; it is a consistent exploration of the medium, the conditions it requires and the possibilities it presents. His geometric forms are abstracted, often quite directly, from nature and his life experience, including his experience of existing art – art from the Modernist canon.[32] It is characteristic of Knoebel's experimental, conceptual approach that he undermines geometry with new forms; in his paintings, form and color coalesce into energetic fields.[33]

Mennige (Pentagon)
1992

Wall painting in red lead paint, 61 × 68".
Limited to 12 installations.
Certificate (**1**): red lead paint on board, in window mat, 40 × 29", signed and numbered.

Installation:

To be painted on a wall with paint provided, according to the artist's diagram (**2**).
Note: we recommend installation by a professional painter.

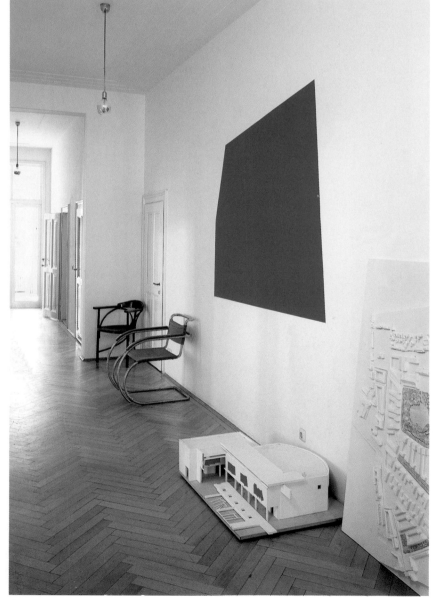

4

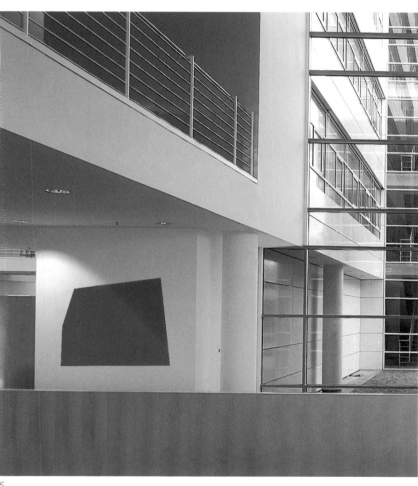

5

IMI Knoebel

Mennige (Polygon)
1996

Ausführung:

Seit 1976 entsteht – zunächst auf Papier, dann auf Leinwand und direkt auf der Wand – eine Vielzahl von Kombinationen aus Rechteckfeldern, die sich aus irregulären, vielkantigen Umriß-formen mal deutlicher, mal bis zur Unkenntlichkeit verschleiert, wiedererkennen lassen. Die Ambivalenz zwischen der sichtbaren Gesamtkonstellation und dem unsichtbar Verdeckten, das vom Betrachter mitgedacht, ja mit gesehen wird, erschwert die definitive Wahrnehmung. Der Blick oszilliert zwischen dem suggestiven Raumeindruck und der tatsächlich gegebenen Planimetrie, ohne durch einen Spannungsausgleich zur Ruhe kommen zu können.[34]

Wandmalerei (Bleimennige bzw. Eisenoxyd) in drei verschiedenen Farbvarianten, Maße variabel. Limitiert auf 12 Ausführungen. Zertifikat (**1**): Bleimennige oder Eisenoxyd auf Karton, in gestanzter Schablone, 100 x 70 cm, signiert und numeriert.

Farbe direkt auf die Wand zu malen. Die Form ist mittels eines gelieferten Films in der gewünschten Größe an die Wand zu projizieren. Die Umrisse sind mit einem Lineal nachzuzeichnen, dann abzukleben, und die Fläche auszumalen. Hinweis: Wir empfehlen Ausführung durch einen Maler. Gelieferte Materialien: Film zur Projektion und Farbe im gewählten Farbton.

108

1

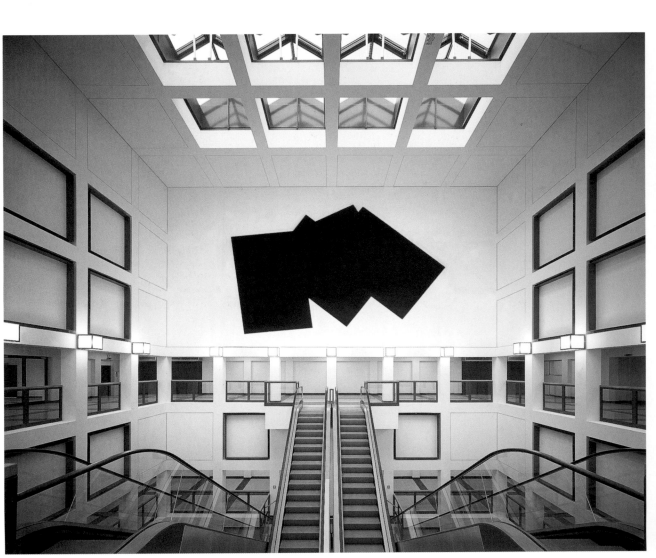

2

IMI Knoebel

Beginning in 1976 – first on paper, then on canvas, later, directly on the wall – Knoebel has created a great many different surfaces employing combinations of rectangular silhouettes. Sometimes irregular, often multi-faceted, the surfaces fluctuate from sharply defined to merely implied – hinted at, almost impossible to discern. The viewer tries to reconcile the ambivalence of simultaneously perceiving what is given and what is suggested, and the view oscillates between the imaginary and the actual.[34]

Mennige (Polygon)
1996

Wall painting in red lead or ferric oxide paint, in three different color variations, size variable.
Limited to 12 installations.
Certificate (**1**): painting in red lead or ferric oxide paint on board, in window mat, 39 ½ x 27 ½", signed and numbered

Installation:

To be painted on a wall using a wall projection adjusted to desired size.
Note: we recommend installation by a professional painter.
Components provided: acetate for projection and paint in chosen color.

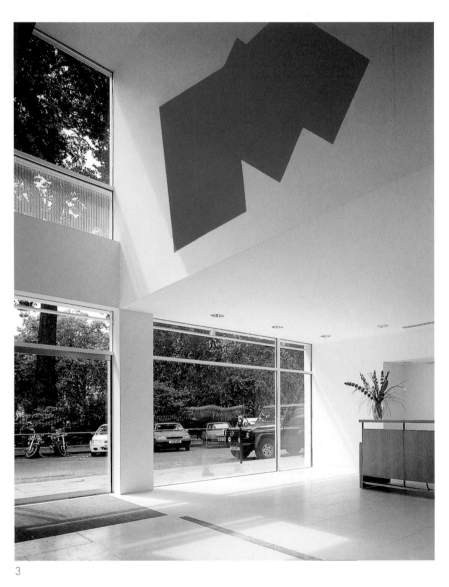

3

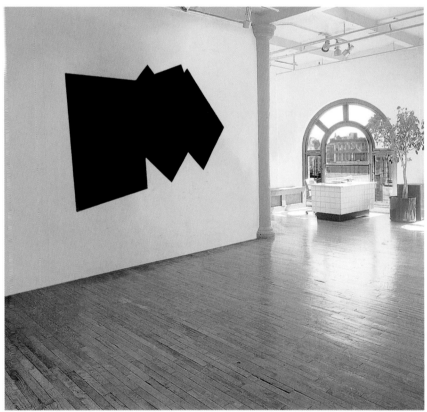

4

Als Künstler gehen wir alle bei unserer Arbeit von etwas aus, das es schon gibt.[35]

As artists we all begin to construct with what is given.[35]

Joseph Kosuth

Joseph Kosuth

Geboren 1945 in Toledo, Ohio, lebt und arbeitet in Rom und New York. Kosuth ist einer der Wegbereiter der Konzeptkunst. Er begann bereits in den frühen 60er Jahren, in seiner Kunst Sprache einzusetzen und arbeitet seither mit Strategien der Appropriation. Er hat konsequent den Herstellungsprozeß von Kunst untersucht und die Rolle, die Bedeutung in der Kunst einnimmt.[36] Bei seiner Erforschung des Verhältnisses von Sprache und Kunst hat Kosuth die unterschiedlichsten Quellen benutzt, lexikalische Definitionen, den Stein von Rosette, Texte von Freud und Wittgenstein und in seinen neuesten Projekten

Literaturtexte von Thomas Mann, Italo Svevo und Franz Kafka. Die Wandarbeit *Sigla, Finnegans Wake* entspringt Kosuths Beschäftigung mit James Joyce. Nachdem er im Irischen Museum für Moderne Kunst in Dublin eine 300 Meter lange Installation und in Tokio und Lyon permanente Werke zum Thema Joyce realisiert hat, konzipierte er in dieser Wandarbeit Neonschrift nach *Sigla* oder Zeichen, die Joyce 1923 in seinem Buch Finnegans Wake verwendete, um seine Hauptfiguren und deren Persönlichkeitsstrukturen zu charakterisieren. Die freie, an einen Sternenhimmel erinnernde Anordnung dieser Leuchtzeichen läßt die Symbole in immer anderen Konstellationen an der schwarzen Wandfläche erscheinen.

Sigla, Finnegans Wake
1998

Neon warmtonweiß auf einer schwarz gestrichenen Wand; Anordnung variabel. Neonzeichen, 10 Elemente, je ca. 12 x 12 x 4 cm; Gesamtmaße der Installation je nach Wand. Limitiert auf 12 Installationen. Zertifikat: Text und Diagramme auf Papier, 30 x 21 cm, signiert und numeriert.

Ausführung:

Die Wand ist mattschwarz zu streichen. Die Neonzeichen (**1**) sind direkt auf die Wand verteilt in freier, aber gleichmäßig verteilter Anordnung zu montieren. Die montierten Zeichen sind mit den gelieferten elektrischen Kabeln, die in leichten Bögen frei nach unten hängen, miteinander zu verbinden und an einen Transformator anzuschließen, der am Boden oder an anderer Stelle versteckt zu plazieren ist. Hinweis: Die Installation der Neonzeichen muß von einem geprüften Elektriker ausgeführt werden. Gelieferte Bestandteile: Dispersionsfarbe, 10 Neonteile und Verbindungskabel, in Holzkiste, und Transformator.

114

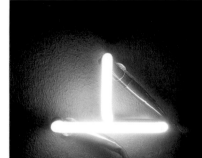

1

2

Joseph Kosuth

Born 1945 in Toledo, Ohio, lives and works in Rome and New York. Kosuth – one of the pioneers of conceptual art – has, since the 60s, consistently explored the production and role of meaning within art using appropriation strategies and language-based works.[36] His inquiry into the relation of language to art has utilized texts from a diverse variety of sources including dictionary definitions, the Rosetta Stone, the writings of Freud and Wittgenstein, the cartoon Calvin & Hobbes, and in his recent

projects literary sources by Thomas Mann, Italo Svevo, and Franz Kafka.

The wall work Sigla, Finnegans Wake is one of several Joyce-based Kosuth works – others include an immense installation at the Irish Museum of Modern Art in Dublin and permanent installations in Tokyo and Lyon. For Sigla, Kosuth has made white neon "text" after the sigla (signs) Joyce used in his seminal 1923 work Finnegans Wake to designate characters and their identities. These luminous signals are to be configured freely on a black wall, suggesting a starry night sky.

Sigla, Finnegans Wake
1998

Installation

Warm white neon on a black painted wall; configuration of the neon signs variable. Signs approximately 5 x 5 x 1½"; installation size according to the wall.
Limited to 12 installations.
Certificate: text and diagrams on paper, 11¾ x 8¼", signed and numbered.

Wall to be painted in a matte-satin black. Neon signs (**1**) to be mounted directly on the wall, distributed in a "starry night" configuration. Electrical cords are to be left free hanging, and the transformer may be placed on the floor or concealed.
Note: the installation of the neon signs requires a licensed electrician.
Components provided: latex paint, 10 neon signs and electrical cords in a wooden crate, and transformer.

3

4

Es ist nicht so, daß ich in der Vergangenheit graben will aus einem archäologischen Interesse heraus ... , sondern weil die Vergangenheit eine Realität besitzt, die uns noch heute tief prägt. Und wenn du sie langsam an die Oberfläche bringst, eröffnen sich dir viele Möglichkeiten.[37]

I don't want to delve into the past for archeological pleasure ... but because the past has a reality which conditions us deep-down. Then, if you bring it slowly to the surface, it's full of possibilities.[37]

Jannis Kounellis

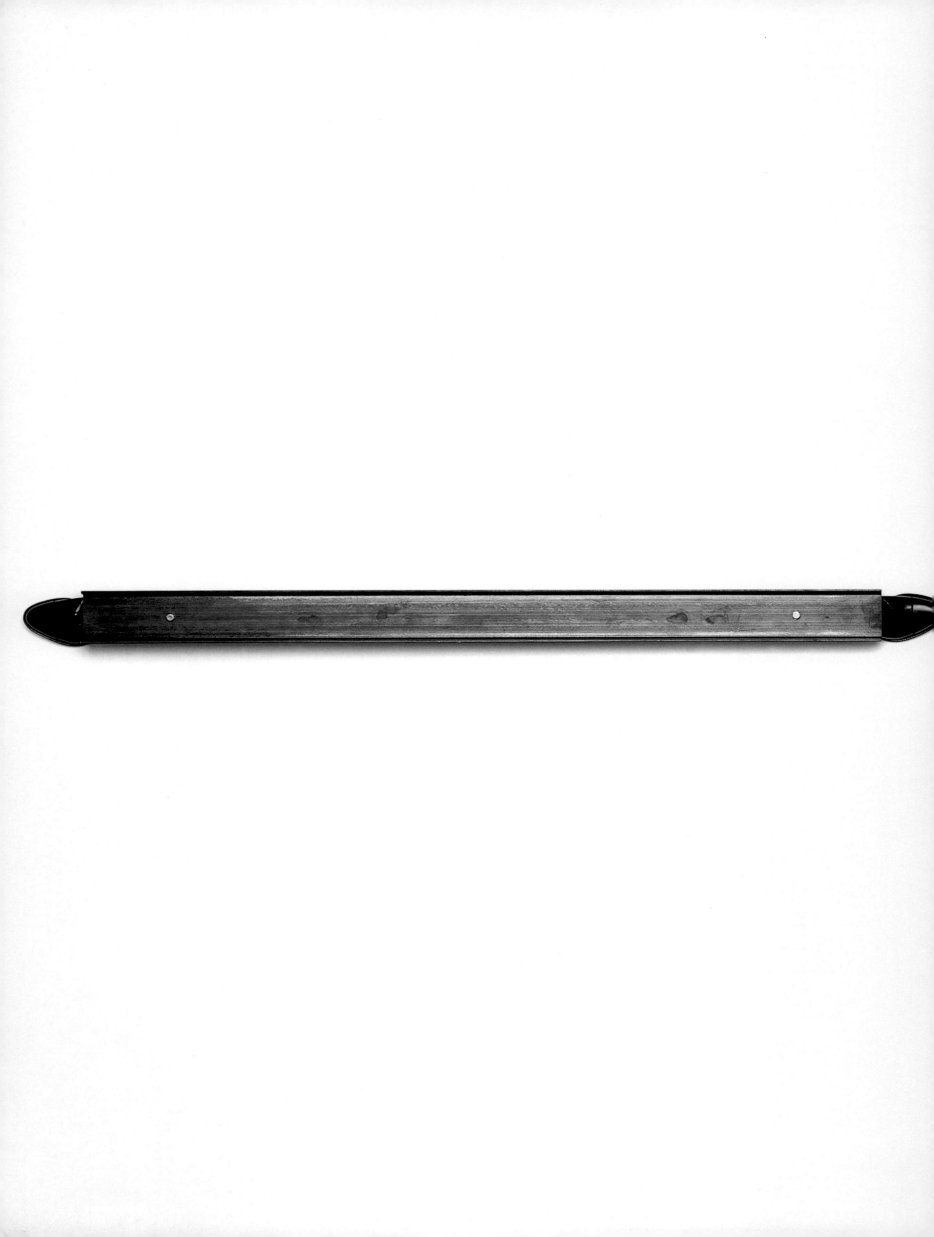

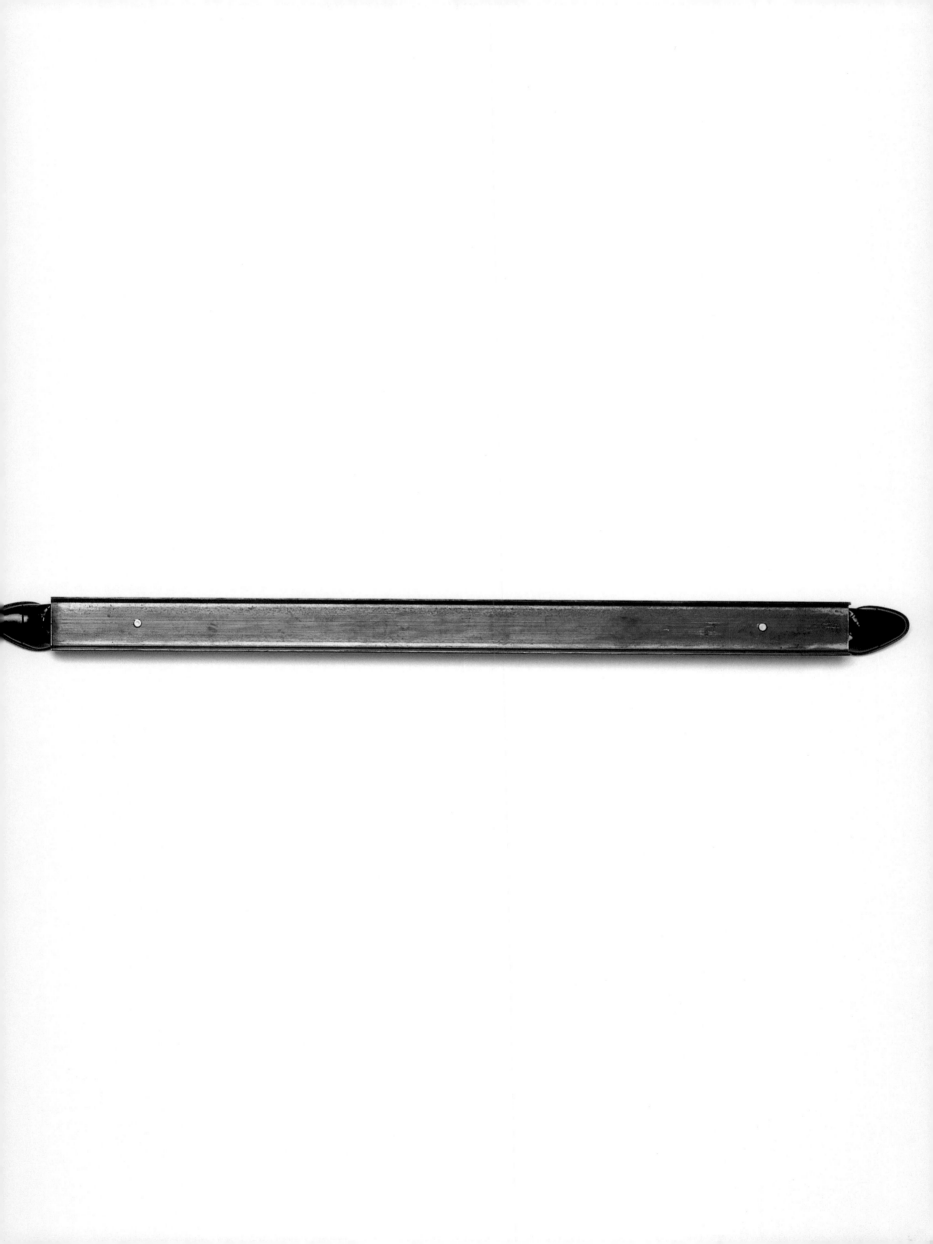

Jannis Kounellis

Geboren 1936 in Piräus (Griechenland), lebt und arbeitet in Rom. Neben Künstlern wie Beuys, Merz, Morris und Serra gilt er als einer der Klassiker der Zweiten Moderne, die in den sechziger Jahren mit einer neuen Materialikonographie unsere Vorstellungen von Kunst grundlegend erweiterten. Als exponierter Vertreter der Arte Povera verwendet er vorwiegend "arme" Materialien, Relikte und Fragmente aus mediterraner Geschichte und Alltag, die aus ihrem Funktionszusammenhang gelöst und durch verfremdende Konfrontation in einen neuen poetischen Kontext gestellt werden. Sein Einsatz von Holz, Kohle, Eisen und Feuer in seinen Bildinszenierungen läßt uns an ihn als einen mythischen Schmied im 20. Jahrhundert denken.[38]

Ohne Titel 1993

Zwei Eisenträger, zwei Paar Schuhe, montiert an einer Wand. Träger 12 x 6 cm Querschnitt, Länge je nach Wand.
Limitiert auf 10 Installationen.
Zertifikat (**1**): Druck auf Papier, 29,7 x 21 cm, signiert und numeriert.

Ausführung:

Zwei Doppel-T-Träger aus Stahl, Querschnitt 12 x 6 cm, entsprechend der Länge der Wand zuschneiden, so daß nach Montage an der Wand die beiden äußeren Schuhe 8 cm Abstand von den Wandecken, die beiden inneren 4 cm Abstand voneinander haben. Die Träger sind auf 160 cm Unterkante vom Boden zu montieren. Die Schuhe stecken etwa zur Hälfte verdeckt in den Trägern.
Gelieferte Bestandteile: Zwei Paar schwarze Schuhe; zwei Eisenträger nach Maß, mit Bohrungen und Schrauben.

120

1

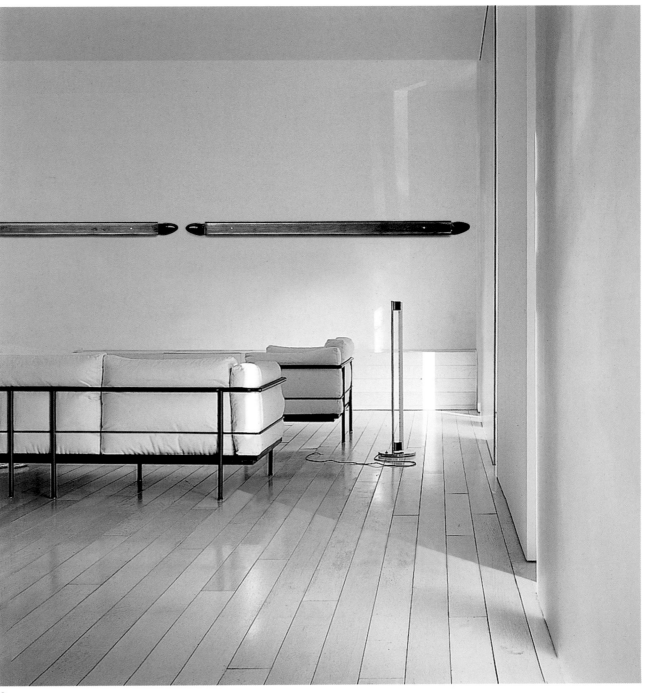

2

Jannis Kounellis

Born 1936 in Piraeus (Greece), lives and works in Rome. Along with artists like Beuys, M. Merz, Morris and Serra, he is part of a second wave of modernists who, in the 60s, radically expanded our vision of fine art with a new iconography of materials. As a pioneering figure of arte povera, Kounellis used "poor" materials – relics and fragments of Mediterranean history and everyday life – placing these objects in often-startling juxtapositions, to create a new poetic context. Kounellis conjures a 20th century version of the mythic village blacksmith, forging his environments with wood, coal, iron and fire.[38]

Untitled 1993

Two steel I-beams and two pairs of shoes mounted on a wall. I-beam $5 \times 2\frac{1}{2}$" cross section, length according to the wall. Limited to 10 installations. Certificate (**1**): printing on paper, $11\frac{3}{4} \times 8\frac{1}{4}$", signed and numbered.

Installation:

The two steel I-beams are to be cut so that, when installed, the very left and the very right shoes are to be 3" from the edges of the wall, and the two inner shoes are to be $1\frac{1}{2}$" apart from each other. The beams are to be mounted on the wall in a height of 63" from the floor to the bottom of the beam. The back half of each shoe is to be hidden in the beam.
Components provided: two pairs of black shoes, two steel I-beams cut to size, with drilled holes and screws.

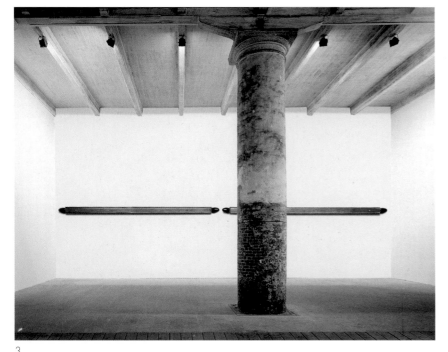

3

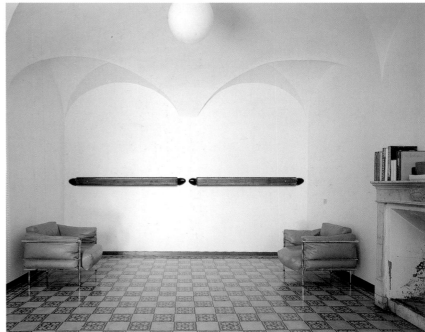

4

Ich bin am Physischen und am Sensitiven interessiert, am Zufälligen und am Flüchtigen.
Ich bin interessiert an der hauchdünnen Gratwanderung zwischen dem, was bewußt entschieden wurde, aber nicht in das Werk eingeht, und dem, was in das Werk eingeht, worüber aber nie entschieden wurde.
Ich erstrebe ein Höchstmaß an historischen Bezügen und metaphorischen Möglichkeiten, damit die Arbeiten mit Bedeutung so stark aufgeladen sind, daß sie implodieren und neue Denkmuster vermitteln.[39]

I am interested in the physical and the sensory, the contingent and the unstable.
I am interested in that infra-thin difference between what was decided on but does not make its way into the work, and what makes its way into the work but was not decided on.
I want to maximize the historical references and metaphorical possibilities so that the meaning of my work becomes so overdetermined and congealed that it implodes and brokers a new paradigm.[39]

Sherrie Levine

Sherrie Levine

Geboren 1947 in Hazleton, Pennsylvania, lebt und arbeitet in New York. Die Konzeptkünstlerin ist in den achtziger Jahren vor allem bekannt geworden durch ihre "appropriations", Kunst nach Kunst anderer Künstler. Levine setzt beim Bestreben Duchamps und später der Konzeptkunst an, das Erschaffen von Kunst in Frage zu stellen. In ihren Werken untersucht sie systematisch die von den postmodernen Theoretikern Foucault, Barthes und Baudrillard aufgeworfenen Fragen nach Urheberschaft und Originalität des Kunstwerks.

Die hier gezeigte Wandarbeit wurde inspiriert von dem Ready-made *Pharmacie* von Marcel Duchamp, einer Reproduktion eines banalen Landschaftsbildes, in das der Künstler einen roten und einen grünen Punkt eingesetzt hatte - in Assoziation an zwei erleuchtete Fenster, die er während einer nächtlichen Zugfahrt von Paris nach Rouen in der Landschaft gesehen hatte und welche ihn an Glasbehälter mit farbigen Flüssigkeiten wie sie in Schaufenstern französischer Apotheken zu sehen waren, erinnerten. Diese minimale künstlerische Geste Duchamps nahm Levine zum Ausgangspunkt für die streng-poetische Wand installation gleichen Titels.

Pharmacie 1996

Zwei Industrielampen (rot und grün) auf mauvefarbener Wandfläche. Lampen (Aluminiumguß, Glas), je 22 x 11 x 13 cm; Gesamtmaße der Installation je nach Wand.
Limitiert auf 12 Installationen.
Zertifikat (**1**): Text, Abbildung und Schema mit Farbmuster auf Karton, gefaltet, 21 x 29,7 cm, signiert und numeriert.

Ausführung:

Die beiden Lampen (**2**) werden an eine Wand montiert, die in der auf dem Zertifikat angegebenen Farbe zu streichen ist. Die Lampen werden in einer Höhe von 2m angebracht. Die rote Lampe ist links im Abstand von einem Viertel der Wandlänge zu montieren, die grüne Lampe rechts im entsprechenden Abstand, siehe Skizze auf dem Zertifikat.
Hinweis: Die Installation der Lampen sollte von einem Elektriker ausgeführt werden.
Gelieferte Bestandteile:
Zwei Lampen in Holzkiste und Wandfarbe (Dispersion).

126

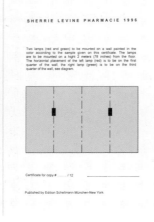

1

2

3

Sherrie Levine

Born 1947 in Hazleton, Pennsylvania, lives and works in New York. In the 80s the New York-based conceptual artist became famous for her "appropriations," art directly referencing art by other artists. Levine positions herself at the Duchampian – and, later, conceptual – task of questioning the production of art. She systematically investigates the theoretical critiques of originality and authorship theorized by postmodern philosophers such as Foucault, Barthes, and Baudrillard.

The wall work shown here is inspired by an early assisted readymade, Pharmacie, by Marcel Duchamp. Riding an evening train from Paris to Rouen, he saw in the distance a pair of lit windows. Soon afterward he bought three copies of a banal landscape at an art supply store and painted a red and green dot on each, suggesting the jars of colored liquids in the windows of French pharmacies. Levine used this minimal artistic gesture as a point of departure for the austere and poetic wall installation of the same title.

Pharmacie 1996

Two industrial lamps (cast aluminum, one with red glass, one with green) on a mauve-painted wall. Lamps 9 x 4½ x 5", installation size according to the wall.
Limited to 12 installations.
Certificate (**1**): text, illustration, and diagram with color sample on card stock, folded, 8¼ x 11¾", signed and numbered.

Installation:

The lamps (**2**) are to be mounted on a wall painted mauve. The placement height for both lamps should be 78" from the floor; the red lamp is to be placed exactly one-fourth the length of the wall from the left, and the green lamp is to be placed exactly one-fourth the length of the wall from the right (see diagram on the certificate).
Note: we recommend installation by an electrician.
Components provided: two lamps with bulbs in a wooden crate, and latex paint.

5

4

Alle Ideen sind Kunst, wenn sie sich auf Kunst beziehen und innerhalb der Konventionen von Kunst liegen.[40]

Die gesamte Planung und die notwendigen Entscheidungen stehen am Anfang, die Ausführung ist dann eine mechanische Angelegenheit. Die Idee wird zur Maschine, die die Kunst macht.[41]

All ideas are art if they are concerned with art and fall into the conventions of art.[40]

When an artist uses a conceptual form of art it means that all of the planning and decisions are made beforehand, and the execution is a perfunctory affair. The idea becomes a machine that makes the art.[41]

Sol LeWitt

wall a

drawing

Sol LeWitt

Geboren 1928 in Hartford, Connecticut, lebt und arbeitet in New York und bei Spoleto (Italien). LeWitt gilt als einer der Hauptvertreter der Concept Art, einer Kunst, deren Essenz die Idee und nicht die handwerkliche Ausführung ist. Ähnlich einem Architekten entwirft der Künstler ein Konzept, daraus ein Kunstwerk, dessen Ausführung Handwerkern überlassen wird. LeWitt hat sein künstlerisches Vokabular aus einfachen geometrischen Formen und deren Verwandlungen entwickelt und sich dabei – typisch für die minimalistischen Künstler seiner Generation – des Mittels der seriellen Wiederholung oder sequenziellen Abwandlung einfacher Module bedient.

LeWitts andauerndes Interesse gilt der Vielfalt der Dinge, vor allem der Dinge, die durch einfache Ideen entstehen.
Seit 1968 hat LeWitt als erster Künstler seiner Zeit Wandzeichnungen gemacht. Am Anfang waren es von ihm selbst ausgeführte Bleistiftzeich-nungen, sehr bald aber bestand eine Wandzeichnung zunächst nur aus "instructions", Diagrammen mit textlichen Erläuterungen, die Arbeitsanweisungen für einen kompetenten Handwerker darstellen. Diese Arbeitsweise bestätigt LeWitts Vorstellung vom Künstler als einem Denker und Urheber von Ideen und nicht als einem geschickten Handwerker. Es liegt in der Absicht LeWitts, daß viele der Wandarbeiten nur eine begrenzte Lebensdauer haben, die Anweisungen des Künstlers fungieren so ähnlich wie musikalische Partituren, deren immer wieder neue Aufführung an verschiedenen Orten vom Autor erwünscht ist.[42]

Wall Drawing 1992

"wall drawing" vom Besitzer der Arbeit an eine Wand zu schreiben, Technik und Größe frei zu bestimmen.
Limitiert auf 10 Ausführungen.
Zertifikat: Der Besitzer schickt ein Photo (schwarz/weiß, circa 18 x 24 cm) seiner Wandzeichnung an den Künstler, der das Photo signiert und numeriert zurückschickt.

Ausführung:

Der Besitzer schreibt die Worte "wall drawing" eigenhändig in Technik und Größe seiner Wahl auf eine Wand seiner Wahl.

2

132

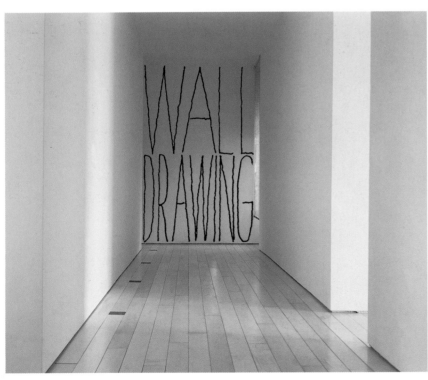

1

Sol LeWitt

Born 1928 in Hartford, Connecticut, lives and works in New York and near Spoleto (Italy). LeWitt is considered one of the most influential practitioners of conceptual art, a form in which the essence of the work is the artist's idea rather than the craftsmanship of execution. LeWitt sees the artist in a role analogous to that of the architect, who designs a building but does not build it. He developed his artistic vocabulary from basic geometric structures and their transformation by using – as is typical for the minimalist tendencies of his generation – these fundamental elements as regular repeated modular units or as

series which explore a range of possibilities in a logical, predetermined sequence. LeWitt is fascinated by the multiplicity of things, especially the multiplicity of things that can be generated by a simple idea.

As one of the first truly contemporary artists, LeWitt did wall drawings beginning in 1968. Initially they were executed in pencil in his own hand, but soon they were replaced by written "instructions" and sketches meant to enable any competent draftsperson to execute a wall drawing. This concept confirmed LeWitt's notion of the artist as a thinker and originator of ideas rather than as a craftsperson. Due to the temporary nature of most LeWitt wall drawings the instructions given by the artist function somewhat as do musical scores, and the artist welcomes subsequent performances in other locations.[42]

Wall Drawing 1992

"wall drawing" to be written on a wall in the hand of the owner, medium and size to be chosen by the owner.
Limited to 10 installations.
Certificate: an 8 x 10" black and white photograph of the installation, sent by the owner to the artist, who will sign, number and return it.

Installation:

The owner will write the words "wall drawing" in his own hand on any wall of his choice, in any medium of his choice, in any size of his choice.

133

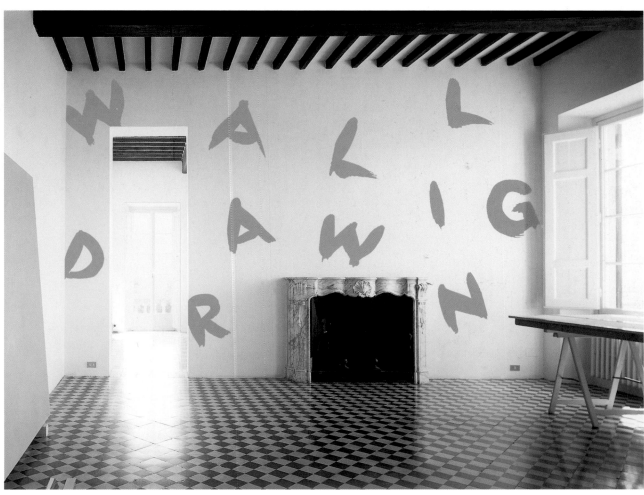

3

Sol LeWitt **Wall Drawing #891a**
1998

Ein Kreis von 91 cm Durchmesser in einem Quadrat von 150 x 150 cm. Der Kreis ist blau, matt, das Quadrat blau, glänzend, direkt auf die Wand gemalt. Limitiert auf 1 Ausführung (Unikat). Zertifikat: Text auf Papier, signiert, und eine schematische Zeichnung, 20 x 25 cm.

Es gibt drei weitere Farbvarianten, die bei Ausführung ihre eigene Werknummer erhalten:

Ein Kreis von 91 cm Durchmesser in einem Quadrat von 150 x 150 cm. Der Kreis ist gelb, matt, das Quadrat gelb, glänzend.

Ein Kreis von 91 cm Durchmesser in einem Quadrat von 150 x 150 cm. Der Kreis ist rot, matt, das Quadrat rot, glänzend.

Ein Kreis von 91 cm Durchmesser in einem Quadrat von 150 x 150 cm. Der Kreis ist grau, matt, das Quadrat grau, glänzend.

Die Wandarbeiten sind von einem Assistenten des Künstlers auszuführen.

136

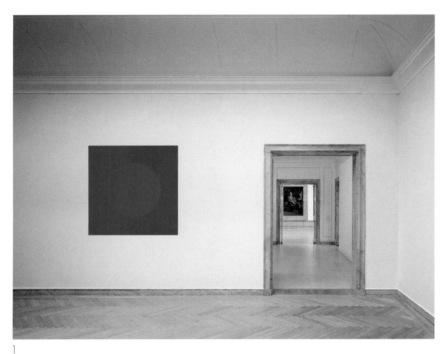

1

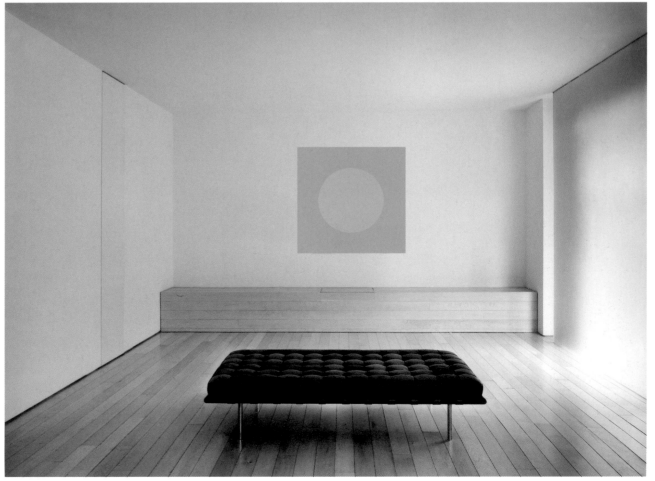

2

Sol LeWitt

Wall Drawing #891a
1998

A flat blue 36" (91 cm) circle within a 60" (150 cm) glossy blue square, painted directly on the wall.
Limited to one installation (unique). Certificate: text on paper, signed, and a diagram of the work in pencil or ink, 8 x 10".

Three other color variations are possible, each to be titled upon execution:

A flat yellow 36" (91 cm) circle within a 60" (150 cm) glossy yellow square.

A flat red 36" (91 cm) circle within a 60" (150 cm) glossy red square.

A flat gray 36" (91 cm) circle within a 60" (150 cm) glossy gray square.

Installation:

The wall drawings are to be installed by an assistant designated by the artist.

137

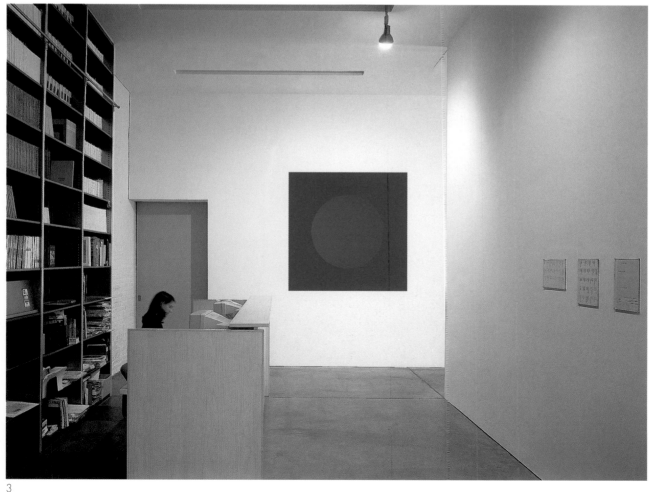

3

Das Schöne ist stumm und leer.[43]

Es geht darum, die Kunst auf ihre eigenen Mittel – Maß, Farbe, Licht – zurückzuführen.[44]

Kunst ist die Möglichkeit für den Menschen, absolut ideal zu denken, jenseits aller pragmatischen Überlegungen; sie ist eine Äußerung, wie das Leben sein soll, und nicht, wie es ist.[45]

The beautiful is mute and void.[43]

My work is about reducing art to its very own means – measure, color, light.[44]

Art gives us the chance to think absolutely idealistically, beyond any pragmatic considerations; it is a statement of what life should be, and not of what it is.[45]

Gerhard Merz

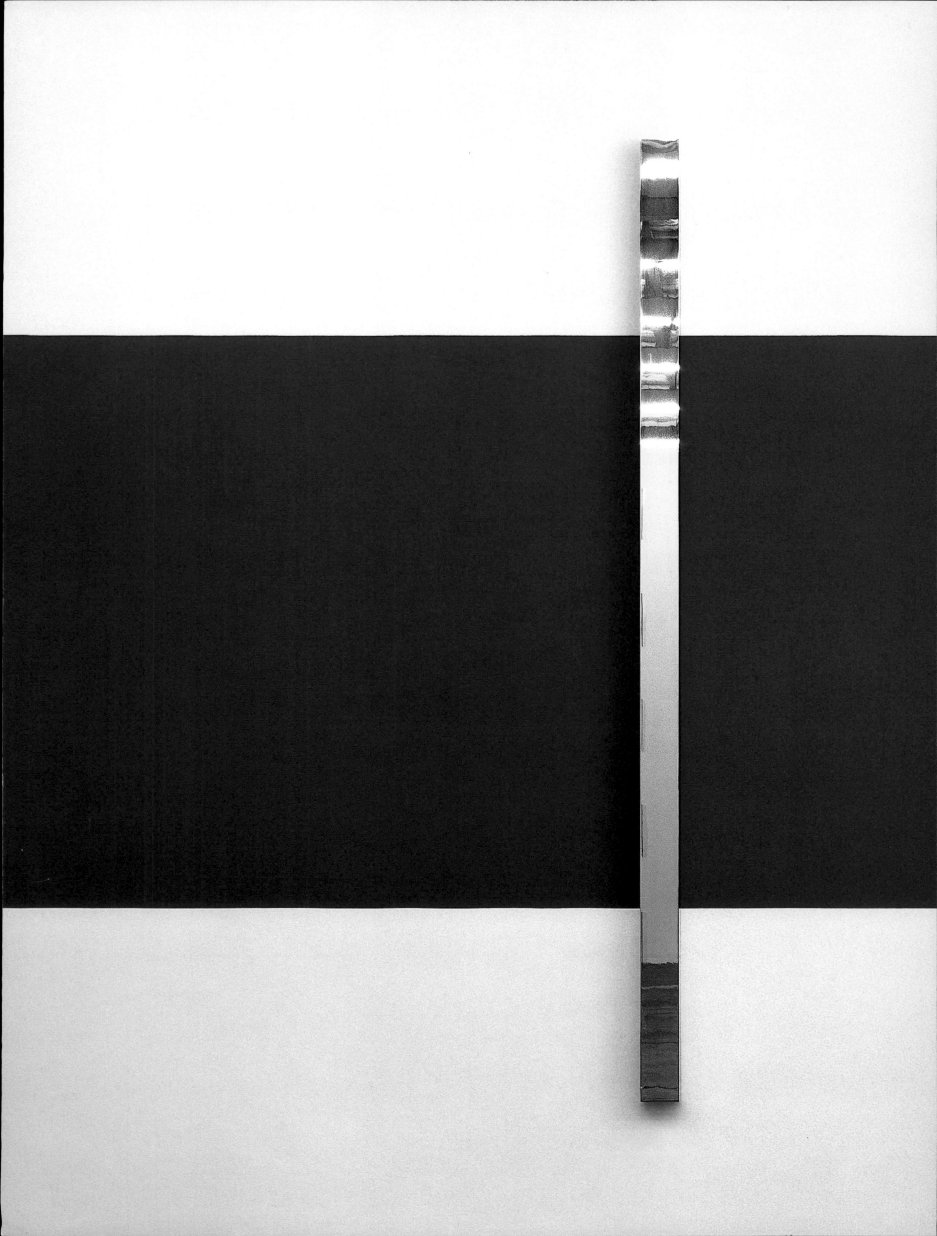

Gerhard Merz

Geboren 1947 in Mammendorf bei München, lebt und arbeitet in Berlin und Pescia (Italien). Seine künstlerische Entwicklung ist geprägt von dem Bestreben, die großen Ideen der Kunst fortzuentwickeln, die Moderne zu verfeinern und zu vollenden. Merz formuliert ganz dezidiert den Unterschied zwischen "Kunst" und "Leben" und bezieht damit die Gegenposition zu einer Mentalität der Vernetzung und Durchdringung von allem mit

allem, wie sie im 20. Jahrhundert immer wieder neu von jungen Künstlergenerationen beschworen wird.[46] Merz' Arbeiten sind Versuchsanordnungen, in denen Vollkommenheit erprobt wird. Dabei bezieht er die Architektur als sinn- und maßstabgebende Bezugsgröße in seine Arbeit ein, er verbindet die Forderung nach größtmöglicher formaler Klarheit mit hoher Komplexität des Ideengehalts. Merz ist Maler; seine Realisierungen sind Anordnungen aus monochromer Malerei, Wandmalerei, Schrift, Architekturfragmenten und Licht. Es sind künstlerische Setzungen im Raum.

Ohne Titel 1993

Wandmalerei in Pigment kobaltgrün oder elfenbeinschwarz, Edelstahl poliert. Wandmalerei 150 cm hoch, Länge je nach Wand; Edelstahlstab 250 x 10 x 10 cm.
Limitiert auf 6 Installationen.
Zertifikat (**1**): Druck auf Transparentpapier, 42 x 60 cm, signiert und numeriert.

Ausführung:

Wandmalerei, 150 cm hoch, mittig zwischen Boden und Decke auf die gesamte Länge der Wand anzubringen. Der Edelstahlstab ist senkrecht auf die gedachte Linie zu montieren, die die Wand in zwei gleiche Teile teilt oder auf eine der beiden Linien, die die Wand in drei gleiche Teile teilt. Der Stab muß oben und unten jeweils 50 cm über die Wandmalerei hinausstehen. Hinweis: Wir empfehlen Ausführung durch geeignete Handwerker. Gelieferte Bestandteile: Farbpigment in der gewünschten Farbe und Edelstahlstab mit Halterungen, in Holzkiste.

142

Ohne Titel, 1993
Wandmalerei in Pigment kobaltgrün oder elfenbeinschwarz, Edelstahl poliert. Wandmalerei 150 cm hoch, Länge je nach Wand. Edelstahlstab 250 x 10 x 10 cm. Limitiert auf 6 Installationen, signiert und numeriert auf diesem Zertifikat.

Ausführung:
Wandmalerei, 150 cm hoch, mittig zwischen Boden und Decke auf die gesamte Länge der Wand anzubringen. Der Edelstahlstab ist senkrecht auf die gedachte Linie zu montieren, die die Wand in zwei gleiche Teile teilt oder auf eine der beiden Linien, die die Wand in drei gleiche Teile teilt. Der Stab muß oben und unten jeweils 50 cm über die Wandmalerei hinausstehen. Hinweis: Wir empfehlen Ausführung durch geeignete Handwerker. Gelieferte Bestandteile: Farbpigment in der gewünschten Farbe und Edelstahlstab mit Halterungen, in Holzkiste.

Untitled, 1993
Wall painting in cobalt green or ivory black pigment, polished stainless-steel. Wall painting 59" high, width according to the wall, stainless steel bar 98½ x 4 x 4". Limited to 6 installations, signed and numbered on this certificate.

Installation:
Wall painting 59" high, centered between floor and ceiling, width to the length of the wall. The stainless-steel element is to be placed on the wall painting either on half the wall's length or at one-third or at two-thirds the wall's length. It should be mounted centered vertically, so that it extends the wall painting evenly at both top and bottom. Note: we recommend installation by skilled craftspersons. Components provided: pigment of the color chosen and stainless steel bar with hanging brackets, in wooden crate.

EDITION SCHELLMANN MÜNCHEN NEW YORK

G E R H A R D M E R Z

1

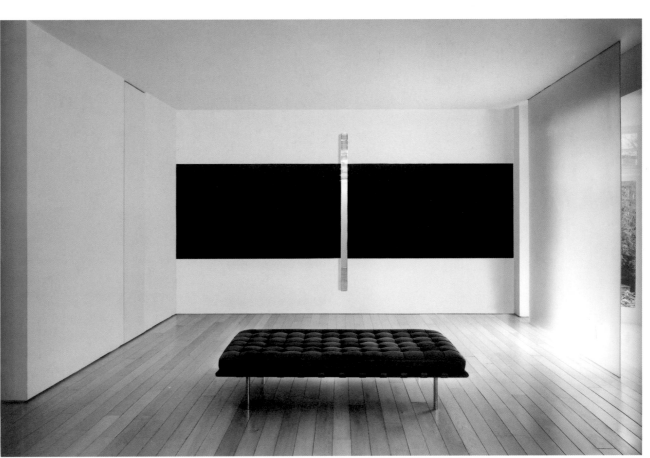

2

Gerhard Merz

Born 1947 in Mammendorf (near Munich), lives and works in Berlin and Pescia, Italy. Merz' career has been devoted to further developing, refining, and perfecting the major ideas of modernism. Merz decisively points out the difference between "art" and "life", a mentality opposed to that of young artists throughout the 20th century.[46] Merz' works are experiments, arenas where he investigates perfection. To achieve this, he incorporates architecture into his work as a standard and a reference of meaning: he calls for a rigorous and exacting formal purity and a high complexity of ideas behind the forms. Merz is a painter, but his "paintings" are artistic interventions in space, composed of monochrome paintings, wall painting, typography, architectural fragments, and light.

Untitled 1993

Wall painting in cobalt green or ivory black pigment, polished stainless-steel bar. Wall painting 59" high, width according to the wall; stainless steel 98½ x 4 x 4". Limited to 6 installations. Certificate (**1**): printing on transparent paper, 16½ x 23½", signed and numbered.

Installation:

Wall painting 59" high, centered between floor and ceiling, width the length of the wall. The stainless-steel bar is to be placed on the wall painting at half, one-third, or two-thirds the wall's length. It should be mounted centered vertically, so that it extends the wall painting evenly at both top and bottom.
Note: we recommend installation by skilled craftspersons.
Components provided: pigment of the color chosen and stainless steel bar with hanging brackets, in wooden crate.

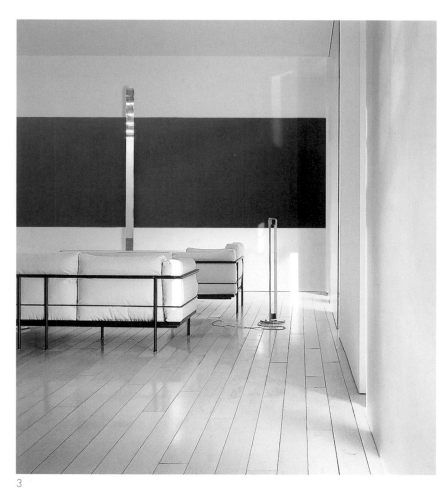

3

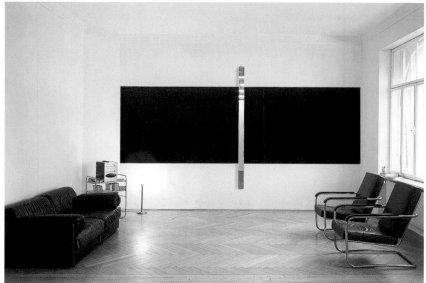

4

143

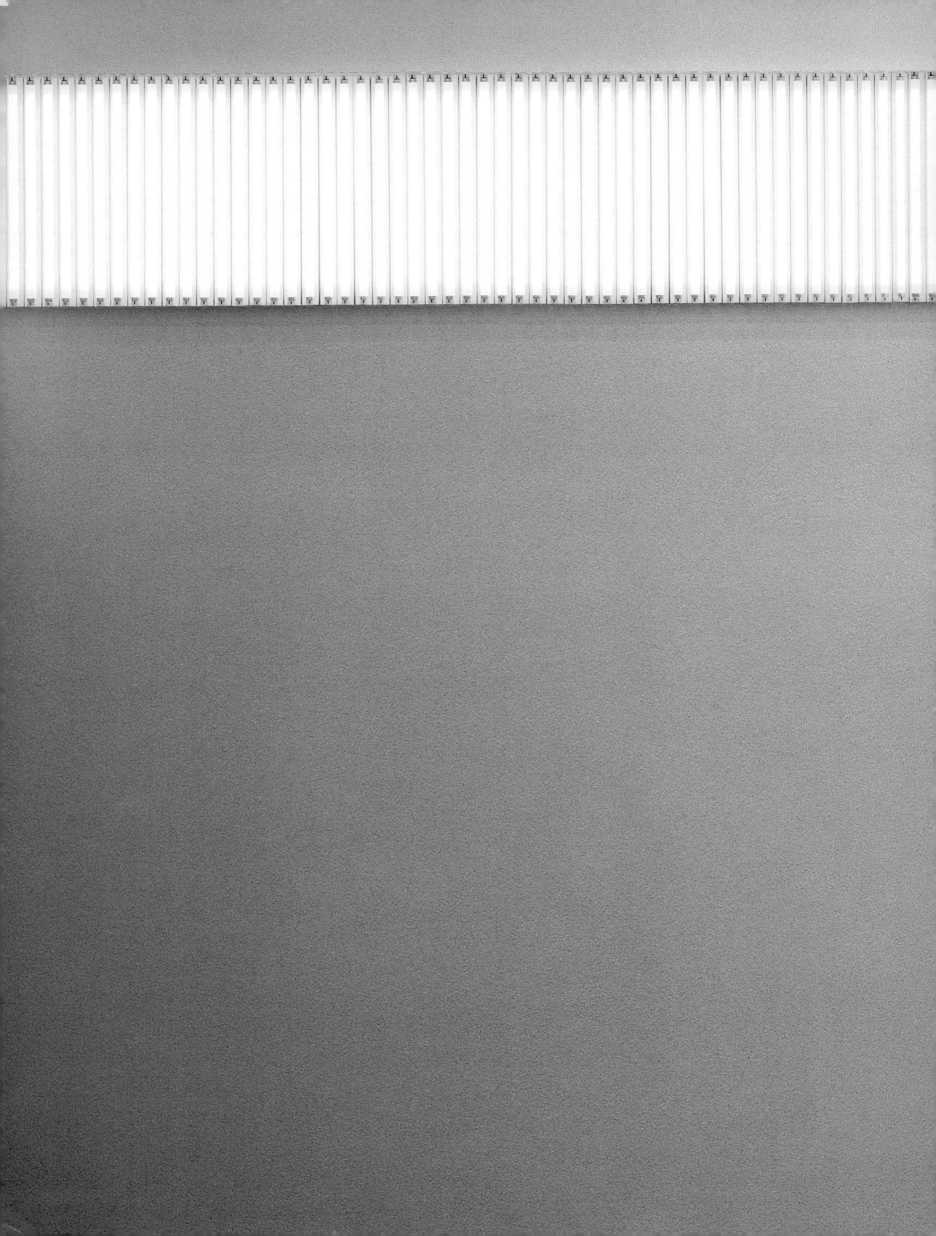

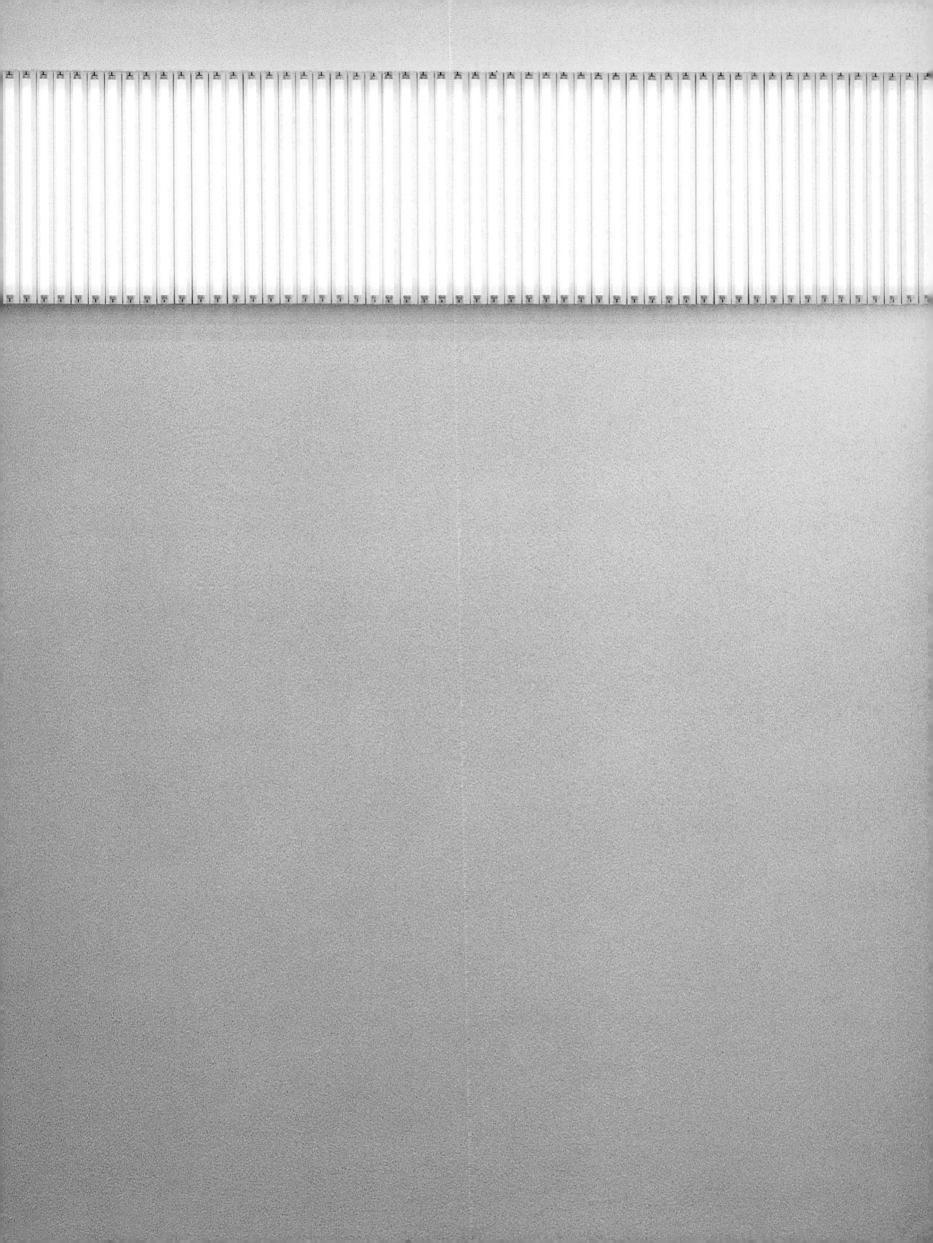

Gerhard Merz

Ohne Titel 1994

Leuchtstoffröhren tageslichtweiß, 46 oder 60 cm, als Fries auf die Länge der Wand montiert. Limitiert auf 6 Installationen. Zertifikat (**1**): Druck mit Text auf Transparentpapier, 42 x 60 cm, signiert und numeriert.

Ausführung:

Leuchtstoffröhren auf die gesamte Länge der Wand als Fries zu montieren (Montageanweisung liegt dem Zertifikat bei). Zur Lichtregulierung kann ein Dimmer eingebaut werden, oder die Lampen sind so zu schalten, daß wahlweise alle Röhren (3) oder jede zweite (2 und 4) leuchtet.
Hinweis: Die Installation der Leuchtkörper muß von einem geprüften Elektriker ausgeführt werden.
Gelieferte Bestandteile: Leuchtkörper mit Röhren Lumilux 11 in der gewünschten Länge und in der für die Wand benötigten Anzahl.

Ohne Titel, 1994
Leuchtstoffröhren tageslichtweiß, 46 oder 60 cm, als Fries auf die Länge der Wand zwischen Oberkante Tür und Decke zu montieren. Limitiert auf 6 Installationen, signiert und numeriert auf diesem Zertifikat.

Ausführung:
Leuchtstoffröhren auf die gesamte Länge der Wand zwischen Oberkante Tür und Decke zu montieren (Montageanweisung liegt dem Zertifikat bei). Zur Lichtregulierung kann ein Dimmer eingebaut werden, oder die Lampen sind so zu schalten, daß wahlweise alle Röhren oder jede zweite leuchtet. Hinweis: Die Installation der Leuchtkörper muß von einem geprüften Elektriker ausgeführt werden. Gelieferte Bestandteile: Leuchtkörper mit Röhren Lumilux 11 in der gewünschten Länge und in der für die Wand benötigten Anzahl.

Untitled, 1994
Fluorescent light fixtures, daylight white, 18" or 24", installed as a freeze along the full length of the wall. Limited to 6 installations, signed and numbered on this certificate.

Installation:
Fluorescent light fixtures to be installed along the length of the wall between door and ceiling according to the certificate. The intensity of light can be moderated by installing a dimmer switch, or by wiring the fixtures to illuminate alternating bulbs. Note: the installation of the fluorescent light requires a licensed electrician. Components provided: Fluorescent light fixtures with Lumilux bulbs in the size chosen and in the quantity needed for the wall.

EDITION SCHELLMANN MÜNCHEN NEW YORK

G E R H A R D M E R Z

1

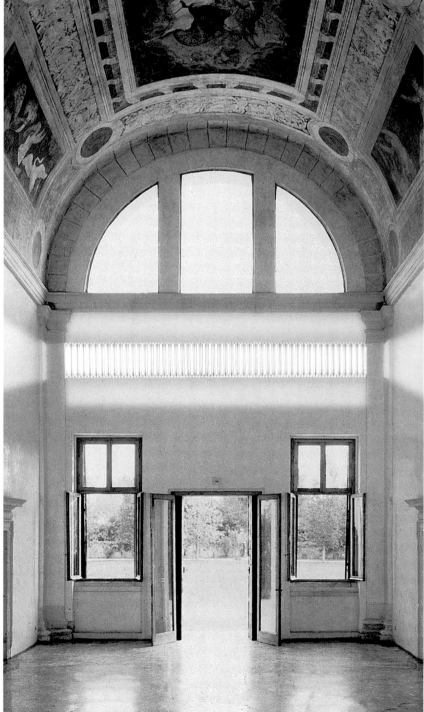

2

Gerhard Merz

Untitled *1994*

Fluorescent light fixtures, daylight white, 18" or 24", installed as a frieze along the full length of the wall.
Limited to 6 installations.
Certificate (1): diagram with instructions, 16½ x 24½", signed and numbered.

Installation:

Fluorescent light fixtures to be installed along the length of the wall as a frieze according to instructions coming with the certificate. The intensity of light can be adjusted by installing a dimmer switch, or by wiring the fixtures to illuminate either all bulbs (3) or alternating bulbs (2, 4).
Note: we recommend installation by a licensed electrician. Components provided: fluorescent light fixtures with Lumilux 11 bulbs in the size chosen and in the quantity needed for the wall.

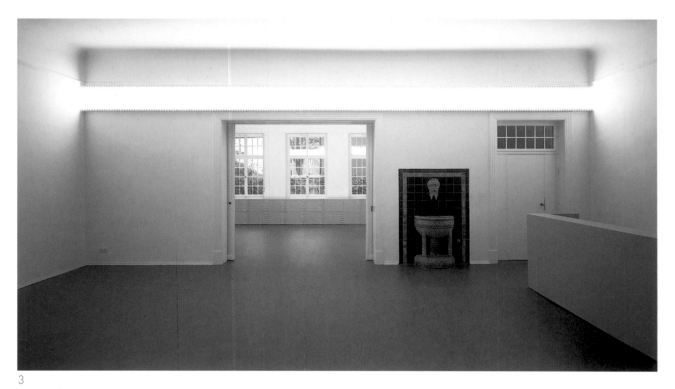

3

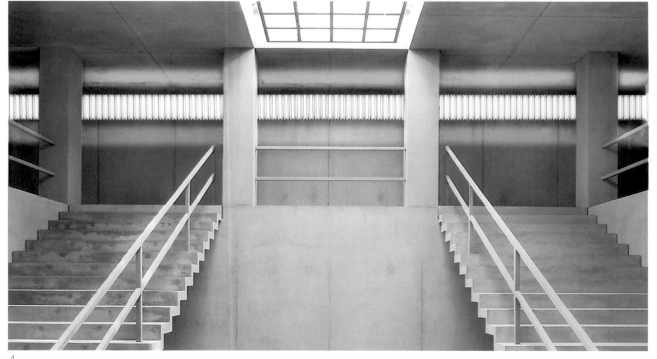

4

Meine Kosmologie ist nicht real, sie ist ein Modell einer Kosmologie. Eine Kosmologie ist ein soziales Phänomen, nicht ein formales, es ist eine Wertordnung, auf die sich Menschen verständigen.[47]

My cosmology is not real, it is a model for a cosmology. A cosmology is a social phenomenon, not a formal one; it is a belief structure, a value structure between people. It's an understanding.[47]

Matt Mullican

Matt Mullican

Geboren 1951 in Santa Monica, Kalifornien, lebt und arbeitet in New York. Der Konzeptkünstler denkt über das Denken nach. Von Beginn an hat er in seinem auf ein Thema gerichteten aber dennoch vielgestaltigen Werk versucht, die Vorgänge unserer Wahrnehmung von Realität zu verstehen. In 25 Jahren hat Mullican ein Lexikon stilisierter Zeichen und Bilder entwickelt, ein reichhaltiges Vokabular, das ebenso persönlich wie allgemein ist. Er hat eine Vielfalt von Strukturen entwickelt, wie Zeichen

unsere Welt organisieren und ihre Systeme beschreiben können.[48] Dem künstlerischen Konzept von Matt Mullican liegt eine eigene Weltsicht zugrunde. Jede Arbeit enthält die komplexe Logik einer universalen Form, in der die Bedeutung des Gesamtkonzeptes aus der symbolischen Bedeutung der jeweiligen auf Sprache basierenden Arbeiten hervorgeht.[49] In Mullicans Kosmologie fungiert Farbe als Organisationssystem, insbesondere repräsentiert rot = Subjektivität, schwarz = Sprache/ Zeichen, gelb = die Welt gestaltet (die Kunst), blau = die Welt ungestaltet (das Unbewußte), grün = die Elemente.

Untitled 1998

Fünf Zeichen, mit Temperafarbe direkt auf die Wand gemalt. Größe und Anordnung variabel. Limitiert auf 15 Ausführungen. Zertifikat (**1**): Siebdruck auf Karton, 42 x 60 cm, signiert und numeriert, und Textblatt.

Ausführung:

Zeichen mit matter Temperafarbe mit Hilfe der gelieferten Schablonen direkt an die Wand zu malen. Die Größe ist frei zu bestimmen, jedoch müssen alle Zeichen gleich groß sein. Sie können in einer waagerechten oder senkrechten Linie oder in jeder anderen Anordnung unter Beachtung der Reihenfolge rot, schwarz, gelb, blau, grün an die Wand gemalt werden. Hinweis: Die Wandarbeit sollte von einem Maler oder Schriftenmaler ausgeführt werden. Gelieferte Bestandteile: Tempera (fünf Farben) und Schablonen in der gewünschten Größe.

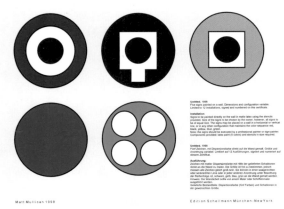

152

Matt Mullican 1998

1

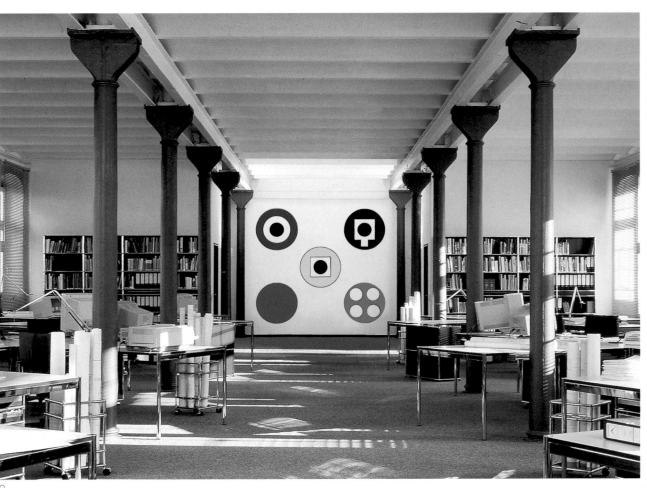

2

Matt Mullican

Born 1951 in Santa Monica, California, lives and works in New York. This conceptual artist thinks about thinking. From the very beginning, through his single-minded (though multifaceted) body of work he has tried to understand the process by which we consider reality. Over the last 25 years Mullican has developed a lexicon of stylized signs and images, a rich vocabulary which is simultaneously personal and generic. He has devised a variety of structures for the signs to organize our world and describe its systems and relationships.[48] Underlying his work is an artistic concept encompassing, in a literal sense, a worldview. Every work, therefore, contains the complex logic of a universal form in which the meaning of the greater concept derives from the symbolic significance of the individual works that are based on language.[49] Color is the organizing principle in Mullican's cosmology, specifically red = subjective, black = language/sign, yellow = world framed (the arts), blue = the world unframed (unconscious), green = elements.

Untitled 1998

Five signs painted on a wall. Dimensions and configuration variable.
Limited to 15 installations.
Certificate (**1**): silkscreen on board, 16 ½ x 23 ½", signed and numbered, and text on paper.

Installation:

Signs to be painted directly on the wall in matte tempera using the stencils provided. Size of the signs to be chosen by the owner, however, all signs to be of equal size. The signs may be placed on a wall in a horizontal or vertical line, or in any other configuration that maintains the color sequence red, black, yellow, blue, green.
Note: we recommend installation by a professional painter or sign-painter.
Components provided: tempera paint (5 colors) and stencils in size required.

153

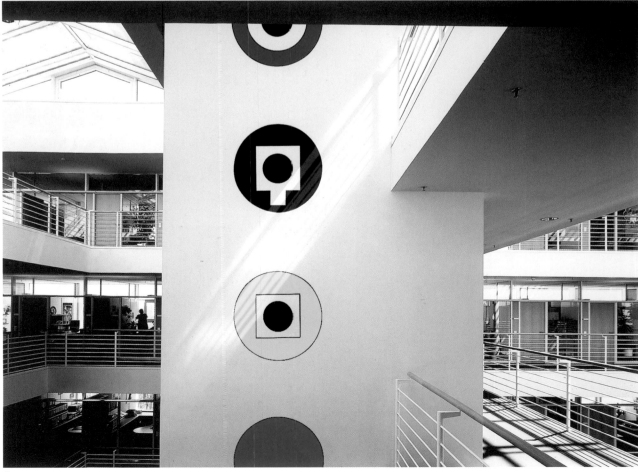

3

In letzter Zeit habe ich mich mit der Entwicklung der Technologie und ihrem Verhältnis zur menschlichen Psyche beschäftigt. Die Entdeckung der Camera obscura im Jahre 1553 faszinierte mich besonders. Sie markiert einen historischen Punkt, der unsere Sicht der Welt nachhaltig verändert hat. Das Grundprinzip, nachgeahmt in den beiden hier gezeigten Arbeiten, beruht auf reflektiertem Licht, das von Gegenständen ausgeht und durch eine Öffnung hindurch auf eine Fläche geworfen wird. Ursprünglich war die Camera obscura einfach nur ein Loch in der Wand eines dunklen Raumes (vgl. Platons Höhlengleichnis); durch das Loch hindurch wurde ein Abbild der Außenwelt auf eine Innenwand geworfen – eine leuchtende, zweidimensionale Echtzeit-Projektion. Alles, was sich außerhalb des Hauses abspielte, erschien im Haus auf einem "Bildschirm" und stellte so den ersten Projektor dar und, wenn man so will, die erste Installation. Man sieht sofort, daß alles, was wir als Medien kennen, auf dieser wunderbaren und einfachen Entdeckung basiert. Dieses System beinhaltet auch die Trennung zwischen wirklicher und mimetischer Erfahrung, zwischen Wirklichkeit und Schein, und erweitert so den bildlichen Erfahrungsbereich, der die menschliche Psyche widerspiegelt. Dieses Schisma ist auch die Basis für die beiden hier gezeigten Videoarbeiten – die fortdauernde Trennung zwischen Natur und ihrer Simulation, die dadurch geschieht, daß Licht durch eine Öffnung strahlt.[50]

154 *Recently I have been exploring the history of technology and its relationship to psychological drives. The development of the Camera Obscura in 1553 fascinated me; it marks a historical crossroads and has forever altered the way we view the world. The basic principle, mimicked in these wall works, involves the casting of reflected light emitted from objects, which then passes through an aperture and is thus focused onto a flat surface. Originally, the Camera Obscura was simply a hole in a wall of a dark room; a replica of the outside world was focused through the hole onto an interior wall in a glowing two-dimensional real-time projection. (One thinks of Plato's cave parable). Whatever occurred outside the house appeared on a "screen" within the house, producing the first projector, and also the first installation. One can easily see that all that we know as media comes from this wonderful and simple system, one that also implies the separation between real experience and mimetic experience, thus opening the semiotic frontier which mirrors the human psyche and its struggles. This schism – the further separation between nature and its simulation, with the passage of light through the aperture – is the basis for these two pieces.[50]*

Tony Oursler

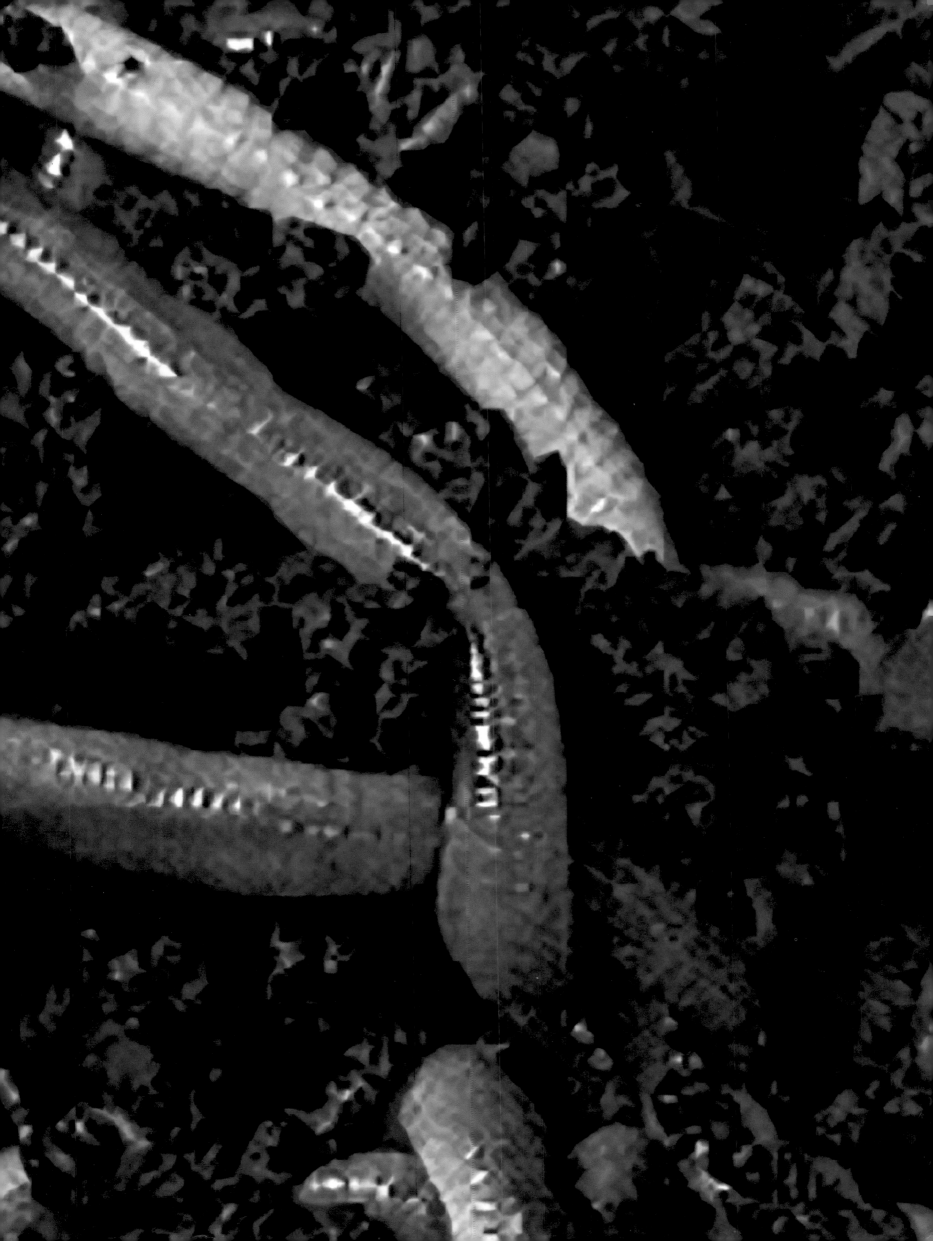

Tony Oursler

Geboren 1957 in New York, lebt und arbeitet in New York. Tony Oursler, bekannt durch seine geistvoll-verschmitzten Videoprojektionen, lotet die verzerrte Bildwelt der populären und der Punk-Kultur aus, Bilder, die unser kollektives Unbewußtes und die Ideologie unserer Zeit ausmachen. Oursler arbeitet mit Installationen, Video, Skulptur und Kombinationen dieser Elemente. Sein Werk ergründet, wie Sex und Gewalt, wie Geschlecht und Macht in Gesellschaft und Kultur wirken.[51]

In den beiden Videoprojektionen *Way of All Flesh* vergrößert Oursler die Mikrokosmen honigsammelnder Bienen und die Erde durchpflügender Regenwürmer in episch-riesige Größenverhältnisse. Dieser dramatische Wechsel der Perspektive zwingt den Betrachter, die faszinierenden und immer wiederkehrenden Grundvorgänge der Natur bewußt wahrzunehmen.

The Way of All Flesh (Air) 1998

Videoprojektion auf die Wand. Maße variabel. Limitiert auf 9 Exemplare. Zertifikat: Computerausdruck mit Text auf Papier, 29,7 x 42 cm, signiert und numeriert.

The Way of All Flesh (Sugar) 1998

Videoprojektion auf die Wand. Maße variabel. Limitiert auf 9 Exemplare. Zertifikat: Computerausdruck mit Text auf Papier, 29,7 x 42 cm, signiert und numeriert.

Ausführung:

Das Video wird mit einem LCD-Projektor an eine Wand projiziert. Eine Tür oder ein sonstiges Hindernis kann in die Projektionsfläche integriert werden, solange das Bild lesbar bleibt. Um eine optimale Auflösung und Helligkeit des Bildes zu erreichen, gibt der Künstler individuelle Hinweise für die Wahl des Projektors und seines Abstandes von der Wand, abhängig von der Größe der Wand und der Helligkeit des Raumes. Gelieferte Bestandteile: VHS Videoband, Videorecorder und LCD Projektor (Modell je nach den Gegebenheiten des Raumes).

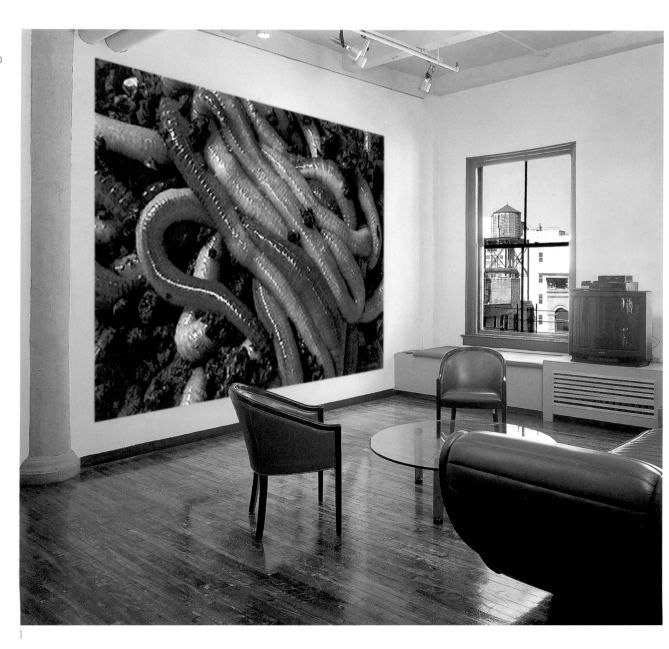

1

Tony Oursler

Born 1957 in New York, lives and works in New York. Best known for his sly, often humorous video projections, Tony Oursler plumbs popular and punk culture for the twisted icons that structure our collective unconscious and the ideology of our time. Working in installations, video, sculpture, and a variety of mixed media, Oursler's work delves deeply into the question of how the twinned forces of sex and violence, gender and power, function in our culture.[51]

In the two Way of All Flesh projections, Oursler enlarges to epic proportions the microcosmic worlds of a bee gathering pollen and earthworms churning soil. The dramatic shift in scale forces the viewer to take notice of two of the frenetic activities which comprise the essential, unceasing industry of nature.

The Way of All Flesh (Air) 1998

Video projection on the wall. Installation size variable. Limited to an edition of 9. Certificate: computer printout and text on paper, 11½ x 16½", signed and numbered.

The Way of All Flesh (Sugar) 1998

Video projection on the wall. Installation size variable. Limited to an edition of 9. Certificate: computer printout and text on paper, 11½ x 16½", signed and numbered.

Installation:

The video is to be projected by a LCD projector upon a wall. If there is a door or any other obstacle, the video may be projected upon these obstacles as long as the images of the video remain visible. To ensure that the video's optimal resolution and brightness is achieved, the artist will provide guidelines for the appropriate choice of projector and its placement within the room, based on the size of the wall and the room's proportions and lighting. Components provided: 30 minute VHS videotape, VCR, LCD projector (model dependent upon range and illumination required).

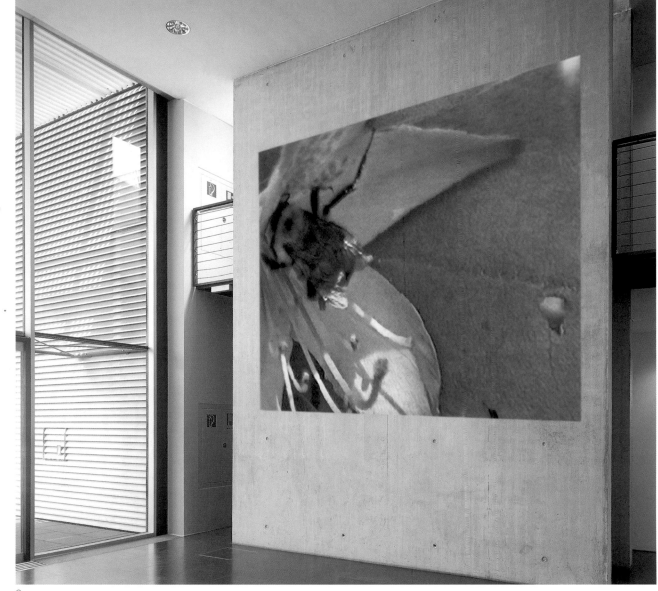

"Wir nehmen heute nicht mehr am Drama der Entfremdung, sondern an der Ekstase der Kommunikation teil." (Jean Baudrillard)[52]

Licht ist die effektivste Form der Übertragung von Information.[53]

Ich schaue mir nie Videos an.[54]

"Today we are no longer participating in the drama of alienation, but in the ecstasy of communication." (Jean Baudrillard)[52]

Light is the most efficient form of information transmission.[53]

I never watch video.[54]

Nam June Paik

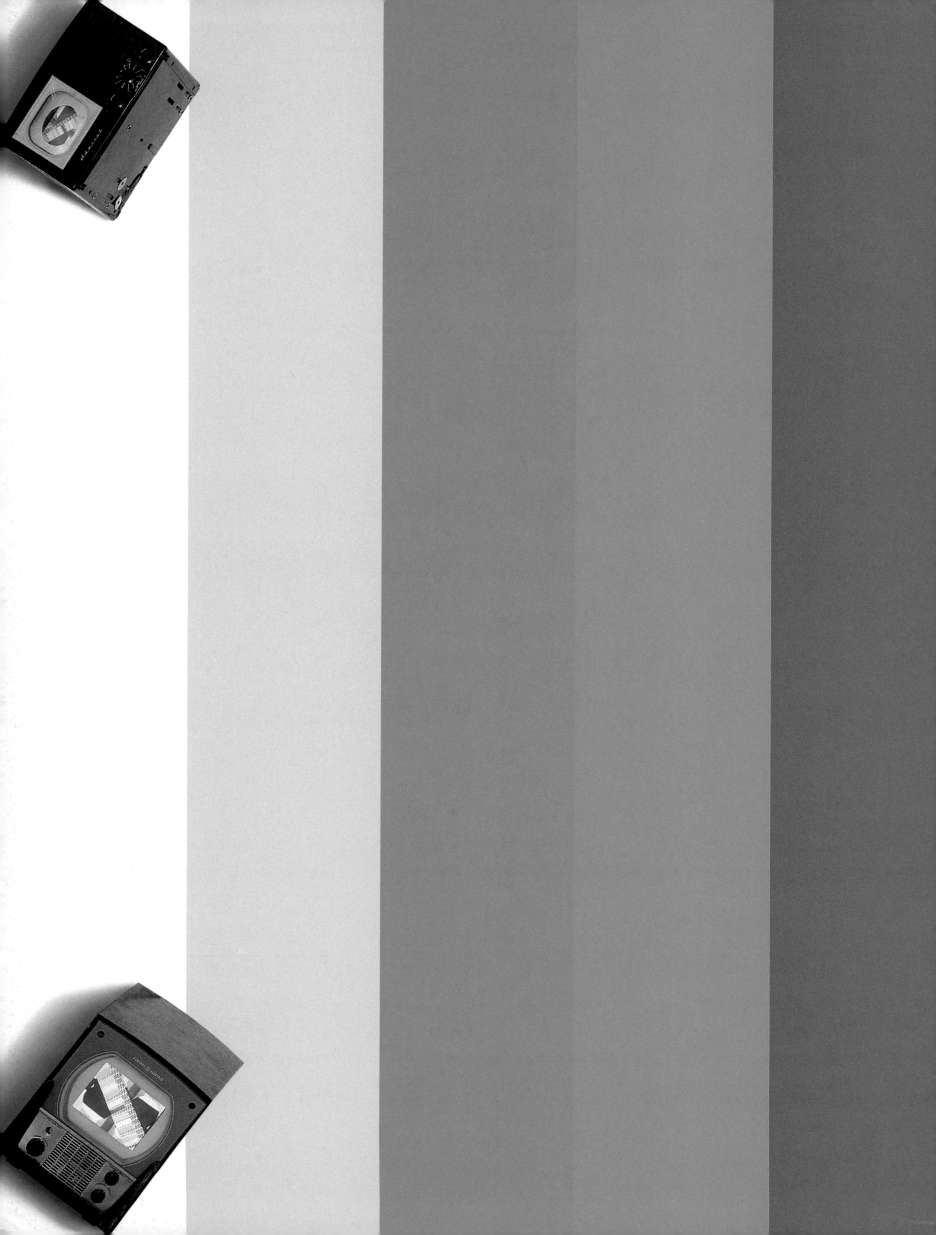

Nam June Paik

Geboren 1932 in Seoul (Korea), lebt und arbeitet in New York. Er gilt als der "Vater der Video-kunst" und hat die Entwicklung des Mediums zu einer eigenständigen Kunstform entscheidend geprägt. Der Musiker, Philosoph, Fernseh-, Video- und Satellitenkünstler, der sich erklärtermaßen auf Marx, Schönberg, Cage und Beuys beruft, realisiert seine Projekte und Video-Installationen als kosmopolitischer Nomade weltweit. Spektakuläre Werke wie die globale Satellitenüber-

tragung von *Good Morning Mr. Orwell* am Neujahrstag 1984 und der Medienturm aus über 1000 Monitoren anläßlich der Olympischen Spiele 1988 in Seoul haben ihn bei einem großen Publikum bekannt gemacht und zeigen sein untrügliches Gespür für die Möglichkeiten der neuen elektronischen Medien und ihrer Bedeutung für die Weltzivilisation.[55]
In der Wandarbeit *I Never Read Wittgenstein* zitieren die sieben Farbstreifen das Farbtestbild des US-Fernsehens; in den Fernsehgeräten läuft synchron ein Video, das diese Farbstreifen variiert und mit anderen Bildern aus Paiks visuellem Vokabular versetzt.

I Never Read Wittgenstein 1998

Wandmalerei in sieben Farben und vier Fernsehgeräte (Gehäuse aus den 30er bis 50er Jahren), auf deren Bildschirmen das Video *Color Bar Theme and Variations* läuft. Fabrikate und Maße der Geräte unterschiedlich; Gesamtmaße der Installation je nach Wand.
Limitiert auf 12 Installationen.
Zertifikat: Text auf Papier, 28 x 21,5 cm, signiert und numeriert.

Ausführung:

Die Wand ist mit mindestens sieben Farbstreifen, die die gesamte Wand ausfüllen, zu bemalen. Die Streifen sind in der Breite so zu wählen (min. 30 cm, max. 60 cm), daß nur ganze Streifen entstehen. Die Wand der Ausführung muß also mindestens 210 cm breit sein. Ist sie breiter, werden die Streifen breiter und/ oder es werden rechts so viele Streifen (beginnend wieder mit weiß, gelb etc.) hinzugefügt, bis die ganze Wand bedeckt ist.
Die vier TV-Geräte sind diagonal in den vier Wandecken anzubringen. Liegt auf der Wand ein Hindernis, z.B. Tür oder Fenster, ist dieses entweder ebenfalls mit Streifen zu bemalen oder auszusparen; liegt ein Hindernis auf einer Wandecke, so ist das TV-Gerät an der nächstmöglichen Stelle zu installieren.
Hinweis: Die Wandarbeit sollte von professionellen Handwerkern (Maler und TV-Elektriker) ausgeführt werden.
Gelieferte Bestandteile: Wandfarben (Dispersion, sieben Farben), vier Fernsehgeräte (unterschiedlich innerhalb der Auflage), Videoplayer (LD bzw. DVD) und Video *Color Bar Theme and Variations*, 1998, von Nam June Paik in Zusammenarbeit mit Daniel Hartnett (**3**).

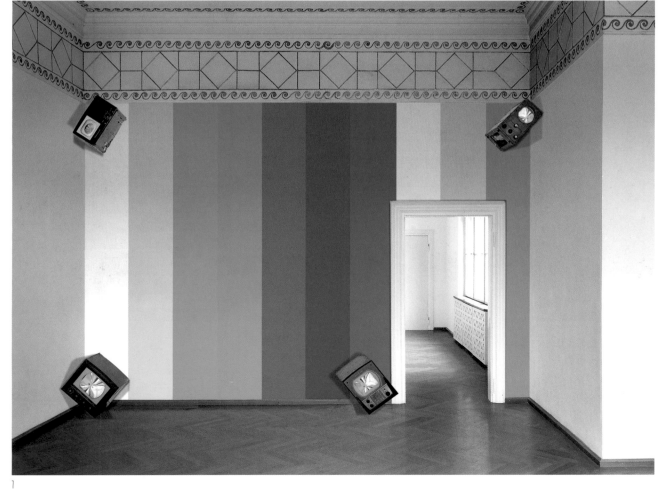

1

Nam June Paik

I Never Read Wittgenstein *1998*

Installation:

Born 1932 in Seoul, Korea, lives and works in New York. Nam June Paik works in many media – including sculpture, performance, music and television – and is a pioneer in the field of video art. Paik is based in New York but realizes his projects and video installations globally. Spectacular works like the worldwide satellite broadcast of Good Morning Mr. Orwell on New Year's 1984 and the Medle Tower of over a thousand monitors built for the Seoul Olympics in 1988 have made Paik famous worldwide, and show his unmistakeable knack for taking advantage of the opportunities afforded by new electronic media and their significance for global civilization.[55]

In the wall work I Never Read Wittgenstein, color bars quote the test pattern of US television. A videotape created by Paik especially for this project varying the color bar theme and mixing it with other images out of Paik's visual vocabulary runs synchronously on the four televisions.

Wall painting in seven colors with four televisions (casings dating from the 30s to 50s) playing the video Color Bar Theme and Variations.
Televisions vary in model and size; installation size according to the wall.
Limited to 12 installations.
Certificate: text on paper, 11 x 8 1/2 ", signed and numbered.

The wall work is to be painted in equal-size color bars, in seven alternating colors. The width of the bars is calculated by dividing the length of the wall into equal segments between 12 and 24" wide. Accordingly, the wall must be 84" minimum. If the width of the wall requires more than seven bars total, more bars must be added on the right, maintaining the same sequence (white, yellow etc.) until the wall is entirely filled. The televisions are to be installed diagonally in the four corners of the wall. If there is a door or window within the wall, it may be left unpainted; if there is an obstacle in the corner of the wall, the television moves to the nearest adjacent spot.
Note: we recommend installation by professional craftspersons (painter and electrician). Components provided: latex paint in seven colors and four televisions (all different within the edition), video player (laserdisc or DVD), and video Color Bar Theme and Variations, 1998 by Nam June Paik in collaboration with Daniel Hartnett (3).

167

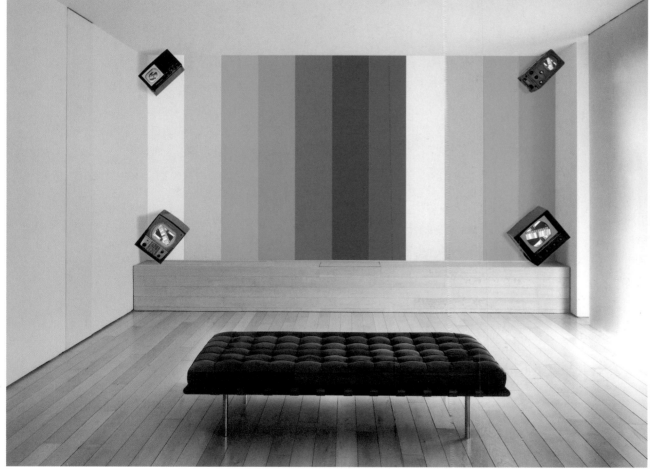

2

3

Nam June Paik

TV Tulip (Computerized One Hundred Flowers)
1998

Computererzeugte Iris prints (100 verschiedene Motive) an die Wand tapeziert und eine Fernsehkommode. Bilder je 32 x 42 cm, Fabrikat und Maße der Fernsehkommode unterschiedlich (Modelle aus den 30er bis 50er Jahren); Gesamtmaße der Installation je nach Wand. Limitiert auf 15 Installationen. Zertifikat (**1**): Text auf Papier, 28 x 21,5 cm, signiert und numeriert.

Ausführung:

Bilder nebeneinander in beliebiger Reihenfolge an die Wand zu tapezieren, so daß die Wand vollständig bedeckt ist; wenn erforderlich, Bilder an den Wandenden beschneiden. Fernsehkommode, ausgerüstet mit modernem TV-Gerät, auf dem Boden vor der Wand zu plazieren und an das Fernsehnetz anzuschließen. Hinweis: Das Kleben der Bilder auf die Wand sollte von einem Tapezierer ausgeführt werden. Gelieferte Bestandteile: Computerbilder in der für die Wand benötigten Anzahl und Fernsehkommode mit moderner TV-Technik (**4**).

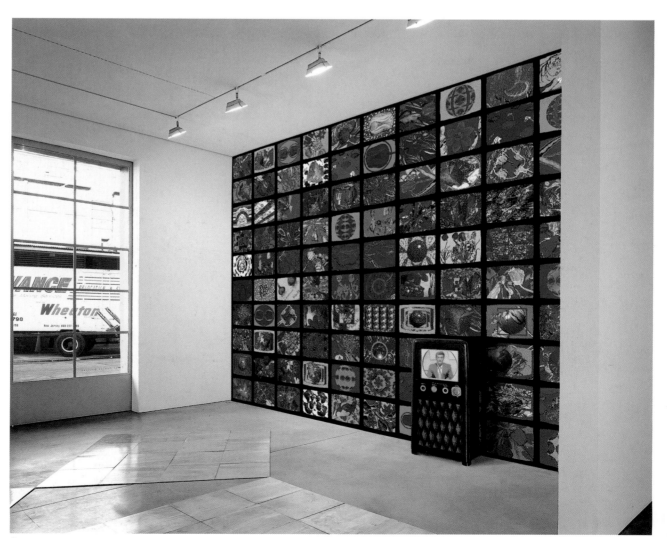

1

2

Nam June Paik

TV Tulip (Computerized One Hundred Flowers)
1998

Iris prints (100 different images) affixed to the wall and antique television console. Prints 12 ½ x 15 ½" each, televisions vary in model (dating from the 30s to 50s) and dimensions, installation size according to the wall. Limited to 15 installations. Certificate (**1**): text on paper, 11 x 8 ½", signed and numbered.

Installation:

Installation prints to be affixed directly to a wall to cover it entirely, aligned in rows in any sequence desired. Prints may be cropped if necessary. Television console may be placed anywhere against the wall, and tuned to any broadcast channel. Note: we recommend installation by a wallpaper hanger. Components provided: installation prints in quantity needed to cover the wall and antique television console equipped with contemporary television (**4**).

171

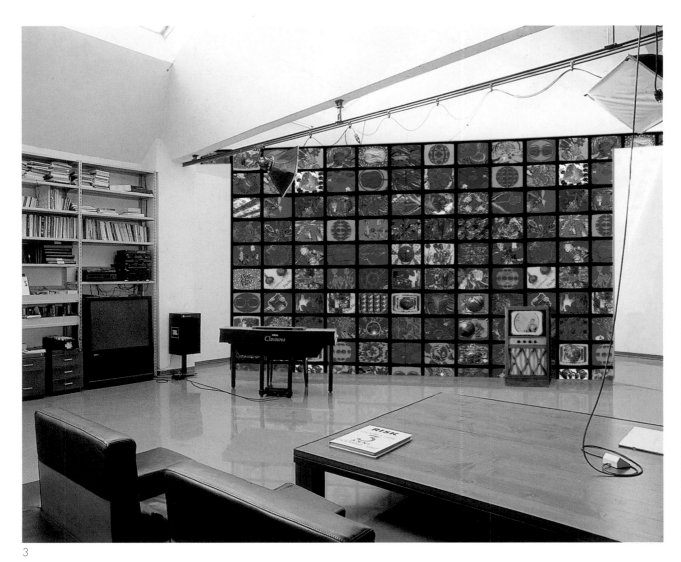

3

4

Meine ganze Arbeit dreht sich um ein dem Bild innewohnendes Diaphragma: gleich einem Spiegel, der diejenigen Erscheinungen widerspiegelt und offenbart, die ihn als Spiegel konstituieren.[56]

All my work revolves around a membrane implicit in the image – like an ideal mirror that reflects and reveals the appearances which constitute it.[56]

Giulio Paolini

Giulio Paolini

Geboren 1940 in Genua, lebt und arbeitet in Turin. Giulio Paolini, einer der Hauptvertreter der Arte Povera, beschäftigt sich mit der Methodologie von Kunst und ihrer Darstellung. Häufig analysiert er in seinen Arbeiten alte "Kunst-Systeme" – etwa eine Renaissance-Perspektive, den Dekor einer Barockfassade oder die formalen Elemente der klassischen Griechischen Kunst – und zerlegt sie, ohne die Schönheit des Originals zu verlieren.[57]
Die aus diesem Prozeß resultierenden Objekte und Installationen untersuchen lyrisch und poetisch die Grundprinzipien des Sehens und der Wahrnehmung.[58]

Vis-à-vis (Hera) 1992

Zwei halbe Gipsabgüsse auf Sockel, an eine Wand plaziert. Gesamtmaße: 169 x 90 x 15 cm. Limitiert auf 10 Exemplare. Zertifikat (**1**): Bleistiftzeichnung mit montiertem Photo, 50 x 65 cm, signiert und numeriert.

Ausführung:

Beide Teile sind mit einem Abstand von 35 cm voneinander gegen eine weiß gestrichene Wand aufzustellen.
Gelieferte Arbeit: Zwei halbe Gipsbüsten, je 40 x 20 x 10 cm; zwei Podeste aus weiß gestrichener Spanplatte, je 130 x 27 x 15 cm.

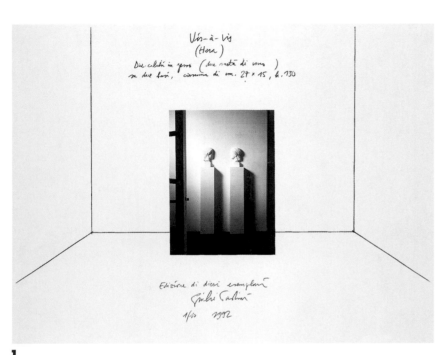

176

1

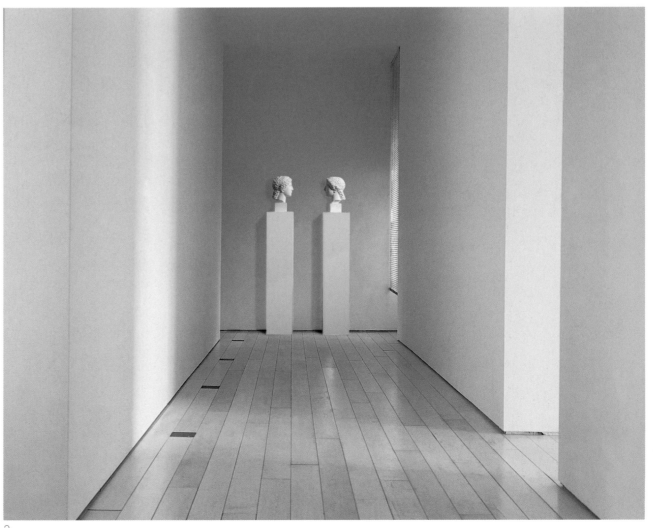

2

Giulio Paolini

Born 1940 in Genoa, lives and works in Turin. Giulio Paolini, one of the key figures of the Arte Povera movement, works with the methodology of art and its presentation. He often dismantles older "art systems" in his work – perhaps taking Renaissance perspective, the rhythms of a Baroque facade or formal elements of classical Greek art – and subverts them without losing the beauty of the original references.[57] The resulting mixed-media or installation pieces always examine the fundamental principles of seeing and being seen in a lyrical, poetic fashion.[58]

Vis-à-vis (Hera) 1992

Two halves of a plaster bust on painted wooden pedestals, installed against a wall painted white. Installation size 66 ½ x 35 ½ x 6".
Limited to an edition of 10.
Certificate (1): drawing in pencil with collaged photograph, 19 ¾ x 25 ½", signed and numbered.

Installation:

Busts on pedestals to be placed 13 ¾" apart against a wall painted white.
Components provided: two halves of a plaster bust, 15 ¾ x 8 x 4" each, and two painted wooden pedestals, 51 x 10 ½ x 6" each.

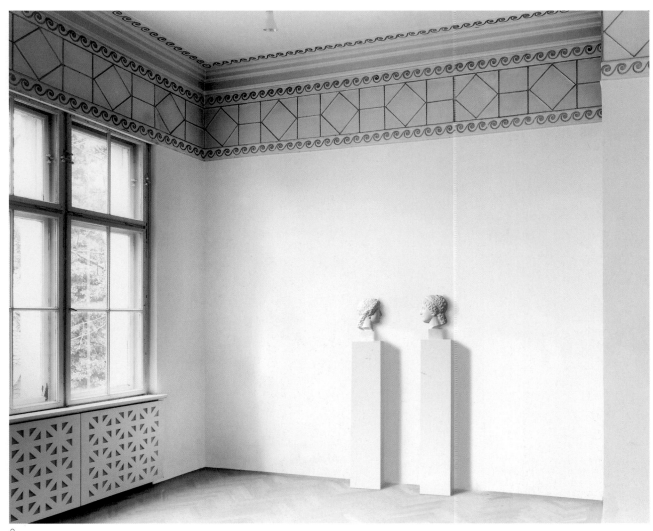

Michelangelo Pistoletto

Michelangelo Pistoletto

Geboren 1933 in Biella (Italien), lebt und arbeitet in Turin und Wien. Als Pistoletto, einer der Hauptvertreter der Arte Povera, 1961 das erste "Spiegel-Bild" erdachte, bedeutete dies ein in der Malerei bis dahin nicht erreichtes Moment der Gleichzeitigkeit, das sich zwischen der gemalten Figur oder Farbfläche einerseits und dem Spiegelbild des Betrachters und des Raumes, in dem er sich befindet, andererseits vollzog. Das Bild wird zur Membrane, an welcher Eines und Vieles, Vergangenheit und Zukunft, und jedes andere erdenkliche Gegensatzpaar ihren Ausgleich finden.[60]

Zu der Wandarbeit *Affresco-5* sagt Pistoletto: "Ein einzelner Spiegel, in mehrere Teile geteilt, reproduziert sich selbst und dehnt sich im Raum aus, ähnlich dem biologischen Prinzip der Zellteilung. Diese Arbeit zieht eine Parallele zwischen der Virtualität des Spiegels und der Realität des Lebens".[61]

Affresco - 5 1998

Fünf Spiegelfragmente auf farbig bemalter Wand (gelb, grün, orange, blau, rot oder grau). Maße und Formen der Spiegelfragmente unterschiedlich, zusammengefügt 150 x 150 cm (**1**); Gesamtmaße der Arbeit je nach Wand.
Limitiert auf 12 Installationen.
Zertifikat: Druck mit Collage, 29,7 x 42 cm, signiert und numeriert.

Ausführung:

Die Wand ist in dem im Zertifikat angegebenen Farbton (Dispersion) zu streichen. Türen oder Fenster oder sonstige Hindernisse bleiben ausgespart. Die Spiegelfragmente sind entsprechend der Zeichnung im Zertifikat in den vier Ecken und in der Mitte der Wand zu plazieren. Liegt ein Hindernis auf der Stelle der Wand, wo ein Spiegel zu plazieren wäre, ist der Spiegel an der nächstmöglichen Stelle anzubringen.
Hinweis: Wir empfehlen die Installation durch geeignete Handwerker.
Gelieferte Bestandteile: Wandfarbe im gewählten Farbton und fünf Spiegelfragmente aus Acrylglas, 4 mm stark, in Holzkiste.

182

1

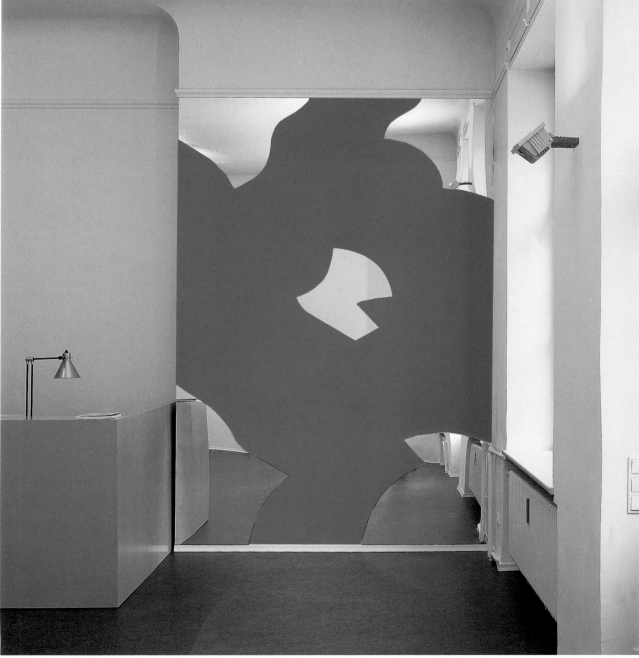

2

Michelangelo Pistoletto

Born 1933 in Biella (Italy), lives and works in Turin and Vienna. When Pistoletto, one of the main figures of Arte Povera, conceived and realized the first mirror painting in 1961, he created a moment of simultaneity – between the painted surface, the viewer, and the viewer's reflection – never before achieved in painting. The mirror painting becomes the equilibrating membrane between unity and multiplicity, past and future, and any other complementary opposites.[60]

About his wall work Affresco-5 shown here, Pistoletto says: "A single mirror divided into several parts replicates itself and expands in space in a process similar to cell division. This wall work makes a parallel between the virtuality of the mirror and the reality of biology".[61]

Affresco - 5 1998

Five mirror fragments mounted on a wall painted in one of six colors (yellow, green, orange, blue, red or gray). Mirror fragments irregularly-shaped and sized; mirror is 59 x 59" before fragmentation (1); installation size according to the wall. Limited to 12 installations. Certificate: printing with collage, 11¾ x 16½", signed and numbered.

Installation:

Wall to be painted in chosen color. Doors, windows or other obstacles remain unpainted. The mirror pieces are to be mounted in the four corners and in the center of the wall according to the configuration given in the certificate. If there is an obstacle where a mirror fragment should be placed, the fragment must move to the nearest adjacent spot. Note: we recommend installation by skilled craftspersons. Components provided: latex paint in chosen color and five pieces of acrylic mirror in a wooden crate.

183

3

Das Besondere an der Kunst ist, daß man gewöhnliche Dinge nehmen und durch neue Zusammenstellung ihre Gewöhnlichkeit transzendieren kann.[62]

The specialness of art is ... about the power to take ordinary things and by arranging them to produce a transcendence of their ordinariness.[62]

184

Julian Schnabel

Julian Schnabel

Geboren 1951 in New York, lebt und arbeitet in New York. Durch den Aufeinanderprall gegensätzlicher Elemente erhält Schnabels Werk eine explosive Kraft, ein vitales Gefühl von Bewegung und Spannung. Schnabel fürchtet Widersprüche nicht; seine Assemblagen gegensätzlicher Bildelemente sind irgendwo zwischen Dissonanz und Poesie angesiedelt, es sind Experimente, mit denen der Künstler die Grenzen der Malerei erforscht.

In all den fragilen und sich ständig wandelnden Landschaften, die er kreiert, bleiben Schnabels eigenständige Handschrift und seine Haltung, die immer wieder Fragen aufwirft, unverändert. Wie ein Archäologe ist er fasziniert von Fragmenten und Rückständen; er verwandelt sie mit lyrischer Ausdruckskraft und malerischer Zügellosigkeit. Er feiert die Überbleibsel menschlicher Existenz, indem er etwa altertümliche architektonische Elemente, ein photographisches Porträt, oder prunkvolle barocke Versatzstücke in großer malerischer Geste und prächtiger Farbigkeit auf die Bildfläche bringt. Dramatik und Gewalt durchziehen Schnabels Werk, verkörpert oft durch farbige Abdrücke, die sich in seinen Bildern finden: handgreifliche Spuren eines farbgetränkten Lappens, der gegen die Bildfläche geworfen wurde, wie hier in *Lost Relative*.

Lost Relative 1998

Wandmalerei (Mischtechnik). Siebdruck auf transparenten Folien, gerahmtes Photo, Siebdruck und Bleistiftlinie auf der Wand. Folien je 65 x 134 cm, Photo 41 x 30,5 cm, Wand-Siebdruck 104 x 46 cm; Gesamtmaße der Installation variabel.
Limitiert auf 12 Ausführungen.
Zertifikat: Farbphoto 20 x 25 cm, signiert und numeriert.

Ausführung:

Die Anordnung der einzelnen Elemente kann variiert werden. Die beiden selbstklebenden Folien und das Bild sind an die Wand anzubringen. Die malerische Form ist im Siebdruck (mit Hilfe eines gelieferten Siebdruckfilms) direkt auf die Wand zu drucken; die Bleistiftlinie ist vom unteren Teil dieser Form bis zum Boden zu zeichnen.
Hinweis: Die Arbeit ist von einem Siebdrucker auszuführen. Gelieferte Bestandteile bzw. Hilfsmittel: Zwei selbstklebende Folien, gerahmtes Photo (von Luigi Ontani), Siebdruckfilm und Farbmuster.

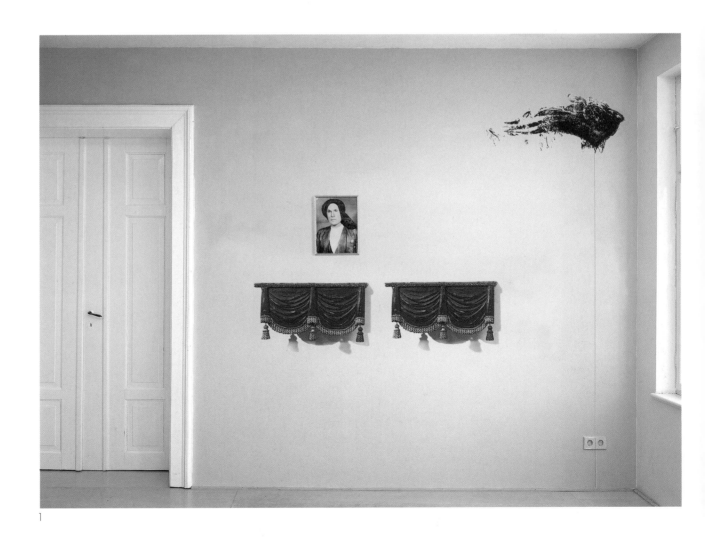

1

Julian Schnabel

Born 1951 in New York, lives and works in New York. Schnabel's work is suffused with a volatility arising from the clash of dichotomous elements; contradictory aspects live as uneasy neighbors. Powered by this sense of imminent combustion, Schnabel's poetic dissonance traverses unstable frontiers, fearless in the face of confrontation and experimentation. Throughout the unstable and shifting landscape he creates, Schnabel's distinctive hand and voice remain constant, his attitude questioning. Schnabel's archeological fascination with fragments and remnants is tempered by lyric expressiveness and painterly extravagance. He celebrates the residue of human existence, arranging antiquated architectural elements, a photographic portrait and primitive shards in a baroque theater of expansive gestures and luxurious color. Drama and violence further pervade Schnabel's work via the marks he makes: the viewer often finds palpable evidence of the trajectory of paint-soaked rags thrown against a surface, as in his Lost Relative.

Lost Relative 1998

Multimedia wall painting. Photosilkscreen on acetate, framed photograph, silkscreen, and pencil line on the wall. Acetates 25 ½ x 52 ⅜" ea., photograph 16 x 12", silkscreen mark 41 x 18"; overall installation size variable.
Limited to 12 installations.
Certificate: color photo 8 x 10", signed and numbered.

Installation:

Configuration of the elements may vary. The two self-adhesive acetates and the photograph are to be placed on the wall. The painterly mark is to be silkscreened directly on the wall using the film provided, and a pencil line is to be drawn from the bottom of the mark to the floor.
Note: the installation requires a silkscreen printer.
Components provided: two self-adhesive acetates, framed photograph by Luigi Ontani, and silkscreen film with ink sample.

189

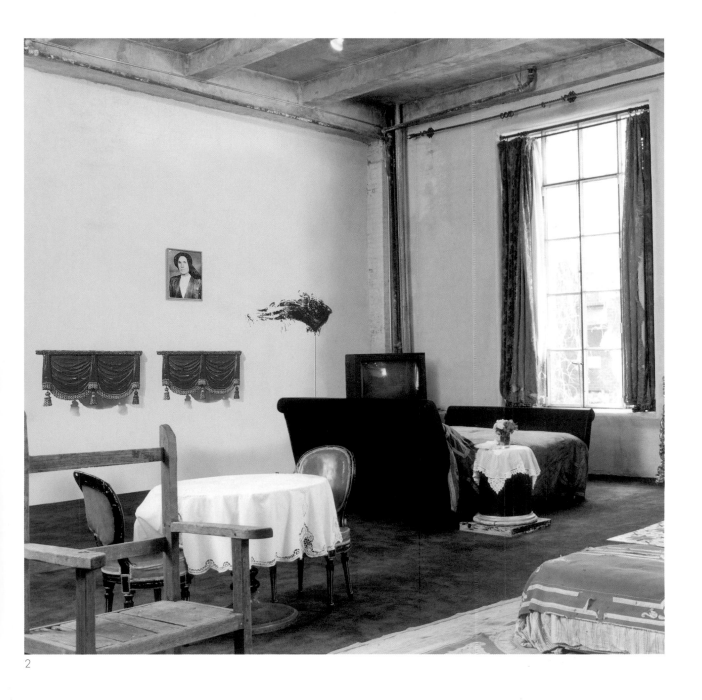

2

Niemand hat je wirklich eines meiner Bilder gesehen bis ich sie produziert habe, und doch hat man irgendwie das merkwürdige Gefühl, sie wiederzuerkennen.[64]

Ich finde, daß Schönheit so viel mehr beinhaltet als das, was wir gewöhnlich für schön halten. Auch Dinge, die anzuschauen oder über die nachzudenken gemeinhin nicht als erfreulich gilt, können doch sehr interessant sein. Ich denke, daß die Dinge, die ich mache, auf ihre eigene Art schön sind. Sie entsprechen nur einem anderen Empfinden.[65]

No one had ever literally seen any of my images until they were produced, and yet one felt the gnawing of recognition upon viewing them.[64]

I think there's so much more to beauty than what we traditionally think of as beautiful. Things that are not considered to be pleasant to look at or think about can be just as interesting. I think the things I make are beautiful in their own way. It's just a different sensibility.[65]

Cindy Sherman

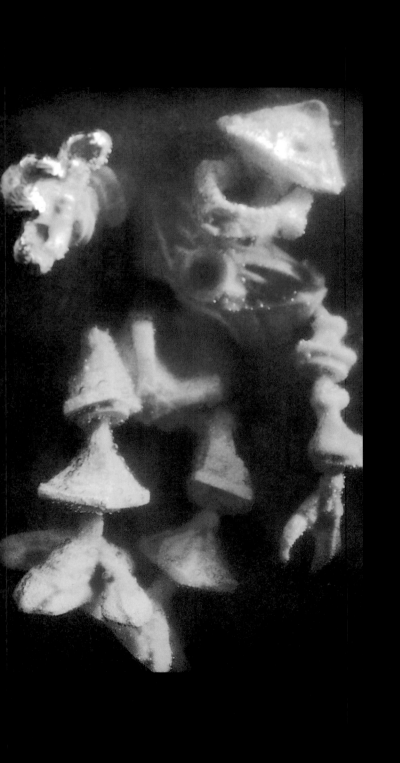

Cindy Sherman

Geboren 1954 in New Jersey, lebt und arbeitet in New York. Gepriesen als eine der wichtigsten Künstler ihrer Generation, untersucht Cindy Sherman in ihren Photoarbeiten Wesen und Wirkung von Darstellung, deren Manipulation ein fundamentales Phänomen in unserer bildorientierten Gesellschaft ist, gleichzeitig aber unsichtbar zu sein scheint.

Ebenso sind die Themen, die sie sich vornimmt – von Fragen der Identität in ihren frühen *Untitled Film Stills* bis zu den eher grotesken neueren Arbeiten – so allgegenwärtig in der aktuellen Kunst, daß sie kaum hinterfragt werden. Mit einem fast unheimlichen Gespür für die Probleme unserer Kultur ist Cindy Sherman immer einen Schritt voraus, indem sie uns einen Spiegel unserer Ängste, Wünsche und Obsessionen vorhält.[66]

Untitled 1993

Farbdia in Lichtkasten, eingebaut in die Wand. Lichtkasten 155 x 100 x 8,5 cm. Limitiert auf 15 Exemplare. Zertifikat: Etikett rückseitig auf dem Lichtkasten, signiert und numeriert.

Ausführung:

In eine Wand einzubauen, Kasten verdeckt. Hinweis: Wir empfehlen Einbau durch einen Trockenbauer. Gelieferte Bestandteile: Lichtkasten, weiß, mit Großdia. 220 oder 110 Volt.

194

1

2

Cindy Sherman

Born 1954 in New Jersey, lives and works in New York. Hailed as one of the most important artists of her generation, Sherman explores the nature of representation, the manipulations of which are so fundamental to our image-based society they escape detection. Similarly, the themes she undertakes in her photo-based works – from the identity issues of the early Untitled Film Stills to her more grotesque recent manifestations – are so ubiquitous in current art that they are taken for granted. With an almost uncanny sense of our culture's concerns, Sherman is always one step ahead, providing a mirror of our fears, expectations, and obsessions.[66]

Untitled 1993

Color transparency in light box, built into a wall.
Light box 61 x 39 ½ x 3 ¼".
Limited to an edition of 15.
Certificate: label on verso of the light box, signed and numbered.

Installation:

Light box to be built into a wall with its frame concealed.
Note: we recommend installation by a drywall contractor.
Components provided: light box (220 or 110 volt) with transparency.

In meiner Arbeit geht es mir um die sozialen Bezüge von Gegenständen und die poetisch-spielerischen Möglichkeiten, die bei ihrem Aufeinandertreffen sichtbar werden. Ich präsentiere Gegenstände wie sie sind, wobei mein Interesse der Auswahl gilt. Ich stelle ihre möglichen Bedeutungen in Frage, indem ich unterschiedliche Objekte einander gegenüberstelle und den Zufall bei der Arbeit mitwirken lasse.[67]

In my work I focus on the social interaction with objects and the poetic games which may result from their encounters. The attention shifts from the Duchampian myth of the "readymade" as an object of total artistic authority to the more relativist norms of our rituals with objects. I present objects as they are, focusing on choice. I question the possibility of meaning in the juxtaposition of heterogeneous objects, allowing chance to play a role in the development of a work.[67]

Haim Steinbach

big
brown
bag

Haim Steinbach

Geboren 1944 in Israel, lebt und arbeitet in New York. Steinbach wurde dadurch bekannt, daß er Objekte, die er dem täglichen Leben entnommen hatte, auf meist selbst entworfenen Wandborden ausstellte. Im Laufe der Jahre hat er dann Slogans aus Werbetexten gesammelt, die er in Zeitungen und Zeitschriften fand. Seine Arbeit mit diesen Slogans faßt die Typologie der Bilder unserer Umgangssprache ins Auge – Sprichwörter und Redewendungen, die oft eine lange Geschichte haben.

"Die Arbeit mit Slogans ermöglicht ein Spiel mit Klassifikation, Auswahl und Zusammenstellung, nicht unähnlich der Beschäftigung eines Schmetterlingssammlers. Ich wähle die markantesten Beispiele für unterschiedliche Typen aus und bestimme sie zu Kunstwerken."[68]

In *big brown bag* hat Steinbach zum ersten Mal Text und Objekt miteinander verbunden. Er nahm die in New York allgegenwärtige Einkaufstüte von Bloomingdale's und stellte ihrer runden Typographie die abgerundete Form eines Designer-Abfallbehälters gegenüber. Die eigentlich funktionalen Behälter (Tüte und Abfalleimer) werden in ein Spiel begriffsvertauschender Resonanz verwandelt.[69]

big brown bag 1992

Schriftzug (Wandfarbe, schwarz) auf einer Wand, Behälter aus Edelstahl. Behälter 91 x 38 cm; Gesamtmaße: 262 x 221 x 56 cm. Limitiert auf 15 Ausführungen. Zertifikat (**1**): Zeichnung, Mischtechnik, mit aufmontierten Photos und Photokopie, 46 x 68,5 cm, signiert und numeriert.

Ausführung:

Der Schriftzug ist mittels Schablone in schwarz auf die Wand zu übertragen, bei Wandhöhe bis zu 290 cm mit 30 cm Abstand zwischen Fußboden und Unterkante des *g* in *bag*; bei mehr als 305 cm Wandhöhe mit einem Abstand von 36 cm. Metallbehälter unter dem Buchstaben *n* in einem Abstand von 18 cm zur Wand zu plazieren. Hinweis: Wir empfehlen Ausführung durch einen Maler oder Schriftenmaler.
Gelieferte Bestandteile: Schablone, Dispersionsfarbe und Metallbehälter (Fabrikat *United*).

200

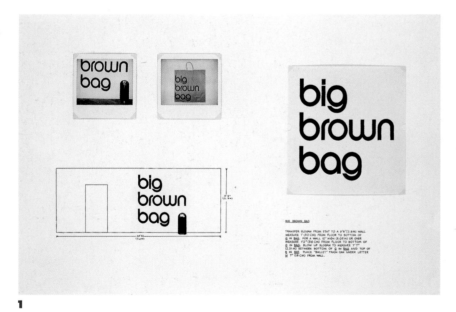

1

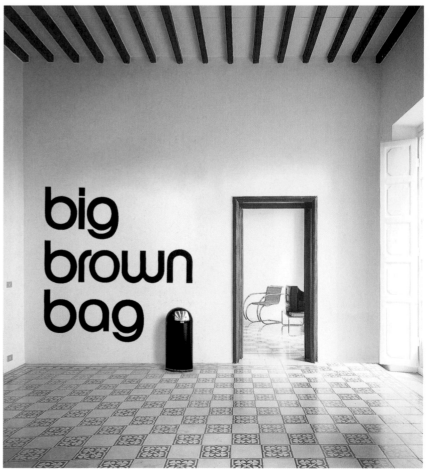

2

Haim Steinbach

Born 1944 in Israel, lives and works in New York. Steinbach first became known for displaying objects culled from everyday life on shelf units, often of his own design. Over the years, Steinbach has also been collecting advertising copy slogans mostly pulled from newspapers and magazines. His work with these slogans is focused on the typological linguistic images of collective speech – sayings and idiomatic expressions with histories that on occasion reach as far back as Aristophanes and La Fontaine. They may be plays or puns on scientific truisms, as with once again the world is flat, or perhaps when applied to capitalistic mercantilism they give humor to Marx's theory of the alienation of labor, as with on vent du vent ("selling air"). "The slogan works enable a play of classification, selection and arrangement similar to that in which the collector of butterflies might engage. I select the most representative types of their particular distinctions, thus designating them as artworks."[68] In the work big brown bag, Steinbach for the first time incorporates text and object. Taking the ubiquitous Bloomingdale's shopping bag slogan, he sets the bullet trash can against the slogan's repetitive typographic curves. The essentially functional containers (bag and can) are transformed into a play of metonymic resonance.[69]

big brown bag 1992

Slogan stenciled on a wall in black paint, with "bullet" trash can. Trash can 36 x 15" diameter; overall size of installation 103 x 87 x 22".
Limited to 15 installations.
Certificate (**1**): mixed media drawing, with collaged photographs and photostat, 18 x 27", signed and numbered.

Installation:

Slogan to be stenciled on the wall in black paint. Position of slogan: 1' (30 cm) from floor to bottom of g in bag; for a wall 10' high (3.05 m) or over 1'2" (36 cm) from floor to bottom of g in bag. Trash can to be placed under letter n at a distance of 7" (18 cm) from the wall.
Note: we recommend installation by a sign painter.
Components provided: stencil, black latex paint, and black and chrome United steel trash can.

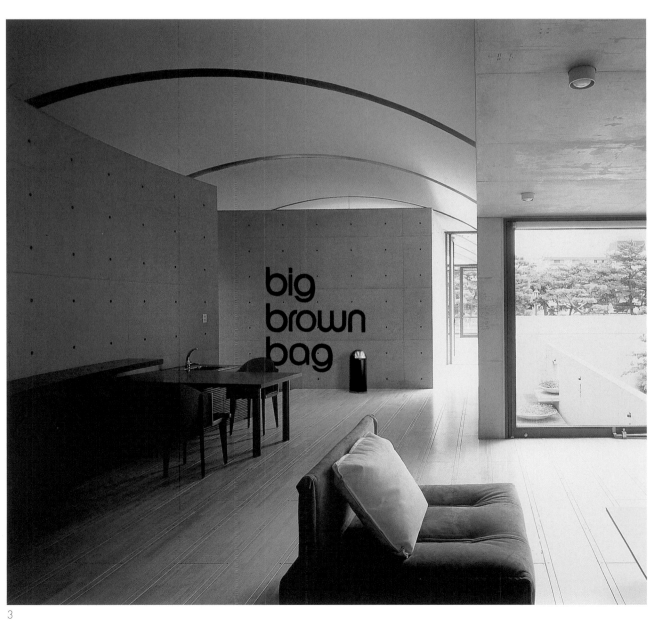

202

Rudolf Stingel

Rudolf Stingel

Geboren 1956 in Meran (Italien), lebt und arbeitet in New York. Rudolf Stingel macht in seinen Arbeiten Mittel und Methoden seiner Malerei transparent; er versagt sich und dem Betrachter mittels analytischer Distanznahme pathetische Illusionismen und betreibt in seiner Malerei eine Entmystifikation des abstrakten Tafelbildes mit all seinen geistigen Überbauten. Das wird besonders deutlich in seinem readymadeartigen Einsatz von Teppichen, wobei die Spuren der handwerklichen Installation die Feinstruktur der Oberfläche modifizieren. Dem Gebrauchscharakter entzogen, werden diese Teppiche zur reinen Präsenz von Farbe, die im Licht der Kunst als ein Substitut monochromer Wandmalerei erscheint, wobei aber nie der Gedanke an demonstrative Systematik oder Polemik aufkommt angesichts des subtilen sinnlichen Reizes dieser Bilder.[70]

Untitled 1997

Teppich, quadratisch, in rot, gelb, blau oder pink, an die Wand montiert. Maße je nach Wand. Limitiert auf 15 Installationen. Zertifikat: Text, Diagramm und Teppichmuster (**1**) auf Karton, 29,7 x 42 cm, signiert und numeriert.

Ausführung:

Ein Quadrat aus Teppich (*Shazam carpet*), dessen Maße sich aus der Höhe der Wand ergeben, an die Wand zu kleben.
Hinweis: Die Installation sollte von einem Teppichverleger ausgeführt werden.
Gelieferte Bestandteile: Teppich in der gewählten Farbe und den erforderlichen Maßen, Kleber.

1

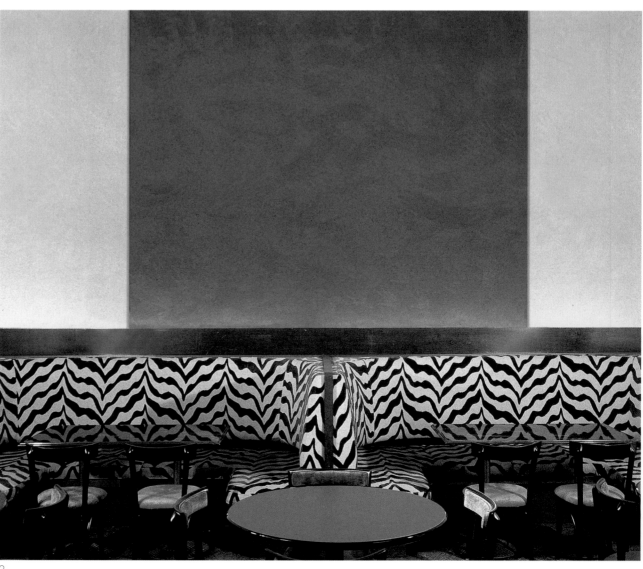

2

Rudolf Stingel

Born 1956 in Meran (Italy), lives and works in New York. Stingel is a painter who reveals the processes of painting. He does not succumb to impassioned illusionism; instead, with analytic detachment, he produces an understated, iridescent art that demystifies abstract painting and its intellectual superstructure.

This can be seen particularly in the assisted readymade use of carpeting where the pattern created by the installer's hands helps make the painting. Deprived of its utility, and outside conventional perception, the carpet is a presence of pure color and, in the light of art, a substitute for monochrome wall painting. The power of these works is that the subtle sensuality they impart pushes aside all consciousness of the system and polemics informing them.[70]

Untitled 1997

A square of carpet, in red, yellow, blue, or hot pink. Size according to the wall. Limited to 15 installations. Certificate: text and diagram on board, with a sample of carpet (1) attached, 11¾ x 16½", signed and numbered.

Installation:

A square piece of Shazam carpet to be installed on a wall. Height and width of the carpet to match the height of the wall. Note: we recommend installation by a professional carpet installer. Components provided: carpet in the color chosen and the size required, and adhesive.

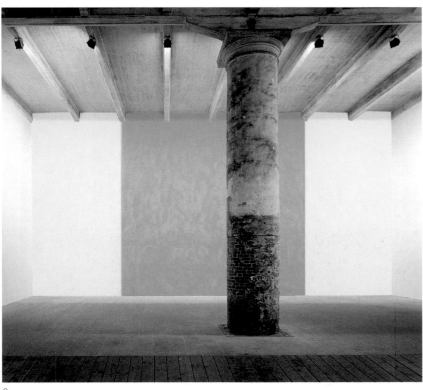

3

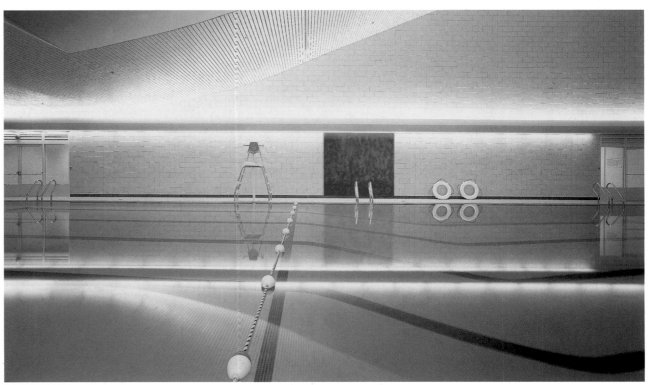

4

"Ich kann gut begreifen, daß Stickerinnen aus Kummer sticken und Frauen Strümpfe stricken, weil es das Leben gibt." (Fernando Pessoa)[71]

"I can well understand that embroideresses embroider out of grief and women knit since there is life."
(Fernando Pessoa)[71]

Rosemarie Trockel

Rosemarie Trockel

Geboren 1952 in Schwerte, lebt und arbeitet in Köln. Rosemarie Trockel ist seit den achtziger Jahren eine der international führenden Konzept-Künstlerinnen. Sie arbeitet mit verschiedenen Medien wie Zeichnung, Skulptur, Installation, Video und Photographie, mittels derer sie gesellschaftspolitische Fragestellungen unter einem feministischen Ansatz diskutiert: Trockel greift geschlechtsspezifische Klischees auf und macht diese durchlässig und brüchig. Sie bearbeitet persönlich besetzte Themen, die sie aber meist in eine eher unterkühlte, sachliche Form- und Bildsprache übersetzt. So demonstriert sie das Klischee des Weiblichen, indem sie etwa in ihren bekannten Strickbildern oder den Arbeiten mit Herdplatten auf traditionell Frauen zugeordnete Tätigkeiten anspielt.[72] Rosemarie Trockel hat ihre Wandarbeit *Prisoner of Yourself* für diesen Katalog virtuell in zwei sehr unterschiedliche Räume plaziert. Der eine (4), der Saal der Villa Wittgenstein, Wien, entworfen 1928 von Ludwig Wittgenstein, ein schmuckloser Bau, der in seiner Vollkommenheit und Vornehmheit als ein vollendetes Werk der Architektur gilt. Der andere (2), ein Raum eines indischen Hauses bei Ahmedabad, erbaut 1918 von Mahatma Gandhi, in dem er bis 1930 mit seiner Frau lebte. Das Spinnrad steht als Symbol für Gandhis Kampf für eine von den Engländern unabhängige häusliche Textilproduktion und ganz grundsätzlich für indische Selbstbestimmung.

Prisoner of Yourself
1998

Siebdruck in blau, braun oder schwarz als Sockel auf die Länge einer oder mehrerer Wände gedruckt. Höhe 127 cm.
Limitiert auf 12 Ausführungen.
Zertifikat (**1**): Siebdruck auf Papier, 29,7 x 42 cm, signiert und numeriert.

Ausführung:

Mit Hilfe eines Siebes in Abschnitten von jeweils 100 cm direkt auf die vorher geglättete Wand zu drucken, wobei an der rechten und linken Wandecke und zum Boden hin (bedingt durch den Rahmen des Siebes) ca. 8 cm unbedruckt bleiben.
Hinweis: Die Ausführung der Wandarbeit erfordert einen Siebdrucker.
Gelieferte Hilfsmittel: Film (127 x 100 cm) zum Herstellen eines Siebes.

212

1

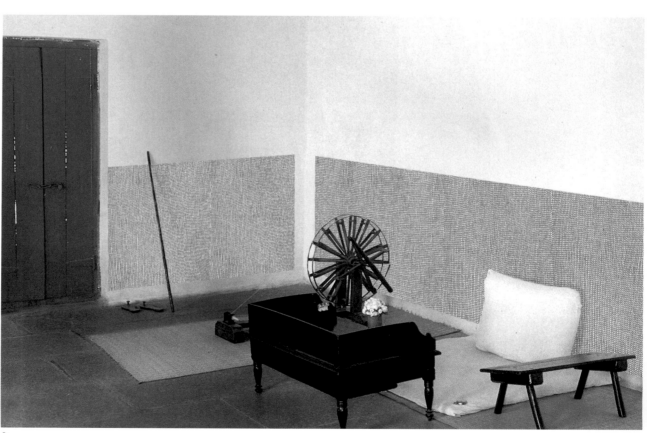

2

Rosemarie Trockel

Born 1952 in Schwerte, Germany, lives and works in Cologne. Rosemarie Trockel has been known as an internationally significant conceptual artist since the 80s. Her works in various media – drawing, sculpture, installation, video and photography – addresses sociological issues with a feminist approach: Trockel takes stereotyped ideas about gender and renders them transparent and fragile. She works with subject matter that personally engages her, translating it into cool and realistic formal language and imagery.

Whether working with knitting paintings or hot plates she demonstrates the cliché of the feminine by alluding to work traditionally associated with women.[72]

For this catalog, Trockel virtually placed her wall work Prisoner of Yourself in two very different spaces. The first (4), the salon of Villa Wittgenstein in Vienna, was designed in 1928 by Ludwig Wittgenstein, and is an austere work of architecture, perfect and refined. The second (2) is the room of an Indian cottage near Ahmedabad, built in 1918 by Mahatma Gandhi, where he lived with his wife until 1930. The spinning wheel symbolizes Gandhi's struggle for Indian self-determination and the domestic production of textiles independent from the British.

Prisoner of Yourself
1998

Silkscreen in blue, brown or black printed on one or more walls as a dado. Height 50", length according to the wall. Limited to 12 installations. Certificate (1): silkscreen on paper, 11¾ x 16½", signed and numbered.

Installation:

To be printed directly on a smooth wall with a screen, in increments of 40". Due to the frame of the screen there will be a border of 3" on the right, left and bottom of the wall.
Note: installation requires a screenprinter.
Components provided: film (50 x 39½") for the production of a screen.

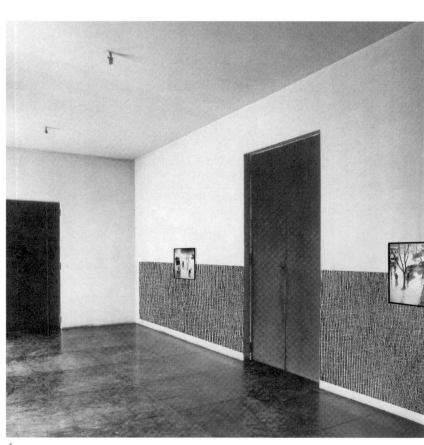

4

Zur Zeit denke ich darüber nach, was Authentizität für die Schwarzen bedeutet. Ich bin an der Fabel als einer trügerischen Form der Vermittlung kultureller Werte interessiert, eine Aufgabe, die vielen Schwarzen in unserer modernen Kultur aufgegeben ist.[73]

Right now I'm thinking about authenticity within the Black "community". Also I'm interested in the Fable as an unreliable method of transmitting cultural values, a task that has been ascribed to many a Negro in modern culture.[73]

Kara Walker

Kara Walker

Geboren 1969 in Kalifornien, lebt und arbeitet in Rhode Island, New York. Kara Walker benutzt die traditionelle Form des Scherenschnitts mit Darstellungen kolonialer Szenen und stellt diese völlig auf den Kopf. In diesen Scherenschnitten, die unsere Wahrnehmung schärfen sollen, zeigt sie eine andere Seite von Amerika und liefert einen beißenden satirischen Kommentar zu üblichen rassistischen Darstellungen.[74]
Sie stellt Szenen voller Sexualität und Gewalt dar, tut dies aber mit sensibler Linienführung und einfacher Abstraktion, die dem Betrachter genügend Distanz lassen, um diese provokativen, starken Bilder zu verarbeiten.
Kara Walker sagt: "Diese Arbeit *Pastoral* ist aus einer ganzen Gruppe von Arbeiten hervorgegangen, die in fiktiven Vorkriegs-Südstaaten angesiedelt sind, einem Ort, an dem gemeine rassische Vorurteile mit der täglichen Realität einer in unterschiedliche Rassen geteilten Kultur einhergehen. Dies ist ein kleines, stilles und beschauliches Bild, in dem eine berühmte Negerin einen Schafspelz anzieht oder vergeblich versucht, es mit sich selbst zu treiben".[75]

Pastoral 1998

Wandbild in schwarz. Größe variabel; Höhe mindestens 120 cm.
Limitiert auf 15 Ausführungen.
Zertifikat: Druck (Zeichnung und Text) auf Papier, 29 x 42 cm, signiert und numeriert.

Skizze der Künstlerin (**1**)

Ausführung:

Mit Hilfe einer gelieferten Schablone an die Wand zu malen.
Hinweis: Wir empfehlen die Ausführung durch einen Schriftenmaler.
Gelieferte Hilfsmittel: Schablone in der gewünschten Größe und Dispersionsfarbe, schwarz.

218

1

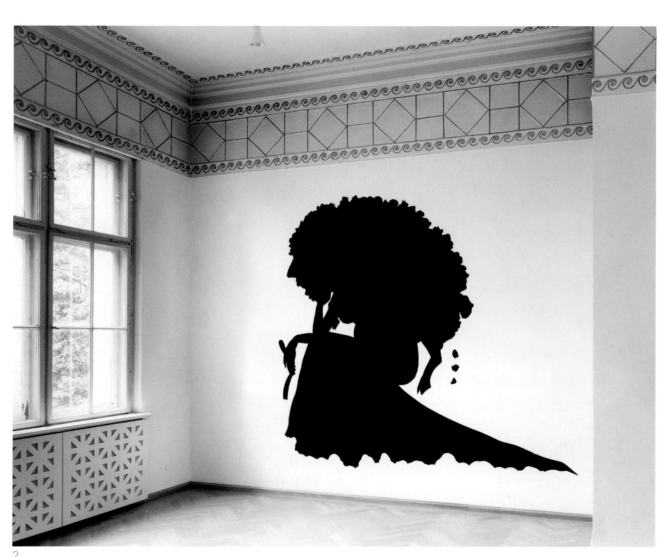

2

Kara Walker

Born 1969 in California, lives and works in Rhode Island. Kara Walker has seized the traditional silhouette – usually a small scale memento – and turned it on its head, showing another side of America to deliver a biting satirical comment on racist representations with an art that's cut to heighten perceptions.[74]

By depicting graphic and violent scenes with beauty of line and abstract simplicity, Walker grants the viewer enough of a remove to digest her provocative, potent material.

Walker says: "This piece Pastoral is a departure from the bulk of my work which is situated in a fictionalized version of the Antebellum South, which is the hub where profane racial mythologies shake hands with the mundane reality of day to day existence in a racially divided culture. This is a quiet little contemplative piece in which a Negress of Renown dons sheep's clothing – or is dry humped by its filthy little self".[75]

Pastoral 1998

Wall painting in black.
Size variable, minimum 4' tall.
Limited to 15 installations.
Certificate: printing of drawing and text, 11½ x 16½", signed and numbered.

Artist's sketch (**1**)

Installation:

To be painted on the wall using the stencil provided in the size chosen.
Note: we recommend installation by a sign painter.
Components provided: stencil and latex paint, black.

219

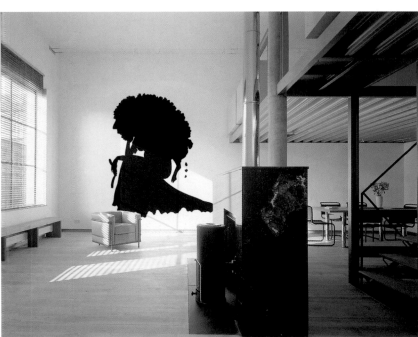

4

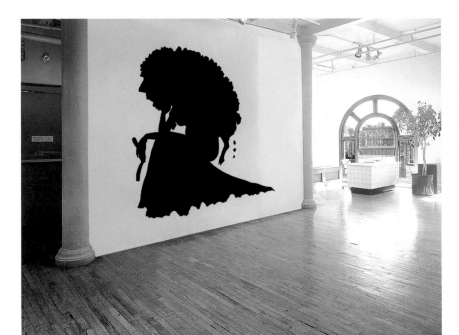

3

Ich mag langweilige Sachen. Ich möchte, daß die Dinge immer wieder ganz genau gleich ablaufen.

Ich glaube nicht, daß Pop Art out ist; sie zieht die Leute immer noch an, aber ich kann nicht sagen, was Pop Art ist; es ist zu kompliziert. Es ist einfach, ...die alltäglichen Gegenstände in die Wohnung zu bringen.
Pop Art ist für jeden da. Ich glaube nicht, daß Kunst nur für wenige Auserwählte sein sollte, ich glaube, sie sollte für die Masse der Amerikaner da sein ...Ich glaube, Pop Art ist eine Kunstform wie Impressionismus oder jede andere sonst. Pop Art ist nicht einfach nur eine Mode. Ich bin nicht der Papst der Pop Art, ich bin nur einer von denen, die sie machen.[76]

I like boring things. I like things to be exactly the same over and over again.

I don't think Pop Art is on the way out; people are still going to it and buying it but I can't tell you what Pop Art is, it's too involved. It's just ... bringing the ordinary objects into the home. Pop Art is for everyone. I don't think art should be only for the select few, I think it should be for the mass of American people ...I think Pop Art is a legitimate form of art like any other, Impressionism, etc. It's not just a put-on, I'm not the High Priest of Pop Art, I'm just one of the workers in it.[76]

Andy Warhol

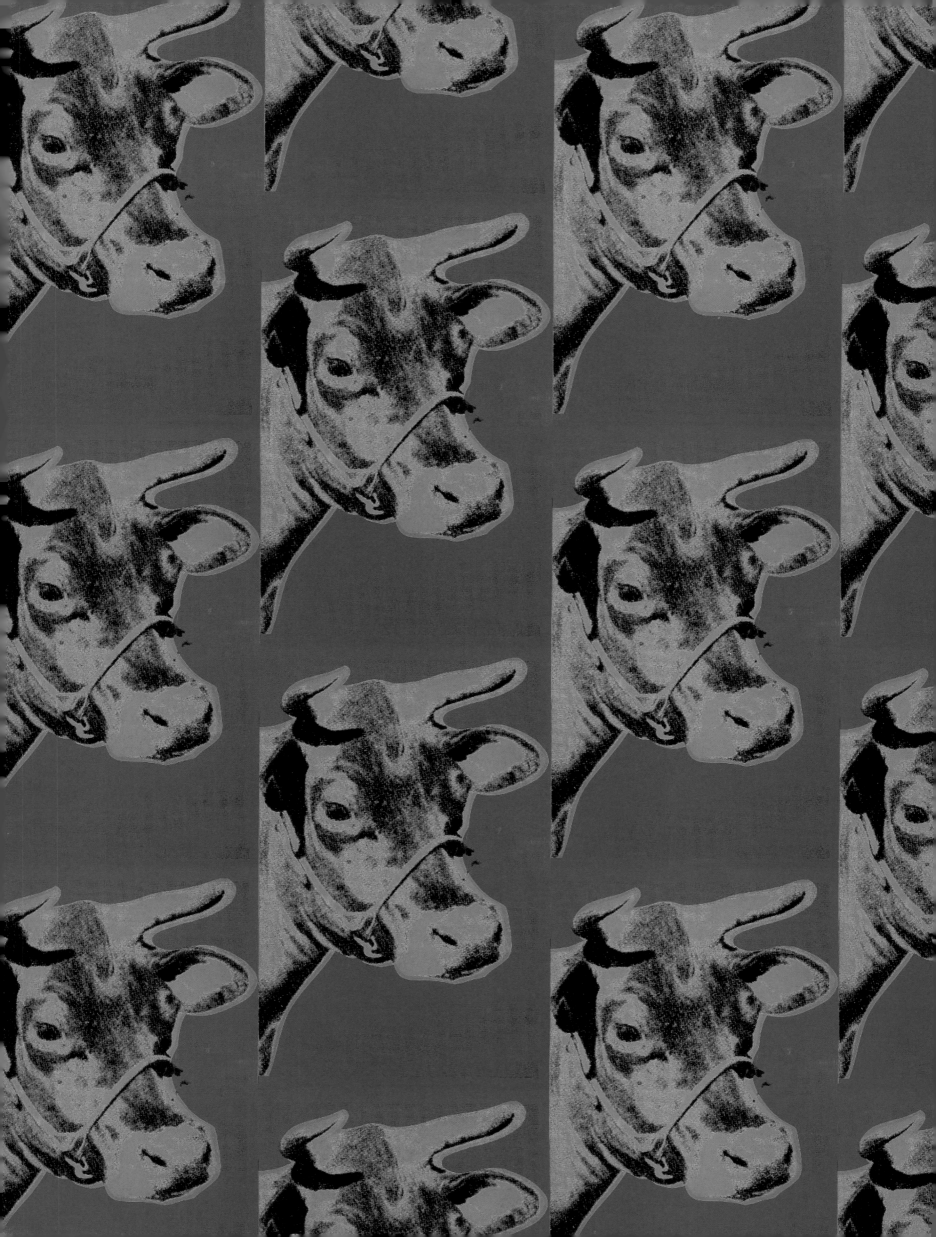

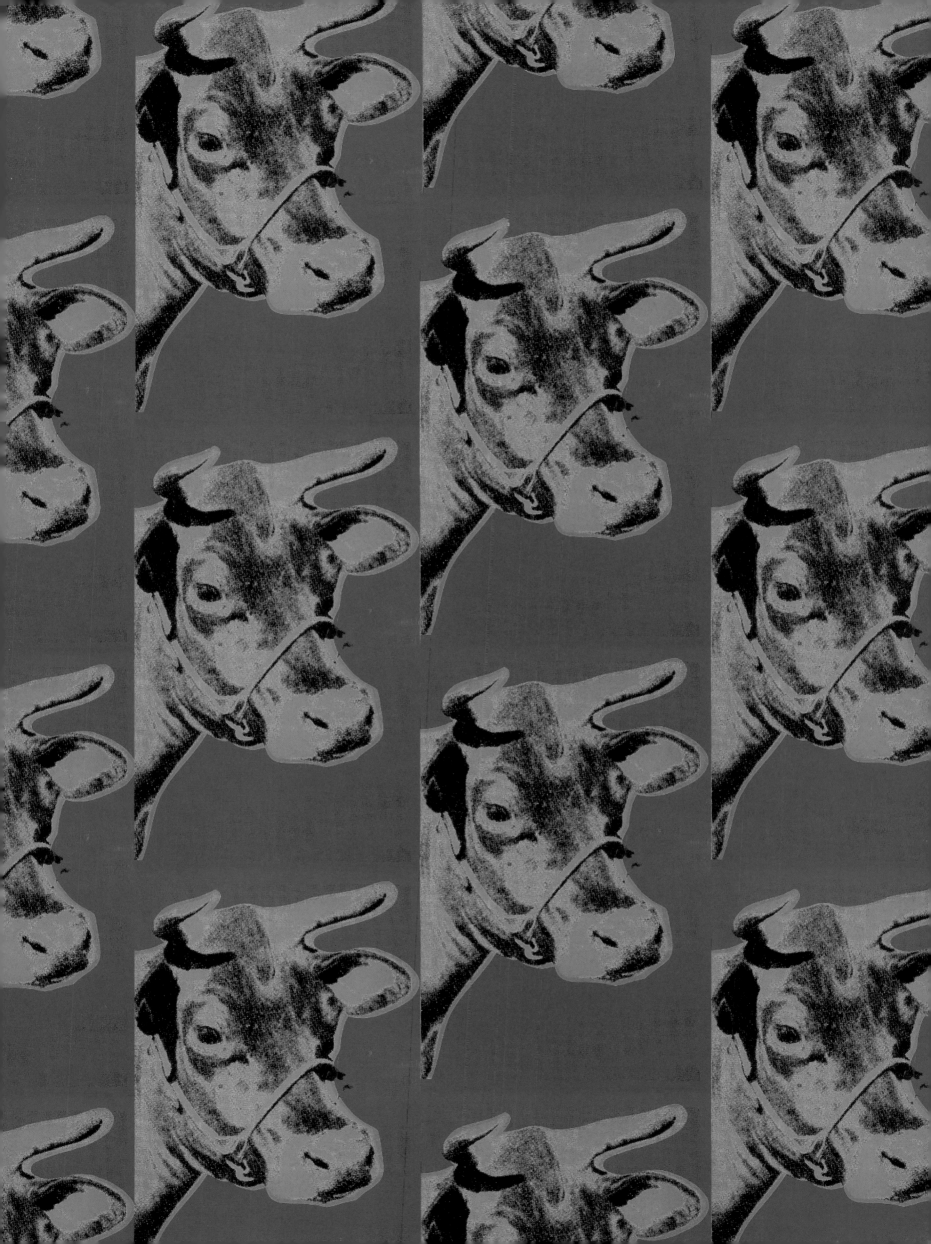

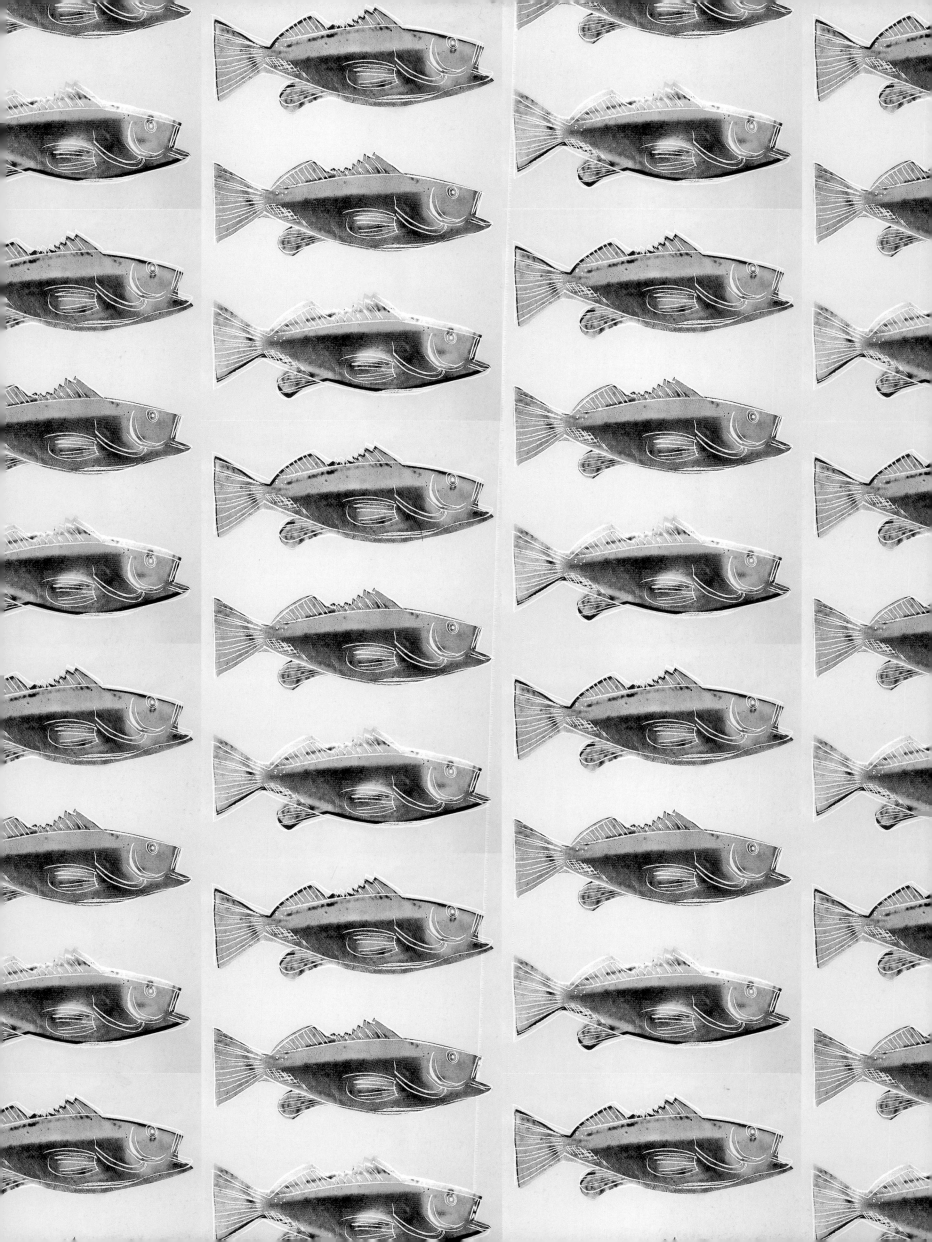

Andy Warhol

Geboren 1928 in Pittsburgh, gestorben 1987 in New York. "Nur sehr wenige Künstler haben einen Grad der Bekanntheit erreicht, der ihnen einen Platz in der Phantasie der Menschen sichert. Andy Warhol war ein solcher Künstler. Jedoch, Warhols Berühmtheit, sein großer, unausweichlicher Ruhm hat oft überdeckt, daß er einer der ernsthaftesten und wichtigsten Künstler unseres Jahrhunderts war. Er hat ganz einfach unsere Vorstellung von der Welt, die uns umgibt, verändert. Er hatte die geradezu unheimliche Fähigkeit, Bilder treffsicher auszuwählen, Bilder, die noch heute große Wirkung haben. Die unverändert übernommenen, überraschend einfachen Bilder – meist aus Zeitungen, Zeitschriften oder Photos, wurden durch ihn zu neuen autonomen Werken, zu zeitlosen mächtigen Zeichen, die unauslöschlich im Bewußtsein der meisten Menschen verankert sind."[77]

Die erste Cow-Wandtapete wurde 1966 in der Leo Castelli Gallery, New York installiert (**1**). In den Jahren 1971 und 1976 entstanden drei weitere Farbvarianten, alle in unlimitierter Auflage, von denen Warhol jeweils 100 bis 150 Exemplare signierte. In einigen Museumsausstellungen wurden Cow-Motive als Tapete verklebt.
Die Tapete Fish wurde 1983 für eine Ausstellung in der Galerie Bischofberger, Zürich gedruckt. In Zusammenarbeit mit der Andy Warhol Foundation for the Visual Arts, New York stehen Cow 1976 und Fish 1983 in kleinen Restauflagen für das vorliegende Projekt Wall Works zur Verfügung.

Cow 1976

Wand bedeckt mit Original-Siebdrucktapete, Motive je 115,5 x 75,5 cm.
Gedruckt 1976 von Bill Miller's Wallpaper Studio, New York. Auflage: unlimitiert (vgl. Werkverzeichnis Feldman/Schellmann Nr. II.12A). Von den Siebdrucken ist noch eine kleine Restauflage verfügbar; sie sind vom Warhol Estate und der Warhol Foundation gestempelt und mit Bestandsnummern versehen.

Fish 1983

Wand bedeckt mit Original-Siebdrucktapete, Motive je 111,8 x 76,2 cm.
Gedruckt 1983 von Rupert Jasen Smith, New York.
Auflage: unlimitiert (vgl./FS Nr. IIIA.30). Von den Siebdrucken ist noch eine kleine Restauflage verfügbar; sie sind vom Warhol Estate und der Warhol Foundation gestempelt und mit Bestandsnummern versehen.

Ausführung:

Die Motive sind an eine Wand oder Teilwand zu tapezieren oder so anzubringen, daß sie ohne Beschädigung wieder abgenommen werden können. Sie sind so anzuordnen, daß die nebeneinander liegenden Motive jeweils um das halbe Motiv versetzt sind.
Hinweis: Die Installation sollte durch einen geeigneten Handwerker erfolgen (auf Anfrage gibt die Edition Schellmann technische Beratung).
Geliefertes Material: Das gewählte Motiv in der für die Wand erforderlichen Menge.

226

1

2

Andy Warhol

Born 1928 in Pittsburgh, died 1987 in New York.
"Very few artists achieve the level of recognition that secures for them a place in the public imagination. Andy Warhol was an artist who did. However, this very celebrity of Warhol's, his sheer, inescapable fame, has often disguised the fact that he was one of the most serious, and one of the most important, artists of the twentieth century. He quite simply changed how we all see the world around us. He also had an uncanny ability to select precise images that still have great resonance today.
The straightforward, shockingly simple images – usually culled from the pages of newspapers and magazines or discovered in photographs – found their way to a new authorship, becoming timeless, potent signs that are indelible in the minds of most of us." [77]
The first Cow wallpaper was installed at the Leo Castelli Gallery, New York in 1966 (**1**). Three other color variations were produced, two in 1971 and one in 1976. All of them were published in unlimited editions, out of which Warhol signed 100-150 prints in each variation. The Cow image was used as wallpaper in several museum shows.
The Fish wallpaper was produced in 1983 for an exhibition at Bruno Bischofberger Gallery, Zurich. The remainder of both the Cow (1976) and Fish (1983) wallpaper is now available for this Wall Works series through a collaboration with the Andy Warhol Foundation for the Visual Arts, New York.

Cow 1976

Wall covered with vintage silkscreen wallpaper, sheet size 45½ x 29¾".
Printed 1976 by Bill Miller's Wallpaper Studio, Inc., New York.
Edition: unlimited (Feldman/ Schellmann catalog raisonné no. II.12A). There is a limited amount of vintage wallpaper available; it is stamped by the Estate and the Foundation and bears the Foundation's inventory number.

Fish 1983

Wall covered with vintage silkscreen wallpaper, sheet size 44 x 30".
Printed 1983 by Rupert Jasen Smith, New York.
Edition: unlimited (F/S no. IIIA.30). There is a limited amount of vintage wallpaper available; it is stamped by the Estate and the Foundation and bears the Foundation's inventory number.

Installation:

Images to be mounted on a wall or part of a wall, either glued directly or mounted so that the images can be removed, aligned as illustrated.
Note: we recommend installation by a professional craftsperson (Edition Schellmann will also advise on the installation).
Components provided: image chosen in the quantity needed for the wall.

227

3

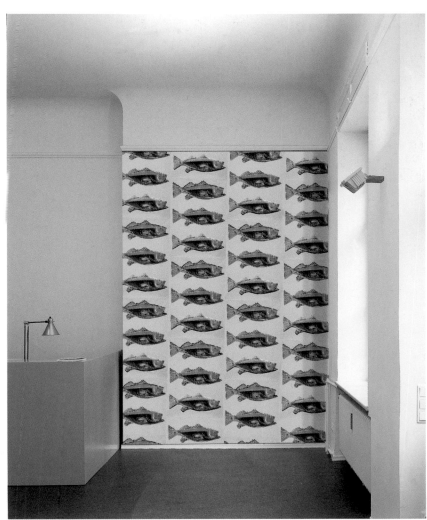
4

■ Wie werden Wall Works realisiert?

Die Wandarbeiten werden entsprechend den Anweisungen der Künstler, wie sie in den Zertifikaten zu den Arbeiten und in dieser Publikation festgelegt sind, von professionellen Handwerkern (Trockenbauer, Maler, Schriftenmaler, Elektriker, Tapezierer, Siebdrucker usw.) installiert. Die Edition Schellmann bietet Beratung und Mithilfe bei der Ausführung an; auf Wunsch erstellt sie in Zusammenarbeit mit dem Künstler eine Computermontage, die die Anwendung der Parameter des Künstlers auf die vorgesehene Wand des Käufers und die Wirkung im Raum zeigt. Die meisten Künstler sind bereit, die individuelle Situation der Installation zu berücksichtigen und evtl. eine zusätzliche Variante in Anordnung, Größe oder Farbe vorzuschlagen.

Auf Wunsch der Künstler erhält die Edition Schellmann von jeder realisierten Wandarbeit ein professionelles Dia, das der Kontrolle der richtigen Ausführung dient und evtl. in einer späteren Publikation über das Projekt abgebildet wird.

Die Wandarbeiten können, wenn der Besitzer umzieht oder die Arbeit verkauft, erneut ausgeführt werden: hierzu liefert die Edition Schellmann das erforderliche Ersatzmaterial. Im Fall einer Neuinstallation muß die alte Arbeit abgebaut werden. Das Zertifikat autorisiert nur jeweils eine Ausführung.

■ How are Wall Works Realized?

These wall works require professional installation by skilled craftspersons (contractor, painter, sign painter, electrician, paperhanger, screenprinter etc.). Each installation must be executed according to the specifications given in the artists' certificates and in this publication; Edition Schellmann will provide additional advice and assistance as needed. Supplied with a photo, Edition Schellmann, in cooperation with the artists, will produce a computer montage illustrating the visual impact of a chosen work upon a given space. In some cases, the artists are willing to consider the specifics of an individual site and are prepared to propose an additional variation in configuration, size, or color.

The artists require each wall work's owner to furnish Edition Schellmann with a professional 4 x 5" transparency of the completed work, for review as well as possible inclusion in a larger publication on the Wall Works project.

The wall works can be re-installed if the owner moves or sells the work. In this case, the necessary new material can be ordered from Edition Schellmann. With a re-installation, the prior installation must be dismantled. Each certificate authenticates only one realized work.

229

Quellenverzeichnis

Sources and Credits

Texte: Quellen
Die verwendeten Textquellen
wurden zum Teil wörtlich zitiert,
zum Teil syntaktisch verändert
oder ergänzt.

Abbildungen: Architekten und Photographen
Die Wandarbeiten wurden meist
per Computermontage in die
architektonischen Innenräume
eingesetzt; um das sichtbar
zu machen, ist die Architektur
in schwarz/weiss, die Kunst in
Farbe dargestellt. Die Räume
mit einheitlichen Farbabbildungen
zeigen reale Installationen.

Texts: sources
Some sources were quoted
verbatim, others paraphrased.

Illustrations: architects and photographers
Illustrations with black and
white architecture and color art
indicate that the wall work was
"placed" in the space through
computer manipulation. Full color
illustrations show actual install-
ations.

Quote p. 2

[1] The basic content of this specific quote (Anatolij Strigaljow, Architekten aus Neigung - *Der Einfluß der Avantgarde-Künstler auf die Architektur*, in *Die große Utopie. Die russische Avantgarde 1915 - 1932*, Frankfurt 1992, pp. 261, 266) derives from much earlier ideas, including the archaic definition of architecture as the "roof of the arts". In his *De architectura* - the first theoretic writing on architecture, based on Greek sources – the Roman architect Marcus Vitruvio Pollio (24 B.C.) points out that the master builder needs to have a comprehensive body of knowledge, and must be a technician, artist, craftsman, surveyor, mathematician, historian, philosopher, etc. In the history of the West, most major architects were artists and vice versa – to name just a few: the Greek Phidias, the Italians Arnolfo di Cambio, Alberti, da Vinci, Michelangelo, Palladio, Bernini, and later Neumann, Schinkel, von Klenze, Le Corbusier; finally, the ideas of Art Nouveau and the Bauhaus also called for such a unity. Walter Gropius claimed in his 1919 Bauhaus manifesto: "Das Endziel aller bildnerischen Tätigkeit ist der Bau" (The building is the final goal of all artistic activities).

Schneede essay

illustrations pp. 8-15:
1 Wild horse, cave drawing, Magdalénien (Le Portel near Loubens, Dép. Ariège), paleolithic, from Der Neue Brockhaus, vol. 1, Mannheim 1991, p. 75.
2 Grave in Thiesi, Sardinia (Italy); photo: Ingeborg Mangold
3 Wall painting, *Casa dei Vetii*, Pompeii, Italy, between 70 and 79 A.C. from Propyläen Kunstgeschichte, vol. 2, Berlin, 1985.
4 Veronese, fresco painting at Villa Barbaro in Masér, Treviso (Italy), 1562; photo: Paolo Marton, Treviso.
5 Hans von Marées, fresco painting at The Zoological Station, Naples (Italy), 1873; photo: Andreas Böttcher, Frankfurt.
6 Oskar Schlemmer, wall design in Dr. Rabe residence, Zwenkau near Leipzig (Germany), 1930/31; photos: Pavel Stecha, from HÄUSER 1/90, Hamburg, 1990, p. 111.
7 Sol LeWitt, wall drawing #415 D;

photo: Richard Cheek, installation view from *Sol LeWitt, 25 Years of Wall Drawings*, 1968-93, Addison Gallery of American Art, Andover, 1993, p. 62.
8 Gerhard Merz, *Tivoli*, 1985, stairwell with wall paintings, Barerstrasse 9, Munich; photo: Klaus Kienold, from *Gerhard Merz, Tivoli*, Cologne, 1986.
9 Joseph Kosuth, *Chambres d'Amis*, Museum van Hedendaagse Kunst, Gent (Belgium), 1986; photo: Attilio Maranzano, Rome.

Rimanelli essay

illustrations pp. 16-19:
1 Japanese residence, Dojinsai, Togu-do, Jisho-ji, late 15th century, from Atsushi Ueda, *The Japanese House*, Tokyo, 1990, p. 54.
2 Mies van der Rohe, German Pavilion at the World Exhibition at Barcelona, 1928-29, from Werner Blaser, *Mies van der Rohe*, Basel, 1997, cover page; and Mies van der Rohe, floorplan of residence at the Berliner Bauausstellung, 1931, from David Spaeth, *Mies van der Rohe, Der Architekt der technischen Perfektion*, Stuttgart, 1995, p. 78.
3 Mies van der Rohe, house with 3 courtyards, project, 1934, with collaged detail of a painting by Georges Braque, from Werner Blaser, *Mies van der Rohe*, Basel, 1997, p. 52.

Richard Artschwager

statement p. 22: [2] the artist, 1999.
text p. 26/27: [3] Richard Armstrong, ed., *Richard Artschwager*, Whitney Museum of American Art, New York, 1988, p. 9, p. 13ff, and David Deitcher, *Parkett* no. 46, Zurich, 1996, pp. 21-23.
illustrations pp. 26/27:
2 installation at the artist's studio, New York; photo: D. James Dee, New York.
3 architecture: Richard Gluckman, Paula Cooper Gallery, New York, 1996; photo: Tom Powel, New York.
4 architecture: Pawson and Silvestrin, Miro residence, London; photo: Richard Bryant / Arcaid, Kingston-upon-Thames (GB), 1990.

Daniel Buren

statement p. 28: [4] the artist in *Erscheinen, Scheinen, Verschwinden*, Kunstsammlung NRW, Düsseldorf, 1986, p. 143.
text pp. 32/33: [5] ibid., front flap.

illustrations pp. 32/33:
3 architecture: Kunsthalle Baden-Baden (Germany); photo: Philipp Schönborn, Munich.
4 architecture: Richard Meier, Siemens AG, Munich, 1990; photo: Dieter Leistner/Architekton, Mainz.
5 architecture: Richard Rogers, Richard Rogers residence renovation 1996; photo: Richard Bryant/Arcaid, Kingston-upon-Thames (GB).

illustrations pp. 34/35
2 architecture: private residence, Munich, 1908/1998; photo: Jens Weber, Munich.
3 architecture: Richard Gluckman, Paula Cooper Gallery, New York, 1996 photo: Tom Powel, New York.

Jessica Diamond

text pp. 42/43: [6] Ralph Rugoff, *Crazy Love (Dimensions Variable)* in *Am Rande der Malerei*, Kunsthalle Bern, 1995, p. 89. [7] ibid.
illustrations pp. 42/43:
1 architecture: Schneider und Schumacher, office building, Frankfurt; photo: Wolfgang Günzel, Offenbach.
2 architecture: Richard Gluckman, Paula Cooper Gallery, New York, 1996; photo: Lydia Gould, New York.
3 architecture: Franz von Stuck, Museum Villa Stuck, Munich, 1898/1998; photo: Jens Weber, Munich.

Dan Flavin

statements p. 44: [8] the artist in exhibition brochure, *Dan Flavin*, Solomon R. Guggenheim Museum New York, 1995, p. 2ff. [9] Dan Flavin, *Dan Flavin*, Kunsthalle Baden-Baden, Stuttgart, 1989, p. 28.
text pp. 48/49: [10] the artist, ibid., front flap.
illustrations pp. 48/49:
2 architecture: Claus und Forster, apartment building, Munich, 1998; photo: Jens Weber, Munich.
3 installation at Edition Schellmann gallery, Munich, 1997; photo: Philipp Schönborn, Munich.

Sylvie Fleury

statements p. 50: [11] from *Süddeutsche Zeitung magazin*, no. 38, Munich, 1996, p. 40.
text pp. 54/55: [12] press release, Galerie Philomene Magers, Cologne, 1995.
illustrations pp. 54/55:

2 architecture: Schneider und Schumacher, office building, Frankfurt; photo: Wolfgang Günzel, Offenbach.
3 architecture: David Chipperfield, private residence, Petersham (GB), 1990; photo: Richard Bryant/Arcaid, Kingston-upon-Thames (GB).
4 architecture: private European residence; photo: Roberto Schezen/Esto Photographics Inc., New York.

illustrations pp. 58/59:
2 architecture: private residence, Munich, 1918/1998; photo: Jens Weber, Munich.
3 architecture: Ludwig Troost, building Meiserstr. 10, Munich, 1934/1998; photo: Jens Weber, Munich.
4 architecture: Mark Guard, private residence, London; photo: John Edward Linden/Arcaid, Kingston-upon-Thames (GB).

Günther Förg

text pp. 64/65: [14] Ingrid Rein in several publications.
illustrations pp. 64/65:
2 architecture: private European residence; photo: Roberto Schezen/Esto Photographics Inc., New York.
3 installation at exhibition hall Edition Schellmann, Cologne, 1993; photo: Nic Tenwiggenhorn, Düsseldorf.
4 architecture: Selldorff Architects, remodeled country residence in Manciano (Italy); photo: Annabelle Selldorff.

illustrations pp. 68/69:
2 architecture: Hendrik P. Berlage, Gemeentemuseum, Den Haag (Netherlands), 1920s.
3 architecture: private residence, New York; photo: D. James Dee, New York.

Gilbert & George

statement p. 70: [17] Gilbert & George, *Parkett* no. 14, Zurich 1987, p. 32.
text pp. 74/75: [18] from Wolf Jahn, *Die Kunst von Gilbert & George*, Munich, 1989, front flap. [19] Mario Codognato, *Parkett* no. 14, Zurich 1987, p. 39.
illustrations pp. 74/75:
1 architecture: RISK publishing studio, Milan, 1989; photo: RISK magazine, Milan.
2 architecture: Philip Johnson, Guest House, New York, 1950; photo: D. James Dee, New York.
3 architecture: David Wild,

231

David Wild residence, London; photo: Richard Bryant / Arcaid, Kingston-upon-Thames (GB).

Thomas Grünfeld
statement p.76: [20] the artist, 1998.
text pp.80/81: [21] Stuart Morgan, *The Useless Art of Thomas Grünfeld*, Artscribe 63, 1987, London, p. 38f.
illustrations pp.80/81:
2 architecture: Galleria Giorgio Persano, Turin (Italy); photo: Paolo Pellion, Turin.
3 architecture: private residence, New York; photo: D. James Dee, New York.

Peter Halley
statement p.82: [22] the artist, 1998.
text pp. 86/87: [23] Steven Shaviro, *On Paper*, Nov/Dec 1997, p.43. [24] Starr Figura, *New Concepts in Printmaking*: Peter Halley, The Museum of Modern Art, 1997.
illustrations pp.86/87:
2 architecture: private European residence; photo: Roberto Schezen/ Esto Photographics Inc., New York.
3 architecture: Philip Johnson, Guest House, New York, 1950; photo: D. James Dee, New York.
4 installation at Museum Folkwang, Essen, Germany (Halley exhibition 1998-99); photo: Museum Folkwang.

Damien Hirst
statements p.88: [25] Damien Hirst, *I Want to Spend the Rest of My Life Everywhere, with Everyone, One to One, Always, Forever, Now*, New York, 1997, pp. 20/21, 246.
text pp.92/93: [26] Jerry Saltz, "More Life, The Work of Damien Hirst", *Art in America*, June 1995, p.85. [27] ibid.
illustrations pp. 92/93:
2 architecture: private residence, Munich, 1910/1998; photo: Jens Weber, Munich.
3 architecture: Philip Johnson, Guest House, New York, 1950; photo: D. James Dee, New York.
4 installation at TowerAir terminal, JFK airport, New York, 1995; photo: Tom Powel, New York.

Donald Judd
statement p.94: [28] Donald Judd, *Architektur*, Münster, 1989, pp143/144.
text pp.98/99: [29] Donald Judd, *Architektur*, Stuttgart, 1991, front flap. [30] Brigitte Huck, ibid., pp.17, 20.

illustrations pp. 98/99:
3 architecture: Mario Botta, private residence at Massagno (Switzerland), 1979-81; photo: Yukio Futagawa, Tokyo.
4 architecture: Villa Chiari, Tuscany; photo: Carlo Gianni, Prato (Italy).

IMI Knoebel
quote p.100: [31] Christian Schenker, *IMI Knoebel, Mennigebilder 1976-92*, Deichtorhallen Hamburg, 1992, p.10.
text pp.104/105: [32] Lisa Liebmann, *Parkett* no. 32, Zurich, 1992, p. 67. [33] Vitali/Fuchs/Harten, *IMI Knoebel, Retrospektive 1968-96*, Haus der Kunst, Munich, 1996, foreword.
illustrations pp. 104/105:
3 architecture: private residence, Munich, 1910/1998; photo: Jens Weber, Munich.
4 installation at Hilmer und Sattler architectural office, Munich, 1997; photo: Jens Weber, Munich.
5 architecture: Lauber + Wöhr, Vereinte Versicherungen, Munich, 1996; photo: Dieter Leistner/ Architekton, Mainz.

text pp. 108/109: [34] Hubertus Gaßner in *IMI Knoebel, Retrospektive 1968-96*, Haus der Kunst, Munich, 1996, pp. 54/55.
illustrations pp.108/109:
2 architecture: Oswald M. Ungers, Messe Berlin 1990-99; photo: Stefan Müller.
3 architecture: Allies & Morrison, Soho Square offices, London, 1997; photo: Peter Cook / View, London.
4 architecture: Novo Art office and studio, New York 1912/1998; photo: D. James Dee, New York.

Joseph Kosuth
statement p.110: [35] the artist, 1998.
text pp.114/115: [36] Kristen Stiles and Peter Selz, *Theories and Documents of Contemporary Art*, UC Berkeley, 1996, p.808.
illustrations pp.114/115:
2 architecture: Franz von Stuck, Museum Villa Stuck, München, 1898/1998; photo: Christoph Born, Munich.
3 architecture: Rafael Viñoly, Tokyo Forum, Tokyo, 1995; photo: Hattori Studio, Tokyo.
4 installation at Edition Schellmann gallery, Munich, 1998; photo: Christoph Knoch, Munich.

Jannis Kounellis
statement p.116: [37] the artist,

Jannis Kounellis, Die eiserne Runde, Hamburger Kunsthalle, 1995, footnote 22, p. 57.
text pp.120/121: [38] Uwe M. Schneede, ibid., foreword.
illustrations pp.120/121:
2 architecture: Pawson and Silvestrin, Miro residence, London; photo: Richard Bryant / Arcaid, Kingston-upon-Thames (GB), 1990.
3 architecture: *Aperto*, Venice Biennale, 1993; photo: G. Koller.
4 architecture: Villa Chiari, Tuscany; photo: Carlo Gianni, Prato, Italy.

Sherrie Levine
statement p.122: [39] the artist, 1998.
illustrations pp.126/127:
3 architecture: private residence, Munich, 1920s; photo: Jens Weber, Munich.
4 installation at Edition Schellmann gallery, Munich, 1997; photo: Philipp Schönborn, Munich.
5 architecture: Christoph Buck, Haus Ferrier, Switzerland, 1992; photo: H.J. Willig / Picture Press, Hamburg.

Sol LeWitt
statements p.128: [40] Sol LeWitt, *Sentences on Conceptual Art*, in Art-Language, May 1969, p.11. [41] LeWitt, *Paragraphs on Conceptual Art*, in Artforum 5, no.10, June 1967, p. 79.
text pp.132/133: [42] Andrea Miller-Keller in *Sol LeWitt, 25 Years of Wall Drawings, 1968-93*, Addison Gallery of American Art, Andover, 1993, pp.37-45.
illustrations pp.132/133:
1 architecture: Pawson and Silvestrin, Miro residence, London; photo: Richard Bryant / Arcaid, Kingston-upon-Thames (GB), 1990.
2 architecture: Frank Gehry, Vitra Museum, Weil am Rhein (Germany) 1989; photo: Peter Mauss / Esto Photographics Inc., New York.
3 architecture: Villa Chiari, Tuscany; photo: Carlo Gianni, Prato (Italy).

illustrations pp. 136/137:
1 architecture: Addison Gallery of American Art, Andover, MA, USA; photo: Richard Cheek.
2 architecture: Pawson and Silvestrin, Miro residence, London; photo: Richard Bryant / Arcaid, Kingston-upon-Thames (GB), 1990.

3 architecture: Richard Gluckman, Paula Cooper Gallery, New York, 1996; photo: Tom Powel, New York.

Gerhard Merz
statements p.138: [43] the artist in Markus Klammer, *Gerhard Merz, Bozen-Bolzano*, Zurich, 1997, p.19. [44, 45] the artist in exhibition folder, Urs Stahel, *Costruire*, Zurich, 1989, p.2.
text pp. 142/143: [46] Marie-Louise Lienhard, exhibition lecture, Helmhaus, Zurich, Sept. 1998.
illustrations pp. 142/143:
2 architecture: Pawson and Silvestrin, Miro residence, London; photo: Alberto Piovano, Milan, 1988.
3 architecture: Pawson and Silvestrin, Miro residence, London; photo: Richard Bryant / Arcaid, Kingston-upon-Thames (GB), 1990.
4 architecture: private residence, Munich, 1908/1998; photo: Jens Weber, Munich.

illustrations pp. 146/147:
2 architecture: Andrea Palladio, Villa Pisani, Bagnolo di Lonigo, Vicenza (Italy); photo: Studio Azzuro, Milan, Paolo Marton, Archivio Ferri de Lazara.
3 installation at Edition Schellmann gallery, Munich, 1997; photo: Philipp Schönborn, Munich.
4 architecture: Gerhard Merz, office building, Bad Hartha near Dresden (Germany), 1997; photo: J. und Ph. von Bruchhausen, Berlin.

Matt Mullican
statement p.148: [47] the artist in interview with Michael Tarantino in *The MIT Project*, MIT List Visual Arts Center, 1990.
text pp.152/53: [48] Katy Kline, ibid. [49] Kasper König in *Matt Mullican Works 1972-1992*, Cologne, 1993, introduction.
illustrations pp.152/153:
2 architecture: Axel Bleyer, USM u. Schärer Söhne AG, Münsingen (Switzerland); photo: USM, Münsingen.
3 architecture: Lauber + Wöhr, Vereinte Versicherungen, Munich, 1996; photo: Dieter Leistner / Architekton, Mainz.

Tony Oursler
statement p.154: [50] the artist, 1999.
text pp.160/161: [51] "Book-forum" in *Artforum*, Nov.1998
illustrations pp.160/161:

1 architecture: private residence, New York; photo: D. James Dee, New York.
2 architecture: Schneider und Schumacher, office building, Frankfurt; photo: Wolfgang Günzel, Offenbach.

Nam June Paik
statements p. 162: [52] Baudrillard, 1983 in *N. J. Paik, Video Time - Video Space*, Kunsthalle Basel, 1991, p. 79. [53, 54] from *Paik, eine DATA base*, Stuttgart, 1993, front flap.
text pp. 166/167: [55] ibid., back flap.
illustrations pp. 166/167:
1 architecture: Franz von Stuck, Museum Villa Stuck, Munich, 1898/1998; photo: Jens Weber, Munich.
2 architecture: Pawson and Silvestrin, Miro residence, London; photo: Alberto Piovano, Milan, 1988.

illustrations pp. 170/171:
2 architecture: Richard Gluckman, Paula Cooper Gallery, New York, 1996; photo: Tom Powel, New York.
3 architecture: RISK publishing studio, Milan, 1989; photo: RISK magazine, Milan.

Giulio Paolini
statement p. 172: [56] Giulio Paolini, 1979 in *documenta VII*, vol. 1, Kassel, 1982, pp. 383, 442.
text pp. 176/177: [57] Michael Archer, *Art Since 1960*, London 1996, p. 86. [58] Germano Celant, *The Italian Metamorphosis*, Solomon R. Guggenheim Museum, New York, 1994.
illustrations pp. 176/177:
2 architecture: Pawson and Silvestrin, Miro residence, London; photo: Richard Bryant / Arcaid, Kingston-upon-Thames (GB), 1990.
3 architecture: Franz von Stuck, Museum Villa Stuck, Munich, 1898/1998; photo: Jens Weber, Munich.

Michelangelo Pistoletto
text pp. 182/183: [60] the artist in Bruno Corà, *Michelangelo Pistoletto*, Palazzo Fabroni, Pistoia, Italy, 1995, p. 43f. [61] the artist, 1998.
illustrations pp. 182/183:
2 architecture: Edition Schellmann gallery, Munich, 1904/1998; photo: Jens Weber, Munich.

3 architecture: private residence, Munich, 1908/1998; photo: Jens Weber, Munich.

Julian Schnabel
statement p. 184: [62] the artist in *Contemporary Visual Arts* magazine, issue 15, 1997, p. 28.
illustrations pp. 188/189:
1 architecture: private residence, Munich, 1898/1992; photo: Mario Gastinger, Munich.
2 architecture: the artist's residence, New York, 1994; photo: François Holard, New York.

Cindy Sherman
statements p. 190: [64] the artist in *Art Talk - The Early 80s*, edited by Jeanne Siegel, New York, 1988. [65] Sherman interviewed by Noriko Fuku, "A Woman of Parts", *Art In America*, June 1997, p. 125.
text pp. 194/195: [66] Kevin E. Consey/Richard Koshalek *Cindy Sherman Retrospective* Chicago/Los Angeles, London, 1997.
illustrations pp. 194/195:
1 architecture: Philip Johnson, Guest House, New York 1950; photo: D. James Dee, New York.
2 architecture: A.J. Kostelac, Grimm residence, Mannheim, 1992; photo: Dieter Leistner / Architekton, Mainz.
3 architecture: Richard Gluckman, The Andy Warhol Foundation for the Visual Arts, New York, 1994; photo: Adam Reich, New York.

Haim Steinbach
statement p. 196: [67] the artist, 1998.
text pp. 200/201: [68, 69] the artist
illustrations pp. 200/201:
2 architecture: Villa Chiari, Tuscany; photo: Carlo Gianni, Prato, Italy.
3 architecture: Tadao Ando, I House, Ashiya, Hyogo (Japan) 1988; photo: Japan Architect (Shinkenchiku-Sha) Co., Ltd., Tokyo.

Rudolf Stingel
text pp. 206/207: [70] the artist in *Rudolf Stingel*, Kunsthalle Zurich, 1995, p. 5ff.
illustrations pp. 206/207:
2 architecture: Rafael Viñoly Architects, Lot 61, New York, 1997; photo: Lucas Michael, New York.
3 architecture: *Aperto*, Venice Biennale, 1993; photo: G. Koller.
4 architecture: Rafael Viñoly Architects, John Jay College Swimming Pool, New York, 1988;

photo: Paul Warchol Studio, New York.

Rosemarie Trockel
statement p. 208: [71] quote chosen by the artist.
text pp. 212/213: [72] courtesy Galerie Monika Sprüth, Cologne, 1998.
illustrations pp. 212/213:
2 architecture: Mahatma Gandhi residence, near Ahmedabad, India; photo: illustration from book *Lifestyle/House and Home, Indian Style*.
3 architecture: Seth Stein, Stein residence, London; photo: Richard Bryant / Arcaid, Kingston-upon-Thames (GB).
4 architecture: Ludwig Wittgenstein, salon of Villa Wittgenstein, Vienna, 1928; photo from Bernhard Leitner, *The Architecture of Ludwig Wittgenstein*, New York, 1976, p. 66.

Kara Walker
statement p. 214: [73] the artist, 1998.
text pp. 218/219: [74] from interview with James Hanneham, *Interview*, Nov. 1998. [75] the artist, 1998.
illustrations pp. 218/219:
2 architecture: Franz von Stuck, Museum Villa Stuck, Munich, 1898/1998; photo: Jens Weber, Munich.
3 Novo Ars office and studio, New York 1912/1998; photo: D. James Dee, New York.
4 architecture: David Wild, David Wild residence, London; photo: Richard Bryant / Arcaid, Kingston-upon-Thames (GB).

Andy Warhol
statement p. 220: [76] the artist in *Andy Warhol, A Retrospective*, The Museum of Modern Art, New York, 1989, p. 457, 461.
text pp 226/227: [77] ibid., Kynaston McShine essay, p. 13.
illustrations pp. 226/227:
2 architecture: Castello di Rivoli, Turin; photo from catalog *Günther Förg*, Kassel, 1990.
3 architecture: Richard Gluckman, The Andy Warhol Foundation for the Visual Arts, New York, 1994; photo: Adam Reich, New York.
4 architecture: Edition Schellmann gallery, Munich, 1904/1998; photo: Jens Weber, Munich.

Special acknowledgements

Jeanne Greenberg, Project Advisor.
Augusto Arbizo, Project Assistant.
Meg Malloy and Klaus Friese,
Production Coordinators.
Co-editing of the catalog:
Jeanne Greenberg, Meg Malloy,
Sarah Falkner, and Bettina Mittler.
Computer montages:
Rudolf Gensberger, Repro Bayer,
München.

We thank
Paula Cooper and Steve Henry
of the Paula Cooper Gallery,
as well as Jo-Anne Birnie Danzker
and Susanne Baumann of the Museum
Villa Stuck for their enthusiasm for
this project.

Additional thanks to the following
galleries
Holly Solomon (Nam June Paik)
Metro Pictures (Cindy Sherman,
Tony Oursler)
Paula Cooper (Rudolf Stingel)
Wooster Gardens (Kara Walker)
Vincent Fremont, Tim Hunt
(The Andy Warhol Foundation)
Susanna Singer (Sol LeWitt).

234